VAN GOGH

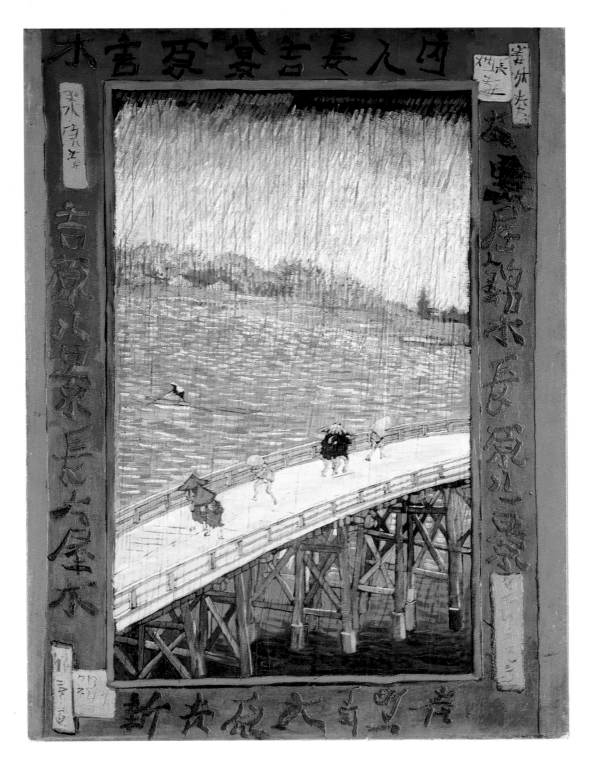

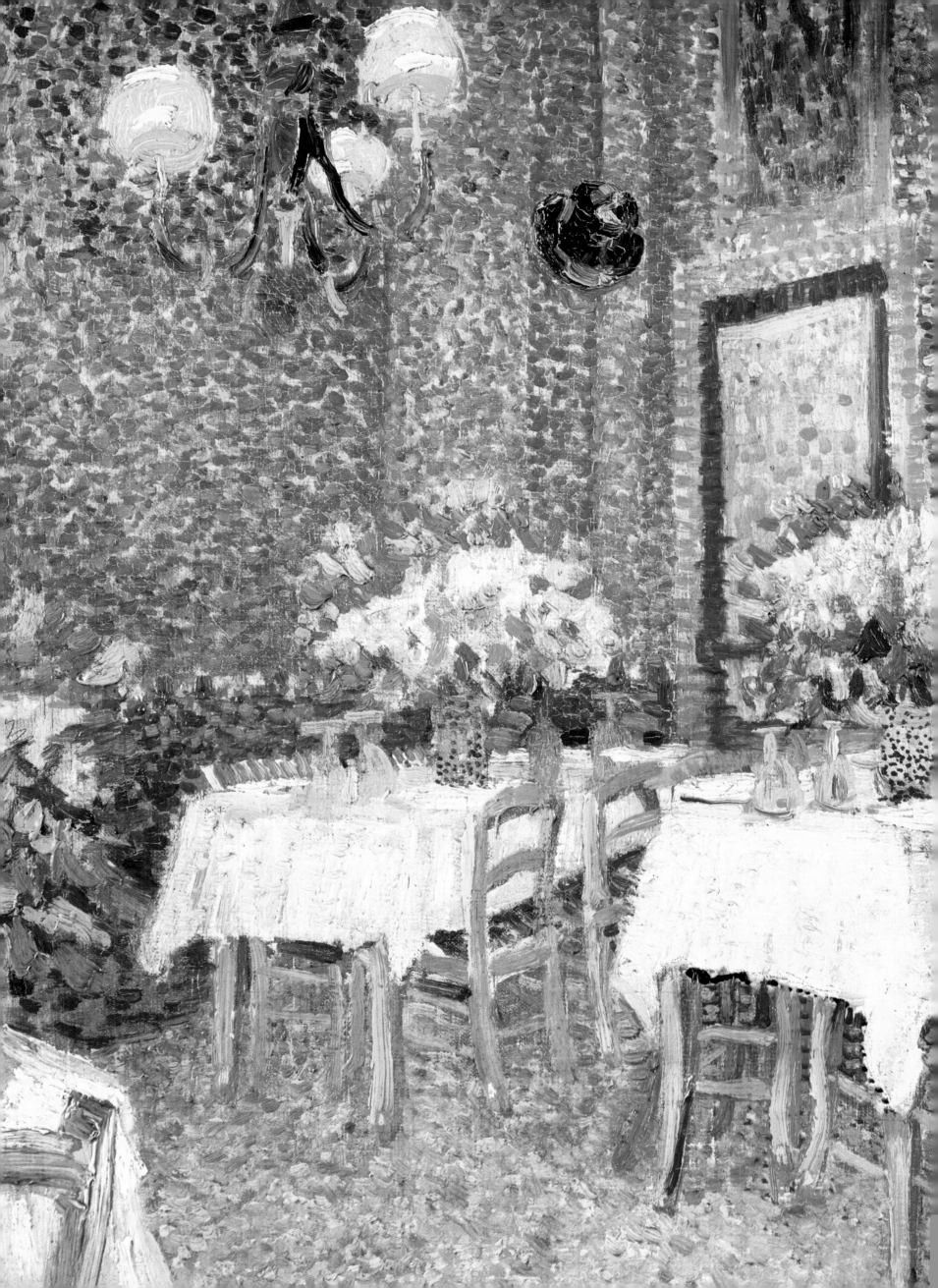

VAN GOGH

FRANK MILNER

PRC

This edition first published in 2001 by
PRC Publishing Ltd,
64 Brewery Road, London N7 9NT

A member of **Chrysalis** Books plc

© 1991 PRC Publishing Ltd.
Reprinted 2002

ISBN 1 85648 687 7

Printed and bound in China

Page 1: *Japonaiserie – Bridge in the Rain
(after Hiroshige)*, 1887
Page 3: *Interior of a Restaurant*, 1887

Contents and List of Plates

Introduction

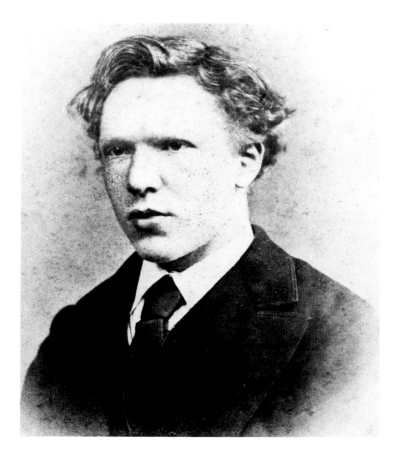

In May 1873, just five weeks after his twentieth birthday, the successful Vincent Van Gogh took a train from The Hague and traveled via Brussels and Paris to London. After completing four years apprenticeship as a salesman for the international art-dealing company of Goupil et Cie he was being transferred on an increased salary of £90 per annum to help with the expanding London branch of the firm. When his train stopped briefly in Brussels Vincent had a short meeting at the station with his younger brother Theo, aged sixteen, who had only four months previously also joined Goupil to learn the art-dealing business and was lonely in his first posting to the Brussels branch of the firm. Vincent had written affectionate supportive letters to Theo, encouraging him to persevere despite unhappiness. Goupil, according to Vincent, was a splendid firm and the longer one worked in it the more ambitious one became.

Within just three years Vincent was forced to resign, his cheerful enthusiasm for business replaced by indifference, his temperament grown depressive and agitated. For the next 16 years, until his suicide in July 1890, his life was a dogged and often unhappy struggle to achieve success in the series of roles that he adopted – teacher, bookseller, theolog-ical student, evangelical preacher and finally artist. Throughout much of this time he was supported emotionally and financially by Theo who, unlike his brother, went on to a relatively success-ful career as an art dealer, until his own death following mental collapse just five months after the death of Vincent. The 18-year correspondence between the two brothers, from Theo's schoolboy letters to the unfinished epistle found in Vincent's pocket when he shot himself, is a magnificent record of fraternal love and one of the most revealing accounts of the step-by-step everyday practice of an artist. It remains the single most im-portant source of information about Van Gogh's life.

Vincent William Van Gogh was born on March 30 1853 at Groot Zundert in Holland into a middle class predomi-nately trade-based Hague family, which included three successful art dealers as well as the Commander of the Dutch naval dockyard. Vincent's father, a Pro-testant pastor, was descended from a pastor; his mother, also originally from The Hague, had a father who was a book-binder good enough to work sometimes for the King of Holland.

Vincent was the eldest of three brothers and three sisters. There is very little information about his childhood although Theo's widow Johanna Bonger later wrote that he was a stubborn, wilful and difficult child. The family was close-knit; two of his mother's sisters were married to two of his father's brothers. Vincent was a bright but not particularly academic child, never seriously con-sidered for university education or the professions. Although his father was a comparatively poor clergyman it is likely that, had Vincent shown any distinct ability, family funds would have been found for him to continue his education. His childhood drawings reveal only a modest talent and there is no evidence that he considered becoming an artist. Starting work at the age of 16 at Goupil's Hague gallery exploited an advanta-geous family connection rather than re-flecting any serious youthful enthusiasm for art.

The Hague 1869-73

Van Gogh's entry in 1869 into his uncles' business came at the beginning of a boom period for Dutch art and art-deal-ing. His uncle Vincent had recently gone into partnership with Goupil and taken up a position in Paris. Goupil's particu-lar market strength lay in reproductions: their 'Goupil Gravures', photomechan-ical etchings after paintings, and their 'Galerie Photographique', principally of

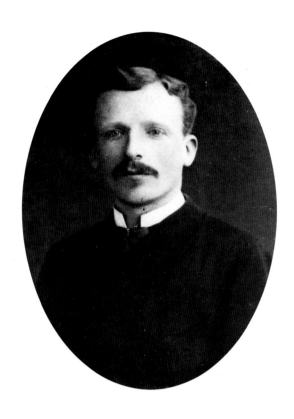

Above Theo as a young man
Right In his letters to Theo, Vincent often included small sketches of the picture he was currently working on.
Below The interior of Goupil & Cie, The Hague, where Vincent worked from 1869-73.

French academic, genre and landscape. Selling these was a major part of Vincent's first duties.

Paintings sold by the Van Gogh/Goupil Hague branch included contemporary Dutch artists, several of whom worked in a rather repetitive manner imitative of the 'golden age' of Dutch seventeenth century art, as well as French and Belgium anecdotal genre and landscape artists. Their most adventurous offerings were landscapes by the Barbizon School, a group of painters who, partly inspired by English landscapes, above all those of Constable, sought a simpler, fresher approach to nature in the 1830s. This safe diet was gradually supplemented during the four years that Vincent was there with paintings by the new wave of Dutch artists, collectively known from about 1870 onward as The Hague School, who combined techniques and subjects inspired by Barbizon with a highly selective and nostalgic view of pre-industrial Holland.

Hague School pictures became popular throughout Europe and the United States (particularly with industrialists). Generally melancholic in mood, invariably showing cows, windmills, canals, fishing boats and linen-capped peasant girls, their distinctive group hallmark during the 1870s was an exquisitely subtle use of harmonic gray or near-gray tones. Before he thought of being an artist himself, Van Gogh developed a considerable love for these works. His particular enthusiasms among the Hague School group were the Maris

Est ce qu'ils ont lu le livre de Silvestre sur Eug Delacroix ainsi que l'article sur la _couleur_ dans la grammaire des arts du dessin de Ch. Blanc.
Demandes leur donc cela de ma part et sinon s'ils n'ont pas lu cela qu'ils le lisent. J'épense mais à Rembrandt plus qu'il ne peut paraitre dans mes études.

Voici croquis de ma dernière toile en train encore en demeur. Semeur disque citron comme soleil. Ciel vert jaune à nuages roses. Le terrain violet le semeur et l'arbre bleu de prusse. toile de 30

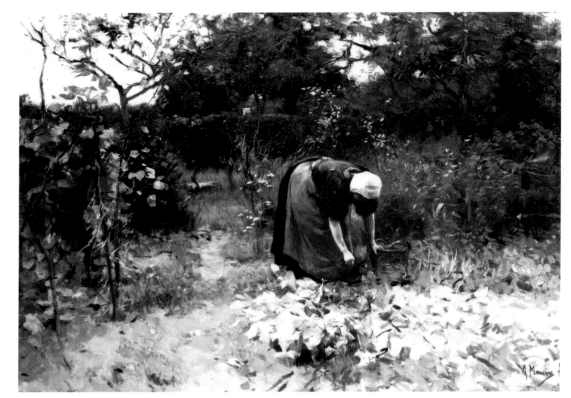

brothers, Anton Mauve, Josef Israëls and H J Weissenbruch and for Jean Baptiste Corot, Jean François Millet, Jules Breton, Narcisse Diaz de la Peña and Charles Daubigny of the Barbizon School and their followers, supplemented by a few contemporary French and Belgium historicist and genre painters. Above all other artists he admired Millet. Although actively involved in art-dealing, he was insulated from the more avant-garde currents of French and English art and the various theoretical discussions surrounding Realism, Impressionism, Aestheticism and Symbolism.

The early importance that Van Gogh attached to the sentiment-imbued landscape and to the possible communion that could develop between an artist and nature was a preoccupation that never left him. It re-emerged 15 years later as one of the most dominant characteristics of his own great mature pictures.

Among the Hague artists that Van Gogh knew personally was Anton Mauve. Depressive in temperament, solitary by nature, Mauve moved to The Hague in 1871 and courted and later married Vincent's aunt. Fifteen years Vincent's senior, he was the first of his many artistic mentors; when Vincent wrote from England he often inquired after Mauve's health.

London 1873-75

Vincent's first year in England was among the happiest of his life and his letters to Theo are full of his curiosity about London's landscape and life. He walked a great deal, visited galleries, read Dickens, Longfellow and George Eliot and worked on the expansion of the London branch of Goupil, from trade-only sales to a public picture gallery. He saw a great deal of art but only slightly modified his enthusiasms. Constable reminded him of Diaz and Daubigny. John Everett Millais attracted him with his Pre-Raphaelite narrative pictures and more especially with his bleak bog and heath subjects reminiscent of Barbizon, like the two that he saw at the 1874 Royal Academy Summer Exhibition. There he also noticed James Tissot's three exhibited pictures and a picture by the now little-remembered G. H. Boughton, both artists whose works were reproduced by Goupil. At the same exhibition he certainly saw but made no comment upon the large Social Realist picture exhibited by Luke Fildes, *Applicants for Admission to the Casual Ward*, which was to have an im-

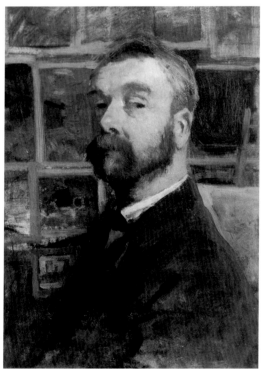

portant impact on his own art. The paintings by Jacob Maris, Israëls and H W Mesdag sent over from The Hague to the Royal Academy exhibition must have confirmed for him the high standing (and saleability) in England of contemporary Dutch art.

Whether Van Gogh saw Paul Durand-Ruel's twice-yearly displays of mixed Barbizon and Impressionist pictures at his Bond Street gallery is not clear. Given that Goupil's was competing in a similar market it seems odd if he was not curious to view. An examination of what Van Gogh was visually receptive to in London reveals that he did not respond to the late Pre-Raphaelites, Rossetti or 1870s Olympian Classicism, nor did he comment on, for example, the high concentration of early Italian Primitive pictures to be seen in the National Gallery. What he did notice were Dutch pictures.

It is the cautious and confirmatory character of Van Gogh's artistic curiosity at this stage that is most striking.

The precipitant for Van Gogh's first mental crisis was his falling in love with and being rebuffed by his Brixton landlady's daughter, Ursula Loyer. His own family took his misery and physical deterioration seriously and may possibly have connived, through the offices of his Uncle Vincent, for him to be transferred for three months to the Paris branch of Goupil. He returned to London for a further six months before being permanently transferred, against his will, to Paris in June 1875 where he stayed until April 1876. Following his rejection by Ursula, Van Gogh became increasingly religious. His letters were punctuated with quotations from the Bible and his plans for his mission in life became increasingly removed from commerce.

Paris 1875-76

During his second period in Paris, lasting ten months, Van Gogh once again seems to have avoided the avant-garde. Although he visited Durand-Ruel's gallery to view prints and drawings by Millet, he does not seem to have had access to any of the Monets, Pissarros or Renoirs also stocked there. The major Parisian artistic events for Van Gogh were the 1876 Corot retrospective exhibition and a sale of Millet drawings and prints at the Hotel Drouort; he bought prints of Millet's *The Angelus* for Theo and himself. On most Sundays he visited the French state collections, divided principally into Old Masters at the Louvre and more recent French pictures accepted into the Luxembourg gallery. He must have absorbed an enormous bank of images; those he commented upon were the Rembrandts

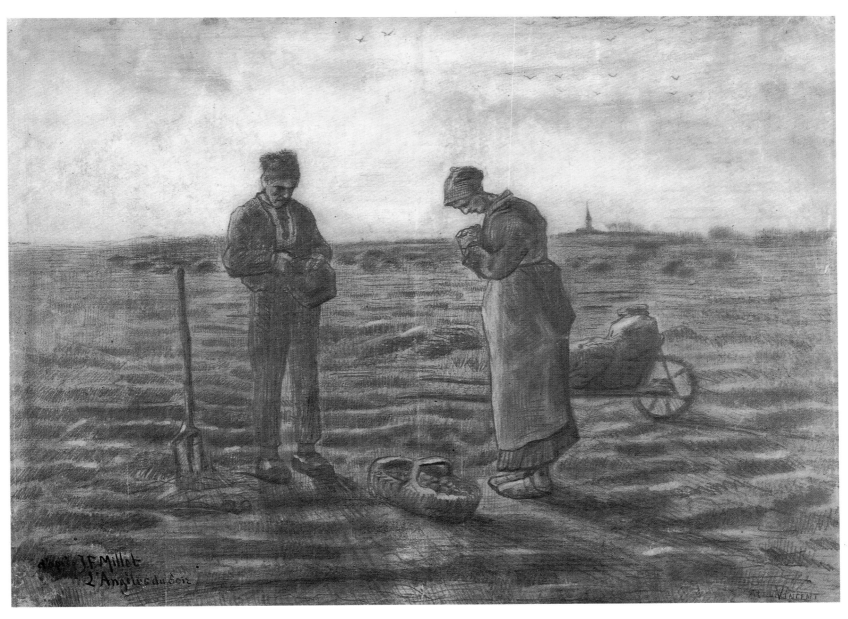

at the Louvre and Barbizon works at the Luxembourg. What he read about art was probably confined to *The Gazette des Beaux Arts* – salon-safe and academic – and the illustrated magazines. There is little mention in his letters of his reading any reviews, pamphlets or even Academy lectures.

His religious zeal developed in Paris into an obsession. During his first few months he lived alone, and in the evenings read English and French fiction or poetry, the Bible and contemporary devotional works like Renan's *Life of Christ*. In September he struck up a strange friendship with an ugly awkward youth named Charles Gladwell, son of a London art dealer and apprenticed to Goupil, who came to live in the same house in Montmartre. Van Gogh dominated the friendship; each morning at dawn Gladwell brought him porridge (made from a 25 lb bag providentialy provided by Gladwell's father) and they

Above This rather weak copy of Millet's *The Angelus* was made in 1880, around the time Van Gogh first decided to become an artist. He thought Millet rather than Manet was the greatest contributor to French modernity.

Right *The Churches at Petersham and Turnham Green*, sketch from a letter to Theo, 27 November 1876.

prayed for an hour or more, two wretched, lonely souls together. Gladwell's rescue came when another employee offered to share his lodgings with him. By January 1876 Vincent's indifference to business had become so pronounced that he was given three months' notice to quit.

England April-December 1876

Leaving Paris, Van Gogh returned to England to take up a post at a small boys' school at Ramsgate, Kent, where he received board and lodgings but no salary. He transferred with the school to

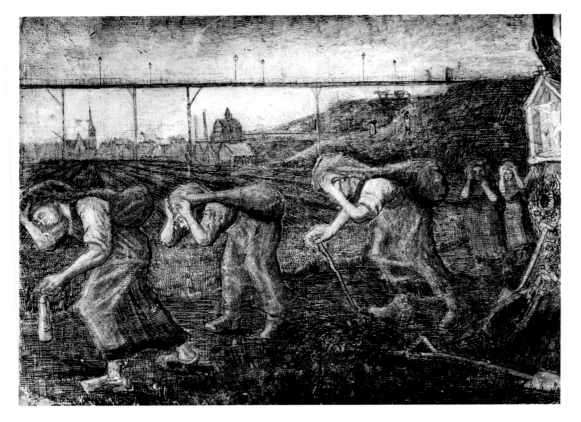

Isleworth near London in July 1876 but, after failing to persuade Mr Stokes, the school's owner, to pay him he joined another small school. This was run by a Methodist minister who encouraged him, in addition to his morning teaching duties, to take Sunday school, conduct private tuition and to preach at various Methodist chapels. Vincent's first sermon, delivered in Richmond, was based upon a Goupil reproduction of Boughton's *A Pilgrim's Progress*.

Although initially optimistic about his new vocation, by November 1876 his letters to Theo were increasingly disjointed and full of long, rambling quotations from the Bible, hymns and devotional literature. When he returned to Holland for Christmas, his father persuaded him to stay.

Holland/Belgium 1877-80

Family connections were once again exploited and a clerical job was obtained for him at a bookshop in Dordrecht, to which Goupil supplied reproductions. For four months Van Gogh stuck at it, working longer hours than he needed in the shop but showing little interest in customers. At times he simply stood reading his Bible and was determined still to teach and preach.

A more long-reaching and expensive family solution to his wishes was then arranged. In order to obtain entry to the Theological Faculty at the University of Amsterdam, he was to live with his widower uncle Johannes Van Gogh at his naval dockyard home in Amsterdam and to study Latin and Greek under a prominent scholar, Dr Mendes da Costa, as part of a two-year preparation for the university entrance examination. For a year he tried to learn until eventually,

without any malice or criticism, Mendes da Costa told Vincent's father that his son was simply not suited to such study. Vincent was relieved. He was also at this time, according to da Costa, beating himself, sleeping without a blanket in mid winter in an outhouse and otherwise chastizing himself for not reaching his goal.

Partly as a reaction to his difficulties, partly because he believed that the academic qualifications needed to become a minister were unnecessary, Vincent became hostile to prolonged study. In August 1878, again with his father's help, he signed on as a probationer at the Flemish School of Evangelism to the Poor at Laeken near Brussels. His hostility to the academic content of the Laeken course, however, meant that after three months he was not accepted to move to the full two-year course. The best that he could obtain was a six-month probationary appointment as a lay preacher in the Masmes sector of the Borinage in southern Belgium.

Although Vincent had considered throwing himself into lay missionary work among the poor while in England, at one time even contemplating going to Liverpool, his contact with the working class had been mostly limited to servants and the agricultural laborers among his father's parishioners. The mining communities of the Borinage where he worked for the next three years were his first direct contact with wretched poverty. His reactions were predictably extreme and personally painful. He shared all his food and clothing and took to living in a miner's shack – an over-literal interpretation of Christ's teaching that led to his contract not being renewed by the Committee for

Evangelism. Going it alone, he received financial help from Theo. Gradually his religious zeal abated and a more thoughtful, phlegmatic stability appears in his correspondence.

Brussels/Etten/The Hague 1880-83

Van Gogh's decision to become an artist is usually dated to the letter in August 1880 when he announced this intention to Theo. Prior to this, during 1879, he had increasingly recorded in awkward sketches the miners with whom he lived. It is hardly surprising that the kind of artist that Vincent aspired to become was modeled on his enthusiasms for the Hague and Barbizon Schools.

Leaving the Borinage he went to Brussels to study, where he was fortunate to be befriended by an aristocratic artist, Anton van Rappard, who allowed him to share his studio. Rappard was probably instrumental in directing Vincent to the black and white wood-engraved reproductions in magazines such as *The Graphic* and *The Illustrated London News*. Artists like Fildes, Frank Holl and Hubert Herkomer, whose works he had seen before, became new mentors and he saw their powerful images of urban poverty as a truthful city parallel to Millet's country peasant themes. He bought individual magazine issues as well as bound volumes and made scrapbooks based upon individual artists. His earliest ambitions as an artist oscillated between wanting to be a painter in the manner of his uncle Anton Mauve and a graphic artist who could work for the journals.

Van Gogh borrowed books on academic drawing, design and perspective via Theo. Although he followed their step-by-step precepts in the structuring of pictorial space, when it came to the proportioning of human limbs and the strength of line and modelling of figures he was influenced by the emphatic line of Mauve's drawings and by the powerful contrasts of black and white in the illustrative work that he admired.

During the five years of religious enthusiasm that followed his rejection by Ursula Loyer, Van Gogh had had little close female company but his new-found role as an artist was accompanied by a resurgence of interest in women. In April 1881, after six months' study of perspective and anatomy in Brussels, Vincent returned home to his father's parsonage at Etten. Among the reasons for his having to leave eight months later

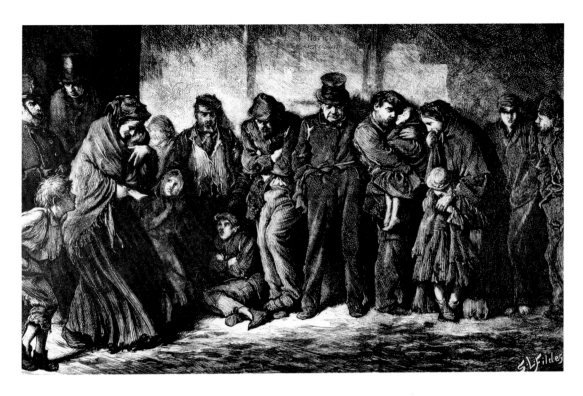

was the family anger that he provoked by his forceful and insensitive declarations of love for his recently widowed cousin, Kee Vos. He compounded this outrage just three months later by setting up home at The Hague with a pregnant prostitute, Sien Hoornik, who already had a child. When Vincent talked of marrying her, his father seriously considered having him certified and confined to an asylum.

Vincent continued his study at The Hague until April 1883, the most fruitful period being from November 1881 to March 1882 under the guidance of Mauve, who gave him paints and lessons and encouraged his ambition. Van Gogh's first fully-resolved oil painting, *Girl under Trees* (page 26) is self-consciously modeled upon Mauve's woodland motifs and techniques. Using the dark tones characteristic of several Hague School artists, including Mauve and Weissenbruch, Van Gogh's paint is applied in broad flat areas, overlaid with surface texture that defines bark, leaves and branches and worked from dark up to paler highlights. Van Gogh and Mauve eventually quarreled and, although this has usually been blamed upon Van Gogh's irascibility, Mauve's own depressive nature may have been contributory. No longterm hostility resulted and Van Gogh always acknowledged the part Mauve played in helping him to become an artist, as shown in his *Pink Peach Tree in Blossom (In Memory of Mauve)* of 1888 (page 49).

Sien became his model at this time. He made several angular drawings and a print of her, of which *Sorrow* is the most powerful. With its appended quotation from Michelet – 'How comes it that on earth such a woman is alone and abandoned?' – it focuses on Sien's destitution as well as his sense of his own family's absence of Christian charity. He lived with Sien and her children as a family for a year but the relationship deteriorated and ended when Vincent, guilty, worn out and suffering from venereal disease, was rescued by his family who paid for him to have a three month rest in the Drenthe region of northern Holland.

Neunen 1883-85

In December 1883, aged 30, Van Gogh once again came home to live with his parents in Neunen, where his father had recently been appointed. Theo provided the finance, giving money to his father to pay for Vincent's board and coming to a 'business agreement' with Vincent that he would send money as an investment against future sales of his paintings, at this stage a pride-salvaging cover for fraternal charity. Vincent's studio was for a while in a converted garden wash-house. Of the pictures that survive from his Neunen period the majority are of the landscape surrounding his home, portraits of peasants, and a series of cottage-based weavers, such as *Weaver* (page 27), whose wood-framed looms were already a pre-industrial relic. He clearly viewed as the culmination of all his peasant studies *The Potato Eaters* (page 28), a dark close-toned picture painted in April/May 1885 over which he worked longer than any other painting. Inspired by Josef Israëls' *The Frugal Meal*, Van Gogh set out to produce a near-sacramental image of a late night peasant Last Supper of potatoes – a theme that he amplified by the juxtaposition of a clock and crucifix on the wall. The caricature-like ugliness of the figures looking, he hoped, as though they had dug the potatoes with their own hands was meant to distance his work from pretty peasant pictures and represents an attempt to combine something of the strength of black and white illustration with a Hague School subject – a modern Realist fillip to a traditional country motif.

In April 1885 Van Gogh's father died. His pictorial memorial is the *Still Life with Open Bible, Extinguished Candle and Zola's 'Joie de Vivre'* (page 30). Vincent's father's own Bible is shown open at Chapter 53 of the *Book of Isaiah* (Chapter 52 visible on the same page opening is not included). The twelve verses of Chapter 53 concerning the ultimate reward for the hardships encountered by the carrier of God's word are prophetic of Christ's ministry and by extension of Pastor Van Gogh's life's work. Despite its title, *Joie de Vivre*, published in February 1884, is a depressing novel which advocates self-sacrifice and the embrace of life's miseries, however bad.

On several subsequent occasions Van Gogh used in his pictures the yellow or blue paper-bound novels of other Realist authors such as the De Goncourts and Maupassant as straightforward affirmative symbols of modernity, as in *Still Life with Plaster Statuette and Two Novels* (page 46), and *Portrait of Dr Gachet* (page 101). In this instance the Bible and novel are more appropriately viewed as complementary ancient and modern literary sources rather than conflicting images of old and new or of the eternal versus the ephemeral.

During his Neunen period Van Gogh's intellectual contacts were limited to a tobacco merchant, Anton Kerssemakers, who was his companion

Above *Homeless and Hungry*, woodcut illustration by Luke Fildes for *The Graphic Magazine*, 1869.
Below *Sorrow*, 1882, modeled by Sien Hoornik.

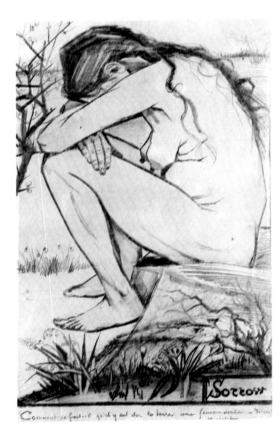

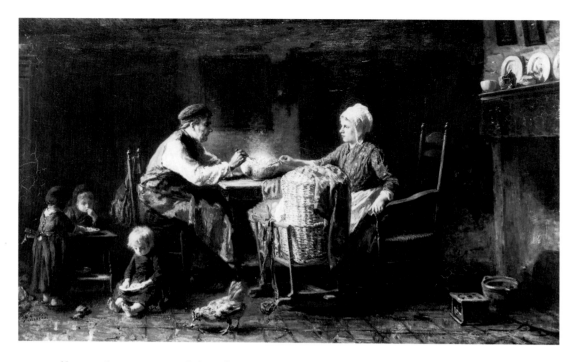

on walks and museum visits; he also gave occasional unpaid painting lessons to various amateur artists. By autumn 1885 a combination of growing local hostility and his wish to broaden his work led him to leave for Antwerp, where the major claims to artistic attention were the museums and the huge altarpieces by Peter Paul Rubens in the cathedral. It was Rubens who now provided a focus for the first major modification in Van Gogh's palette. He had already started to use more blue but now he experimented with red, attracted by the warm tonality that Rubens' work achieved by the use of ruddy underpainting, visible sometimes as a thin edging line on features and fabrics. He also became interested in the French historical painter Ferdinand Delacroix's use of color and explored various theories on complementary color and contrasts. His palette lightened, and the *Head of a Woman* (page 32) of December 1885 indicates that in addition to a blonder coloring he was experimenting with a more broken planar brushwork. In January 1886 Vincent enroled at the Antwerp Academy to improve his figure drawing but fell out with his instructor over his too-vigorous Realist proportioning of a classical figure study.

From January 1886 Vincent badgered Theo to allow him to come to Paris where he could continue his studies, in particular drawing from the completely nude female figure, which was denied him at the Antwerp Academy. Theo was increasingly involved in seeking to promote and sell Impressionist paintings and the discussions in their letters had broadened in late 1885 to include the relative merits of Realism, Naturalism and Romanticism. Edouard Manet's pictures in particular were enthusiastically described by Theo but Vincent was less keen; he thought Millet, rather than Manet, was the greatest contributor to

French modernity. Theo guardedly intimated that Vincent might come to Paris in summer 1886 but his hand was forced in early March, when Vincent suddenly arrived at the Gare du Nord and sent word that he would meet Theo at midday in the Louvre.

Paris 1886-88

Before coming to Paris in 1886 for his third stay, Van Gogh had written of Impressionism as something he had not seen or properly understood. He arrived in time to witness the break-up of the movement and to join in the debate about modifications and new directions for avant-garde art in general. He may have been taken by Theo to the eighth, the last and most diverse, Impressionist Exhibition held during May and June 1886. Among the 230 pictures shown were characteristic Impressionist works by Mary Cassatt and Guillaumin but also literary-inspired Symbolist paintings by Odilon Redon, Georges Seurat's *La Grande Jatte*, a manifesto picture for

the new orthodox stippling of Neo-Impressionism, and similar dot-structured landscapes by Camille Pissarro. These last showed that after a decade of Impressionist practice, Pissarro too had adopted the Pointillist divisionist dot and its attendant theories about simultaneous contrasts of color – colorific concerns that were related to Vincent's recent interest in Delacroix and Rubens.

Edgar Degas, who had always regarded the Impressionists' pursuit of nature's immediacy as intellectually poor, showed a series of pastels of women bathing, in which he attempted a synthesis of the values associated with the traditional academic nude and modern Naturalism. Paul Gauguin, who exhibited 19 pictures that were still broadly in line with Impressionist motifs and paint-handling, was beginning to shift his interests toward paintings that combined emotional intensity with primitive naivity and bright colors, and was looking to Brittany, the South Seas and the Far East for inspiration. Meanwhile Monet, Renoir and Sisley refused to exhibit. Van Gogh's first impressions of 1886 Impressionism must have been of a rather broad church with fratricidal tendencies.

At the outset Van Gogh was disappointed and later wrote to his sister Wil that after Israëls and Mauve, Impressionism looked slovenly and ugly. Gradually he opened up to the various artistic currents, however, and within nine months assimilated techniques, motifs and ideas from across the wide range on offer. His most orthodox step was to register at the studio of the academic artist Fernand Cormon, to improve his drawing and to paint from the live model; among his fellow students, he met the eccentric young aristocrat Henri Toulouse-Lautrec. Working in a makeshift studio at Theo's apartment, he concentrated during the first summer and autumn mainly on self-portraits and still life. Lack of money for models, and also possibly lack of confidence, limited his scope. His earliest Paris still lifes are in somber colors worked in the same broad, interlocking and faceted stroke and overall dark tonal unity as his Brussels and Antwerp pictures, but they are also reminiscent of certain mid-nineteenth century French still lifes. Theo owned at least one flower picture by Fantin-Latour and another by the recently deceased Marseilles artist Monticelli. These richly textured and rather dark

Top *The Frugal Meal* by Joseph Israëls, 1876, strongly influenced Van Gogh's *The Potato Eaters*; the quality Van Gogh most admired in Israëls' work was 'soul'.
Left Van Gogh's father, who died in April 1885.

pictures were transitional models for Vincent as he felt his way toward a more bravura touch and brighter coloring, as in his *Vase of Flowers with Poppies* (page 33).

Writing in autumn 1886 to the English artist Lievens, Van Gogh described his summer still life quest as the harmonizing of 'brutal extremes of color', contrasting blue with orange, red with green and yellow with violet. He only rather tentatively tried out the vocabulary of Pontillist color contrasts, however, and did not as yet take up the distinctive dot-like stroke. The landscapes of 1886 mainly show motifs within walking distance of Theo's apartment, focusing on quiet corners of Montmartre, alleys between gardens and allotments, near-empty mid-week or early-morning streets and panoramas of Paris roof-scapes from the apartment window and the Buttes Montmartre. The thronging boulevards, large public spaces and railway stations so often chosen by Monet, Pissarro, Sisley and Renoir were avoided. A view of the Louvre and the Luxembourg Gardens are among the very few central Paris subjects that he ever painted and each is really a one-off pictorial act of homage to the great picture collections at the Louvre and Luxembourg that he had long admired. More typical of his work at this time is the Kröller-Müller *Moulin de la Galette* (page 36), in which he cautiously experiments in parts with a touch of Impressionism and attempts the accidentally glimpsed Impressionist motif, while still holding on to his earlier gray and brown harmonies.

The big development in Van Gogh's Paris work came in the winter of 1886/87, and his spring 1887 paintings show a rapid absorption of influences. The Pittsburg *Moulin du Blute-Fin* (page 38), unlike the same subject of five months

Above *The Vicarage Garden at Neunen*, April 1884, painted while Van Gogh lived at home between 1883 and 1885.

Below *Digging Peasant Woman*, 1885, shows the strong line and powerful contrast of black and white in Van Gogh's early drawing style.

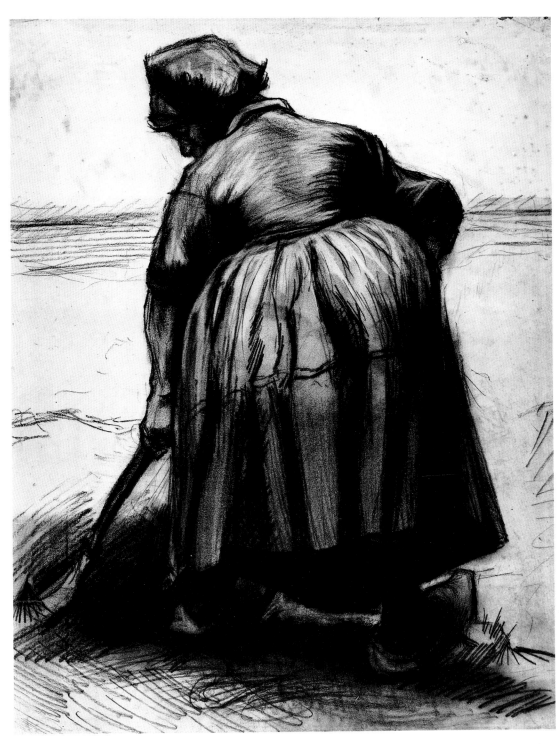

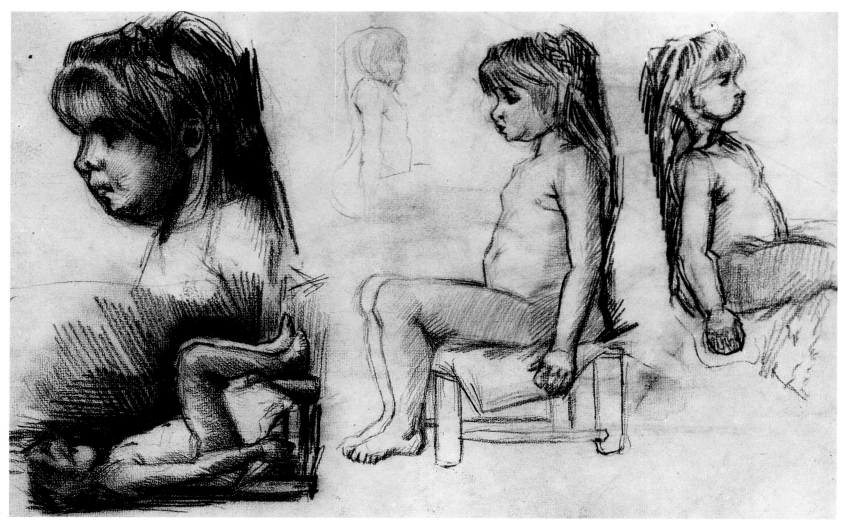

Top and Above Studies of plaster casts and a child made in autumn 1886 at Cormon's Paris studio, where Van Gogh improved his drawing technique and painted from the live model.
Right above Adolphe Monticelli's *Vase of Flowers*, c.1875, was owned by Theo and inspired several of Vincent's 1886 Paris still lifes, influencing the texture of his paint handling.
Right below This study by Lucien Pissarro of Van Gogh in battered hat and workman's blouse was made during his Paris period.

earlier, is now feathery-touched and bright, with varied lush greens, while browns, ochers and blacks are played down. Perhaps his first Impressionist picture, it is like a mid-1870s picture by Pissarro. In contrast *The Boulevard de Clichy* (page 37), painted within the same few weeks, shows Pointillist experimentation, with much bolder contrasts and ladder-like patches of detached short parallel strokes whose color bears little or no relation to the local color of actual buildings.

Van Gogh exaggerated when he later claimed to his sister that he personally knew many of the Impressionists. He met Degas and also almost certainly Monet, both possibly at the Café de la Nouvelles Athenènes in the Place Pigalle on the Boulevard de Clichy, but had little or no personal contact with Renoir, Cézanne, Caillebotte, Morisot or Cassatt. Pissarro was his only really significant personal contact within the older Impressionist group, although he was certainly familiar with their paintings from looking through the stock that Theo and other dealers held. His close Parisian artistic friendships were mainly confined to younger and at the time more marginal artists. The most important after Pissarro was Paul Signac, ten years Vincent's junior and the most persistent advocate of Seurat's Pointillist values. He also befriended the nineteen-year-old Emile Bernard, who after flirting briefly with Pointillism settled in

1887 to the use of outlined bright color, Breton-inspired mystical primitivism and a more subjective Symbolist style similar to the developing practice of Gauguin, which Bernard described as 'Cloisonnism'.

Both Bernard's and Signac's parents lived at Asnières, a northern suburb of Paris about two miles from Montmartre. During spring and summer 1887, in company with one or both of his friends, Van Gogh painted there, extending his subjects to include the suburb of Clichy with its factories and gasometers on the opposite bank of the river to the Asnières boathouse stations and Seine-side restaurants. Both younger artists influenced his work. At times, as in *The Restaurant de la Sirène* (page 41), he used the more orthodox Pointillist dot-stroke and a haloed nimbus like a magnetic force field around figures, but he never seems to have been temperamentally at ease with the self-effacing uniformity of Seurat's or Signac's touch and fought shy of giving up the celebration of paint's sheer physicality. Line, even when short and broken, usually dominated dot and he retained the emphasis on surface animation, a fundamental painterly value in which he had been schooled by Mauve, Rubens and all his previous practice.

Bernard's contribution to Vincent's art, in earnest discussions during shared painting expeditions, was to emphasize his newly developed style of Cloisso-

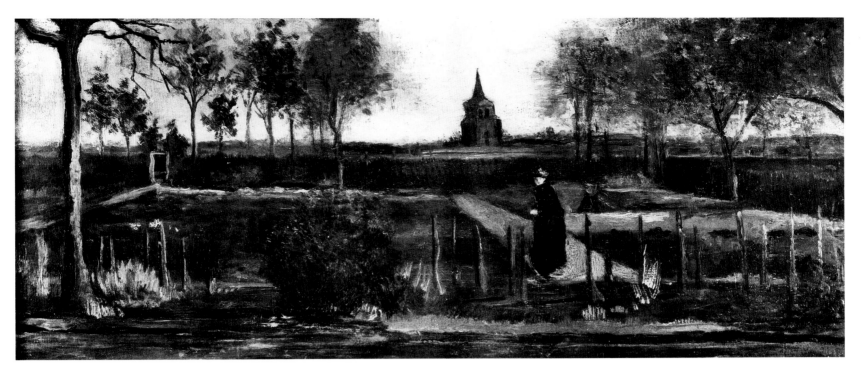

pictures were transitional models for Vincent as he felt his way toward a more bravura touch and brighter coloring, as in his *Vase of Flowers with Poppies* (page 33).

Writing in autumn 1886 to the English artist Lievens, Van Gogh described his summer still life quest as the harmonizing of 'brutal extremes of color', contrasting blue with orange, red with green and yellow with violet. He only rather tentatively tried out the vocabulary of Pontillist color contrasts, however, and did not as yet take up the distinctive dot-like stroke. The landscapes of 1886 mainly show motifs within walking distance of Theo's apartment, focusing on quiet corners of Montmartre, alleys between gardens and allotments, near-empty mid-week or early-morning streets and panoramas of Paris roof-scapes from the apartment window and the Buttes Montmartre. The thronging boulevards, large public spaces and railway stations so often chosen by Monet, Pissarro, Sisley and Renoir were avoided. A view of the Louvre and the Luxembourg Gardens are among the very few central Paris subjects that he ever painted and each is really a one-off pictorial act of homage to the great picture collections at the Louvre and Luxembourg that he had long admired. More typical of his work at this time is the Kröller-Müller *Moulin de la Galette* (page 36), in which he cautiously experiments in parts with a touch of Impressionism and attempts the accidentally glimpsed Impressionist motif, while still holding on to his earlier gray and brown harmonies.

The big development in Van Gogh's Paris work came in the winter of 1886/87, and his spring 1887 paintings show a rapid absorption of influences. The Pittsburg *Moulin du Blute-Fin* (page 38), unlike the same subject of five months

Above *The Vicarage Garden at Neunen*, April 1884, painted while Van Gogh lived at home between 1883 and 1885.

Below *Digging Peasant Woman*, 1885, shows the strong line and powerful contrast of black and white in Van Gogh's early drawing style.

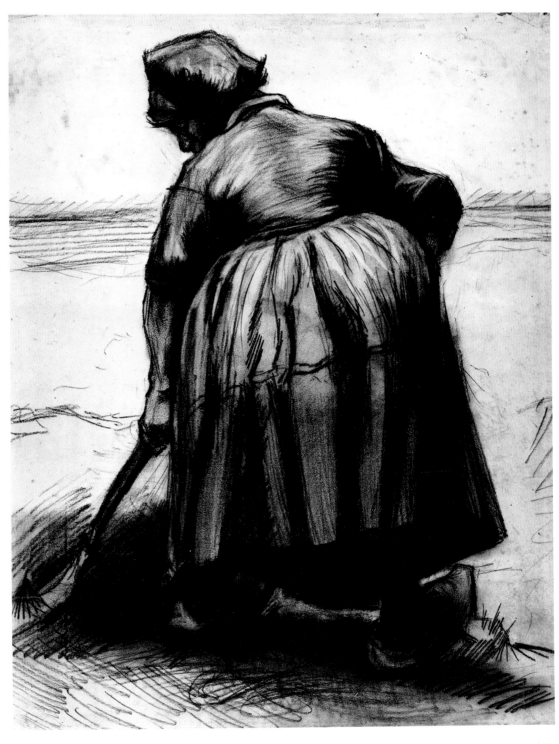

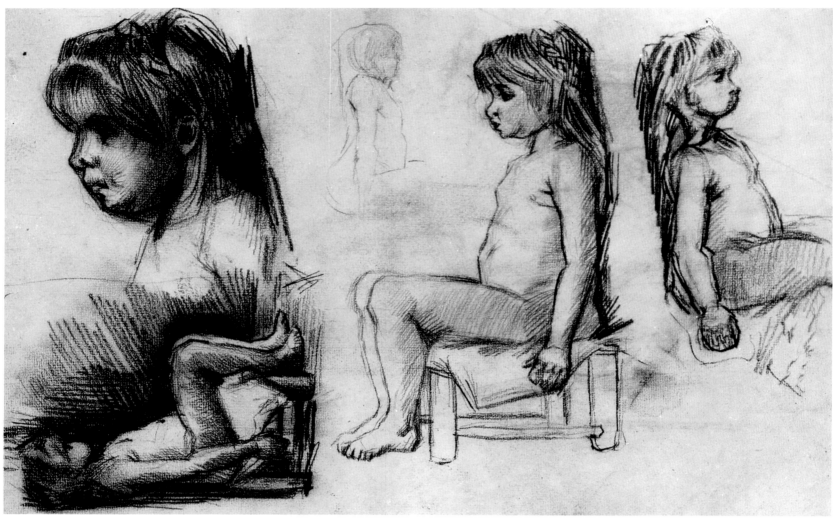

Top and Above Studies of plaster casts and a child made in autumn 1886 at Cormon's Paris studio, where Van Gogh improved his drawing technique and painted from the live model.
Right above Adolphe Monticelli's *Vase of Flowers*, c.1875, was owned by Theo and inspired several of Vincent's 1886 Paris still lifes, influencing the texture of his paint handling.
Right below This study by Lucien Pissarro of Van Gogh in battered hat and workman's blouse was made during his Paris period.

earlier, is now feathery-touched and bright, with varied lush greens, while browns, ochers and blacks are played down. Perhaps his first Impressionist picture, it is like a mid-1870s picture by Pissarro. In contrast *The Boulevard de Clichy* (page 37), painted within the same few weeks, shows Pointillist experimentation, with much bolder contrasts and ladder-like patches of detached short parallel strokes whose color bears little or no relation to the local color of actual buildings.

Van Gogh exaggerated when he later claimed to his sister that he personally knew many of the Impressionists. He met Degas and also almost certainly Monet, both possibly at the Café de la Nouvelles Athenènes in the Place Pigalle on the Boulevard de Clichy, but had little or no personal contact with Renoir, Cézanne, Caillebotte, Morisot or Cassatt. Pissarro was his only really significant personal contact within the older Impressionist group, although he was certainly familiar with their paintings from looking through the stock that Theo and other dealers held. His close Parisian artistic friendships were mainly confined to younger and at the time more marginal artists. The most important after Pissarro was Paul Signac, ten years Vincent's junior and the most persistent advocate of Seurat's Pointillist values. He also befriended the nineteen-year-old Emile Bernard, who after flirting briefly with Pointillism settled in

1887 to the use of outlined bright color, Breton-inspired mystical primitivism and a more subjective Symbolist style similar to the developing practice of Gauguin, which Bernard described as 'Cloisonnism'.

Both Bernard's and Signac's parents lived at Asnières, a northern suburb of Paris about two miles from Montmartre. During spring and summer 1887, in company with one or both of his friends, Van Gogh painted there, extending his subjects to include the suburb of Clichy with its factories and gasometers on the opposite bank of the river to the Asnières boathouse stations and Seine-side restaurants. Both younger artists influenced his work. At times, as in *The Restaurant de la Sirène* (page 41), he used the more orthodox Pointillist dot-stroke and a haloed nimbus like a magnetic force field around figures, but he never seems to have been temperamentally at ease with the self-effacing uniformity of Seurat's or Signac's touch and fought shy of giving up the celebration of paint's sheer physicality. Line, even when short and broken, usually dominated dot and he retained the emphasis on surface animation, a fundamental painterly value in which he had been schooled by Mauve, Rubens and all his previous practice.

Bernard's contribution to Vincent's art, in earnest discussions during shared painting expeditions, was to emphasize his newly developed style of Cloisso-

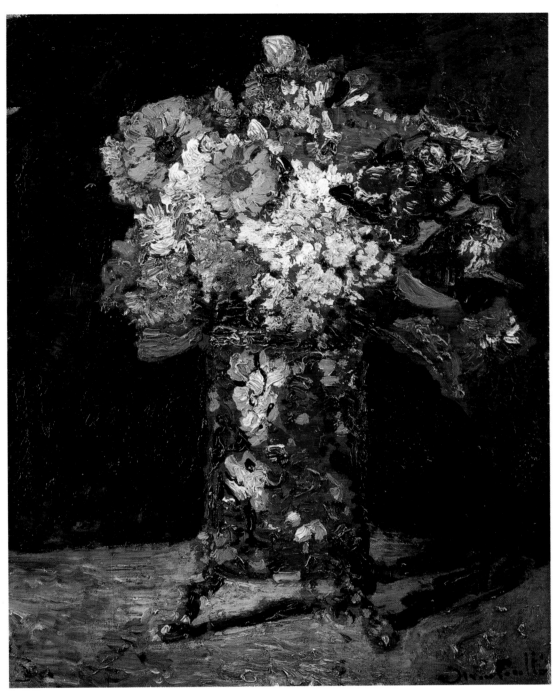

landscapes, actors, courtesans and mythological subjects, with cropped figures and quirky viewpoints at odds with the vocabulary of traditional European tonal and linear perspective and with flat areas of color contained within black outlines, were part of the complex and powerful influence that Japanese artifacts had upon European art and architecture from about 1860 onward. By 1886/87 Japanese paraphernalia was no longer exotic source material for the avant-garde but had become part of fashionable drawing-room taste (like, for example, Odette's apartment, described by Proust as full of Japanese silk cushions, vases and chrysanthemums).

Van Gogh transcribed into oils three *ōban*-sized (15 × 10¼ inches) Japanese prints, of which the most famous is the *Japonaiserie – Bridge in the Rain (after Hiroshige)* (page 47), in which he freely added his own stridently contrasting green and red borders containing vertical panels of Japanese text extracted from both the original print surface and from other Japanese images. The *Portrait of Père Tanguy* (the color merchant who supplied several Impressionists with materials on credit) (page 45), sets the black-outlined hieratic figure of Tanguy, simplified in shadows and modelling, against a backdrop of over-large Japanese prints copied in hot-house colors and based upon prints from Van Gogh's own collection as well as magazine reproductions. Tanguy's trousers, and parts of the sky and fields in the background prints, have short separate caterpillar-like strokes of paint. These and the blue,

nism. With color divided into blocks and then exaggerated to express strong feelings, this represented an alternative to Naturalism and Impressionism and was attractive to Van Gogh, who already saw his paintings as visual metaphors for strong subjective emotion. The 'Dottist' divisionists of color and the Cloissonist compartmentalizers of color were in opposition: the first, in their reductive analysis, regarding themselves as more scientific; the second, in their synthesis of feeling and symbol, seeing themselves as more archetypally emotional. Caught between the two, Vincent took from each without aligning himself dogmatically with either.

Cloissonists, Neo-Impressionists, Realists, Naturalists and Impressionists all found some inspiration in Japanese woodblock prints, the third major ingredient in Van Gogh's liberating 1887 Parisian synthesis. In Antwerp he had bought cheap Japanese prints to pin on his wall but only on his return to Paris did he extract artistic principles from them. These highly colored images of

Above The bridge at Asnières, much painted by Van Gogh during 1887 (see page 43).

Left Kuniyoshi and Yoshituri, *Whale Fishing*, from the series 'Excellences of Mountain and Sea', 1852; an *ōban*-sized print showing a woman reading a woodblock-printed Japanese book of the type that influenced Van Gogh's drawing style in 1887/88.

Right Hokusai's *Fuji Above the Lightning*, from the series '36 Views of Mount Fuji', 1831. Hokusai's woodblock-printed books, produced as source books of visual images for the use of Japanese artists, were a major influence on Van Gogh's mature drawing style.

yellow, red and green stripes are a nod towards Neo-Impressionism, and once again show his interest in the reconciliation of different styles.

Ōban-sized Japanese prints played a major part in the intensification of Van Gogh's use of color but it was the smaller Japanese woodblock books (by Hokusai in particular), printed in black outline often with only one or two relieving colors, that contributed most to his developing drawing style and brushwork. The graphic notation of line, whorl and separate dot which they used to describe landscape and figures was grafted on to his own practice. He dropped the heavy shadows and angularity of his Hague-schooled European drawing mode in favor of a manner which employed an all-over build-up of figure or view using small reed-pen strokes and dots of varying thickness, each lying separate and distinct on the paper surface. This idiosyncratic style of drawing was translated into later landscapes, in many cases a paintstroke on the canvas copying a pen-stroke in a smaller study.

Van Gogh first met Gauguin in autumn 1886, after the latter returned to the capital from his summer spent painting at Pont-Aven, an isolated village on the coast of Brittany frequented by artists wanting cheap living, quiet and rural simplicity. Gauguin was again absent from Paris between April and November 1887 in Martinique and it was after this return from the tropics that Vincent really came to know and admire his paintings. The artists developed a mutual respect for each other and Theo set out to try and sell Gauguin's painting and ceramic sculpture. Discussions with Gauguin provoked Van Gogh's ambitions for the creation of an artistic community sharing expenses and ideas and offering mutual emotional support.

Theo Van Gogh found living with Vincent very trying. Although they ate and socialized together they also argued vehemently. Vincent's hectoring bellicosity – his tendency, as he himself rather ruefully described it, to take any issue discussed 'by the throat' – led to fewer people calling at Theo's apartment. Together with the strain of running the Goupil gallery and the difficulty of persuading the firm's owners to let him expand into more adventurous stock, it led to Theo becoming ill with the debilitating nervous sickness to which he was already susceptible. He was relieved but also rather guilty when in February 1888 Vincent decided to leave Paris to find his own Japan, by going south to Provence and the town of Arles.

During his two years in Paris, Vincent had thrown himself into the world of artistic Montmartre and enthusiastically reeducated himself. He had organized at least three café-based exhibitions, one of Japanese prints, and two of his own paintings and those of Neo-Impressionist fellow-artists. Two of

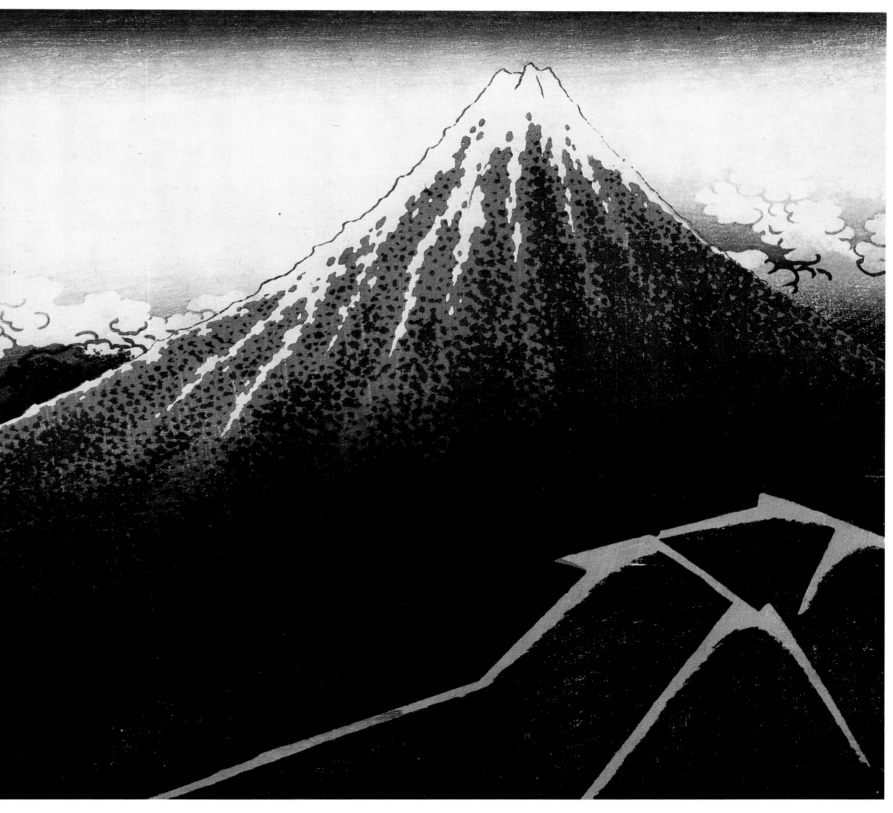

these exhibitions were held at the Café de la Tambourin on the Boulevard de Clichy. The café proprietor, a well-known Italian model, posed for Vincent seated at one of her distinctive tambourine-shaped tables (*Woman at the Café du Tambourin*, page 39). She also probably modeled nude for him and it is possible that for a time she was his lover. Over 230 paintings resulted from his Paris period; works like *Bridges at Asnières* (page 43) and *Portrait of Père Tanguy* (page 45) are among the finest of all his works.

Van Gogh had come to Paris to learn from Impressionism, taken, as he understood it, to mean the many diverse strands of the avant-garde but he was not truly at ease with the frenetic quality of Parisian life. By late 1887 he was exhausted and beginning to suffer from the

effects of excessive drinking of bad alcohol. He had come to dislike Parisian artistic gatherings, possibly recognizing that his social awkwardness was not going to change. When he chose to go to Provence, the hot 'Japanese' south of France, he was partly inspired by Gauguin whose highly colored description of South Pacific islands suggested a truly primitivistic southern alternative to northern Europe. Van Gogh's notion of Japan was of course fancifully idealistic. Rather as an earlier generation of Romantic artists had made the Near East into an orientalist fantasy world, a setting from which to criticize the over-civilized urbanity of Europe, so did he and other artists come to see Japan as a Far Eastern repository for hopes and dreams of an innocent, beautiful life set

within an exquisite landscape. Just before his long train journey south, in late February 1888, he visited, probably for the first time, Seurat's studio where he was able to study at close quarters his painting *Parade* which he described as 'a revelation of color'.

Arles February 1888 – April 1889

'Just like the winter landscape painted by the Japanese' was how Van Gogh described the snow-covered plain and mountain backdrop in his first letter to Theo from Arles. 'As beautiful as Japan as far as the limpidity of the atmosphere and gay color effects are concerned' was how he summed it up to Bernard. He was clearly determined to find what he was looking for.

17

In March he worked enthusiastically and simultaneously on six canvases of peach, pear and apricot blossom. Bernard wrote from Paris reminding him about Cloissonist principles and the primacy of the Imagination over Nature. Van Gogh, confronted by the fleeting beauty of spectacular Provençal spring orchards, admitted that he was utterly captivated by Nature but that, rather

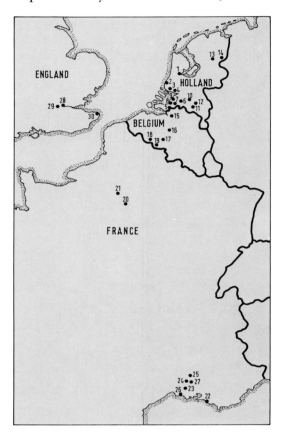

than adopting any clear system, he was simply hitting the canvas with irregular paint marks in front of the motif and only fine-tuning with sincerely felt 'contours' and tonally adjusted color complementaries when he got back to the studio. He wished, he said, strongly to intensify all his colors – only thus could a harmony be achieved, like that achieved when Wagner is played by a large orchestra, producing intimate moments within an overall grander effect; referring to Wagner would have appealed to Bernard, since the composer's theories on synesthesia or the equivalence between sound and color linked with a distinct emotional vocabulary were part of the Symbolist/Cloissonist canon.

Away from Paris, less exhausted by anxious socializing and alcohol, unpressured by the immediacy of conflicting ideas, Van Gogh was able to evolve a fresh personal fusion. One of his peach trees in bloom (page 49) he dedicated to Mauve, who had died suddenly in early February. It symbolizes his feelings for this artist who, despite their disputes, had done so much to help him personally to blossom. He sent the picture, via Theo, to Mauve's widow.

The strength of color, clarity of atmosphere and accelerated intensity of the seasons that he found in Provence shocked Vincent. In his Paris pictures of the spring and summer, 1886, he had charted the seasons' rhythms in a succession of canvases of cut flowers and pot plants. Now, in the wide Arles plain under the huge vault of bright blue sky, he recorded golden wheat fields variously fringed with iris, poppy and cornflowers (*The Mowers*, page 52) rapidly ripening for the June harvest. Using a broad viewpoint with traditionally deep recession toward a blue-hazed horizon, these landscapes employ varidirectional brushwork that weaves together to produce a perfectly integrated paint surface. Working long hours and

Right The Montmartre area of Paris, where Van Gogh lived 1886-88.

1 Theo and Vincent's apartment until June 1886, 25 rue Laval
2 Theo and Vincent's apartment from June 1886, 54 rue Lepic
3 Cormon's studio
4 Café La Tambourin
5 Moulin de la Galette
6 Café de la Nouvelles Athènes
7 Signac's studio
8 Seurat's studio
9 Toulouse Lautrec's studio
10 Degas's apartment/studio
11 Shop of color merchant Père Tanguy

Right Georges Seurat's *Invitation to the Sideshow* shows clearly the dotlike stroke and carefully structured linearity of Neo-Impressionism, which influenced Van Gogh's own pictures. He saw this painting in Seurat's studio just hours before leaving for Arles in February 1888.
Right below The Yellow House, Arles (see also pages 58/59). Van Gogh leased the four rooms in the right-hand section, where he and Gauguin lived together in late 1888; the rooms later became part of the café next door, as shown in this photograph, and the whole building was bombed in 1944.

at concert pitch Van Gogh knew that at last he was achieving a mature fusion of vision, motif and technique.

He combed the area to find new subjects, visiting Les Saintes-Maries in the Rhône delta, where he was attracted by the exaggerated arcs of bow, mast and sail in the local fishing craft – bright and crudely painted (*Boats on the Beach at Saintes-Maries*, page 51). Reminiscent of his Seineside pictures are a few Rhôneside views of barges and industry, and on a quiet canal spur of the Rhône on the southern edge of Arles he found Dutch-style wooden road bridges built by a Dutch engineer. At one he painted a group of women washing clothes (*The Pont de Langlois with Women Washing*, page 50).

Between March and October 1888 Van Gogh lived alone, at first lodging at a café, then taking a six-month lease on a four-roomed house on the Place Lamartine (*The Yellow House in Arles*, page 58). Intellectual stimulation, limited locally to conversation with two visiting artists Boch and MacKnight, came primarily from Theo's letters and from a concentrated correspondence with Bernard, who kept him in touch with Cloissonist and Symbolist developments and with his growing admiration for Gauguin's talents. Bernard's theoretical strictures and questionings can be deduced from Van Gogh's replies. In these letters there is also a tone of brothelwise bravado absent from his letters to Theo. Vincent also befriended his postman Roulin, a

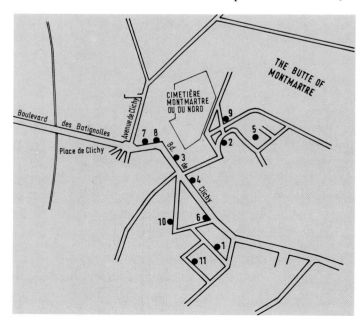

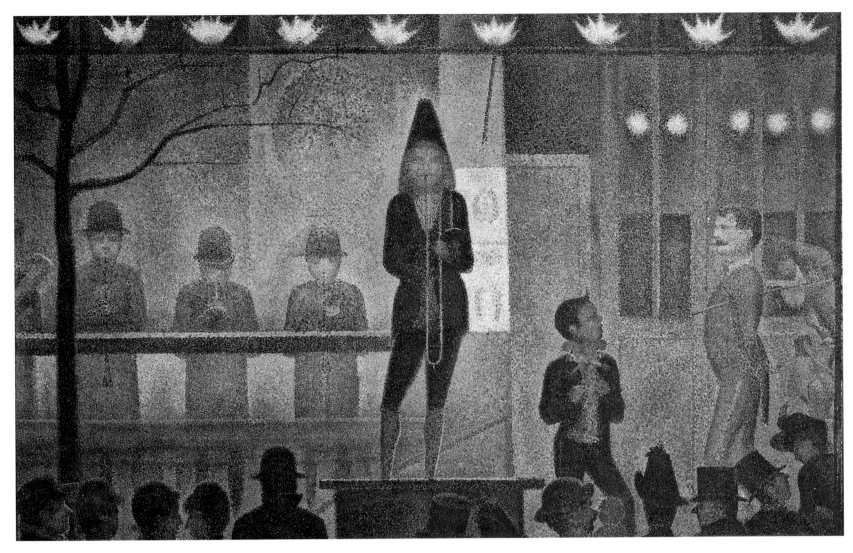

fiercely Republican figure (*Postman Joseph Roulin*, page 53) who reminded him of Père Tanguy, and Milliet, a sub-lieutenant in a Zouave regiment, home on leave.

Despite his daytime activity Vincent was lonely and his wish to work with other artists led Theo, with the aid of a recent legacy, to acquiese in a plan that Gauguin, penniless in Pont-Aven and without prospects for the winter, should share the house at Arles, receiving a monthly stipend in exchange for a monthly picture. Gauguin approached the whole business cynically, as a short-term solution until further funds allowed him to return to Martinique, and he delayed coming to Arles until late October. Meanwhile Vincent wound himself up into an excited and anxious state, believing that Gauguin's presence would herald the setting up of a 'Studio of the South' – a colony of like-minded artists as at Barbizon or Pont-Aven. From August onward he planned furniture buying and house painting and he started the series of still lifes of huge Provençal sunflowers (*Fourteen Sunflowers*, page 54), each with twelve or fourteen flower heads, six of which he planned to decorate their shared studio.

In September his paintings focused on the townscape of Arles itself. Gas piping was being laid and a trench stretched from near the railway station alongside

his new home. He recorded this work in progress in the cheerful view of his freshly painted yellow house (page 58) and also took advantage of the installation to pay 25 francs to have two gas jets laid on, one in the kitchen and another in the studio, part of his plan for Gauguin's comfort. The theme of gaslight dominates a small group of his September canvases. Diagonally across the street from his house, at an all-night café (*The Night Café*, page 60) he painted an interior room. A central gas globe amid three oil lamps casts a ghastly green tinge over the white-coated proprietor

and the marble-topped tables at which are slumped the nocturnal drifters. Acid green contrasts with blood red, intensified by the artist because he wished to evoke the 'terrible passions of humanity' and to produce the feeling of a place where one might lose one's soul.

In a lower key, at the smarter town-center café in the Place du Forum, *The Café Terrace, Arles at Night* (page 62) explores conflicting natural and manmade light – the gas-lit exterior tables under their canvas canopy set off against an inky blue sky full of poached egg stars. Although this café may have looked

much as Vincent painted it, the composition and viewpoint are direct quotations from a painting by his contemporary Louis Anquetin of a gas-lit and canopied butcher's shop in the Boulevard de Clichy. Gaslight may have connoted Parisian modernity for Vincent at this time and reminded him of metropolitan motifs like Signac's gasometers at Clichy and Seurat's gas-lit *Parade*, the picture he had viewed just before leaving Paris.

In early October Van Gogh painted his most contented picture – 'just my bedroom' (*Van Gogh's Bedroom*, page 63) is how he described it to Theo. The scarlet coverlet and simple deal furniture, 'the color of fresh butter', are painted without texture or shadows using 'free flat tints like Japanese prints'. The steeply raked floor and box-like space, so palpably European, blend with these oriental simplifications. Painted in anticipation of Gauguin's visit, this picture was intended to distil peace, rest, sleep and tranquillity.

Gauguin's arrival from Paris led to modifications in Vincent's practice. There is a renewed exploration of the spatial values and the exaggerated color of *ōban*-sized Japanese prints, with increased use of strong circumscribing black lines and a flattening of surface texture. Partly this was an accommodation to Cloissonist notions; *Les Alyscamps* (page 66), showing strollers on Arles's avenue of battered Roman sarcophagi seen from a high viewpoint through dominant foreground blue poplars, is among the clearest examples of this tendency. With its dramatic spatial leap from foreground trees to tonally unified backdrop, it subverts the traditional

European perspectival format within which the majority of Van Gogh's previous six months' landscapes had been constructed. Stained rather than textured paint emphasizes the canvas weave. Although Van Gogh had earlier written suggesting that his color was more arbitrary, this applies more to portraits and their backgrounds; the majority of his landscapes are of local color exaggerated and enhanced.

Gauguin also persuaded him to paint from dream and memory, experience recollected being seen as more intellectually substantial than fidelity to the natural, Gauguin's old criticism of Impressionism. Van Gogh's *Promenade at Arles – Memory of the Garden at Etten* (page 70), showing veiled women and a servant gathering flowers, invites a figurative symbolic reading, suggesting through facial expression and gesture a specific mood and human feeling. Rather than broad vistas of nature in which men and women move as small figures, there is a claustrophobic close-up quality to this view; indeed it may have been painful for Vincent to paint, pushed by Gauguin to recollect something dear to him from the past. The figures are partly based upon his mother and sister and the setting is his old family garden. In extreme contrast to *Les Alyscamps*, the paint surface is a thickly textured mass of dots and short strokes; his most Pointillist canvas since summer 1887 and perhaps provocatively so, given Gauguin's extreme dislike of Seurat and his Neo-Impressionist principles. (Gauguin later wrote dismissively and untruthfully of Van Gogh being completely preoccupied with Neo-Impressionism when he arrived at Arles.)

The Sower (page 64) of late November 1888, again based upon imagination, is a symbolic archetype that is closer to Van Gogh's own concerns and ultimately inspired by Millet's pictures. The dark, cropped, silhouette-like figure and angled tree are once again inspired by Japanese prints and the huge disc of the sun, like an off-center halo around the sower, makes him appear like a man-god cooperating in the rhythms of nature. Vincent characterized such pictures as 'abstractions' – distinct designs influenced by but not dependent upon observed nature. When he wished to paint a motif in open countryside that linked in with his earlier summer recording of the seasons' developments, however, he returned to his earlier spatial depth and paint handling. *The Red Vineyard* (page 68) records vibrant autumnal red vines under a blazing sun. Gauguin also painted a vineyard; he borrowed a figure from Van Gogh's work but gave her a Breton hat and added brooding and melancholic figures, then subtitled his picture *Human Misery*. There is in Gauguin's version none of Vincent's joy at autumnal plenitude. His vineyard is a barely indicated backdrop for human figures charged with symbolic associations of wine, sacrifice and gall. The difference between their approaches was rarely more clearly shown.

During December both artists worked indoors. Temperamentally they were mismatched and frequently quarreled about art, Gauguin given to rather lordly condescension, Vincent passionately defensive. Both men were ill and heavy bouts of absinthe drinking made them worse. Writing to Theo, Vincent was at first guarded about the conflict but by December 23 it was serious enough for him to admit that a crisis had been reached and that Gauguin might leave. By now he was again exhausted, agitated, and wretchedly disappointed that after only two months his plans had failed.

The famous events of that evening and the following day are not entirely clear. After a great deal of drink the two men again argued; Van Gogh apparently threw a bottle at Gauguin and possibly later threatened him with a razor. The following night Gauguin, for his own safety, decided to put up in a hotel. That evening Vincent cut off his earlobe, took it to the local brothel and gave it to a prostitute, and then went home to sleep. He may have expected Gauguin to have

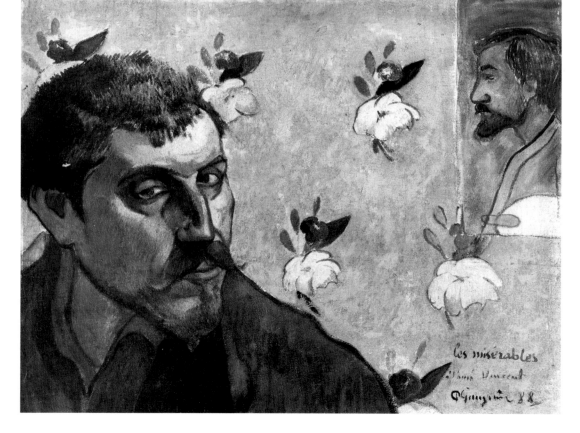

Left *Self-Portrait 'Les Misérables'* by Paul Gauguin, sent to Van Gogh in an exchange of portraits before he came to Arles.
Right above Van Gogh's pen and ink drawing of *The Hospital Garden at Arles* shows his Japanese-inspired drawing style at its most controled.

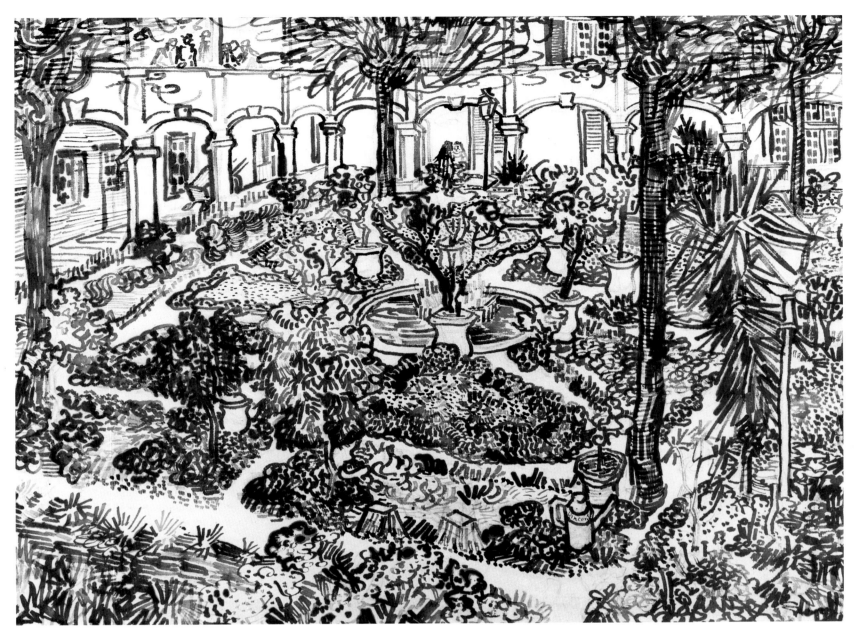

been at the brothel. When Gauguin arrived home next morning to find the house surrounded by police, he satisfied himself that Van Gogh was still alive and, after sending a telegram to Theo, took the next train back to Paris. Vincent was confined to the local hospital and for the next three days was in a state of delirium. Theo visited him briefly and by mid-January 1889, with his mutilated head heavily bandaged, he was allowed home.

The poignant pictorial monument to the breakdown of Vincent's hopes is the pair of pictures of his own and Gauguin's chairs. His own, yellow, simple, rush-seated, upon it his pipe and a twist of tobacco, is set against a kitchen background that includes a box of sprouting onions (page 72) and is an image of warm domesticity complementing the earlier view of his bedroom. *Gauguin's Chair* (page 73), the more comfortable of the two, is more eerily lit by studio gaslight and a bedside candle and sits against an uncomfortably acid-green wall, the floor splattered with red paint, the atmosphere emotionally and colorifically closer to the earlier *Night Café* interior (page 60). Novels on the seat next to the candle suggest solitary night-time

reading replacing busy studio work and shared social life. Sadly this picture of a symbolically charged Gauguinesque object evokes the loss of Gauguin himself.

As soon as Van Gogh was well enough to be discharged from hospital, he fell into his familiar work pattern. In December he had painted portraits of all postman Roulin's family, including his new baby. Among them was a portrait of Madame Roulin with an ornate background of paisley-like flourishes of chrysanthemums, reminiscent of the background of Gauguin's self-portrait which he had given Van Gogh as a gift in October 1888. The squat maternal bulk of Madame Roulin, seated in what is probably Gauguin's armchair and holding a rope connected to a cradle, is an icon of the sort of security that Van Gogh ached for (*La Berceuse: Madame Augustine Roulin*, page 75). Although he often painted two or even three versions of pictures that he liked or wished to modify, the six broadly similar versions that he painted of Madame Roulin between December 1888 and February 1889 are an exceptionally large group. He told Theo that he had thought of seamen far from home who, with a canvas such as

this, might feel the familiar warmth engendered by a cradle-rocking figure.

His own *Self-Portrait with Bandaged Ear* (page 74), painted immediately after leaving hospital, is characteristic of Vincent's recurrent inclination to face up forcibly to unpleasant truths. He told Theo that he found comfort in admitting his possible madness and this visual confrontation with his stern mutilated features is in a similar masochistic vein. The Japanese print of *Geishas in a Landscape* by Toyokuni (1780-1850) in the background was possibly included as an affirmation of his quest for pure Japanese aesthetic values. Unknown to Vincent at the time, it is an 1860s image printed partly with harsh modern western inorganic chemical dyes.

Early in January Theo became engaged to Johanna Bongers, the sister of a mutual Paris friend. Despite conciliatory letters from Johanna to Vincent and mutual assurances between Theo and Vincent that Jo would be an additional member of their long artistic union, she represented a great threat; not least because Theo as part of his impending marriage settlement might have to call on all his capital.

As an outpatient from Arles hospital

Vincent was sympathetically cared for by Dr Rey, whom he trusted and who had some success treating his continued hallucinations using drugs. Despite his improved physical health and reasonably consistent behavior there were occasional relapses. He was evidently given to shouting and talking to himself in public and he came to believe that in his own interest longer-term institutional care was needed. After a serious collapse in mid-February, in which he may have violently threatened Dr Rey, he was again hospitalized. Van Gogh's acceptance that he needed attention was in part provoked by weariness and he was ready for his life's organization and financial management to be taken out of his hands. As long as he could paint with relatively little restriction he was prepared to go into an asylum. Accelerated pressure came when 81 Arles citizens got up a petition demanding his incarceration, and the chief of police and magistrate ordered that from February 26 1889 he should be locked up at the hospital under a strict regime. He had difficulty in writing to Theo but bore his effective imprisonment with surprisingly meek acceptance.

In late March Signac visited Arles and Vincent was allowed out. Together they broke into the Yellow House, the lock of which the police had damaged, and were able to look at and discuss the work that he had done over the past year, since leaving Paris. For Vincent it was undoubtedly much needed intellectual stimulation; for Signac, if his rather cold report is to be believed, it was interesting rather than exciting, but he did report back to Theo that he found Vincent sane and in good health.

The coming of spring and Vincent's steady recovery led to him painting again in earnest. Two superb landscapes date from April, both of orchards in blossom. The first, showing *The Plain of La Crau with Peach Trees in Blossom* (page 78), suggests that he was not simply returning to his art but deliberately generating for himself new pictorial problems. A banded eight-layered emphatically horizontal picture – road, roadside fence, orchard, fields, houses, mountains, sky and clouds – is strengthened by the predominantly dash-stroked horizontal lines of paint across the canvas. Only a few vertical accents of fence, tree-trunk or house side break this emphasis. *A View of Arles* (page 80), possibly of the same road and orchards but closer to the edge of Arles, is clearly related to the earlier Alyscamps view through poplars (page 66), but an even greater Japanese spatial feel is now achieved by a frontal rather than diagonal view of the foreground trees which, like three bars, split up the landscape. Lush-textured variety

characterizes the brushwork, which is less Pointillist than the parallel La Crau work. These two different experiments reaffirmed for Van Gogh that he could still paint at what he recognized had been his peak of the previous summer, prior to Gauguin's visit.

St Rémy

On 8 May 1889, Vincent voluntarily entered, as a patient in the third class, the asylum of St-Paul-de-Mausole near St Rémy. The asylum, about twelve miles east of Arles and set in hilly, rocky countryside, was run by Dr Peyron who told Vincent that his disorder was epileptic. In his hospital register he amplified this diagnosis, stating that Vincent was suffering from acute mania accompanied by visual and aural hallucinations and would need prolonged observation. It had been agreed that he was to rest at Theo's expense and under his guardianship with regular meals and nursing for a year.

There has been considerable speculation and investigation as to the true nature of Van Gogh's illness. Despite his physical debilities, possibly alcoholic, almost certainly syphilitic, the case for his condition being hereditary is strong. His younger brother Cor committed suicide in 1900 in a British concentration camp in South Africa; Wil, his favorite sister, spent the last four decades of her life in an asylum; and recent evidence surrounding Theo's death, connected with the disappearance of all medical records, has led to suggestions that in a state of mental collapse, he too committed suicide. Although Van Gogh had told Peyron that there was epilepsy in his mother's family, an altogether more serious legacy of congenital mental instability seems likely, and there are hints in some of the euphemistic and guarded comments in Vincent's and Theo's letters that their shared worries about mental illness and venereal diseases were much greater than the diseases themselves might seem to warrant.

John Rewald's circumspect summary of Van Gogh's illness is that it was 'epileptoid psychosis', with symptoms in which 'the patient is gloomy, taciturn, defiant, suspicious, always ready to take offence, to injure others, to be carried away by fits of temper, to hit out at people', manifested in 'attacks of indefinite duration, preceded by what is called crepuscular stages and followed by torpor. But in the intervals between attacks the patient behaves in a perfectly rational way.'

Making too direct a connection between Van Gogh's medical condition and his paintings is misplaced. While his pictures are richly symbolic and clear links can be traced between particular

subjects and his own feelings and preoccupations, over-zealous analysis has at times led to the discovery in his pictures of a wealth of apparently significant psychobiographical material that stretches credulity. Also irrevelant are any apparent similarities seen between Van Gogh's high color and distinctive brushlines and the painting of schizophrenics. Had his pictures been produced a century previously, the apparently extraordinary difference between his pictorial language and that of his peers might have justified scrutiny for evidence of mental disturbance. However, Van Gogh's exaggerations of line, color and texture were developed primarily for understood contemporary aesthetic purposes and he saw himself tackling problems within the relatively autonomous realm of European picture-making, shared with contemporary Symbolists like Gauguin and Bernard, but also past masters like Corot and Millet. When Van Gogh was ill he simply did not paint. When he was better he tuned up his work to the point of his previous practice and carried on with his painting.

Understanding of his pictures and intentions has also not been helped by the ease with which statements out of context have sometimes been extracted from his letters to Theo and appended to images, so that an impression of pell-mell creativity perpetually bordering on insanity is seen as his natural mode of operation.

For two months at St Rémy, until a serious midsummer attack left him prostrate, Van Gogh produced a group of pictures exploring the motifs to hand. From the windows of his pair of adjoining rooms the view was toward a small wheatfield enclosed by a dry stone wall, characteristic of a more marginal agriculture than he was familiar with from Holland or the plain of Arles (*Mountainous Landscape, View from St Paul's Hospital*, page 86). Compulsorily confined during May within the hospital walls, he found irises growing in a large bed beside lilac trees in the overgrown garden, and he painted their full blooms in close up (*Irises*, page 84), without sky and with little surrounding ground. Focused downward to undergrowth and shaded plants beneath bushes, this microcosmic exploration of his limited surroundings also included a large *Death's Head Moth* (page 82) settled on a patch of arum lilies, a rare instance of fauna as well as flora catching his eye.

Allowed outside the grounds in June and accompanied by a guard, Van Gogh explored surrounding fields and the Alpilles foothills and was particularly struck by cypress trees, near-black vertical accents in the sunlit radiance, which

he compared in line and proportion to an Egyptian obelisk. For someone as steeped in biblical imagery as Van Gogh, the landscape was rich with suggestions of the Holy Land: goats and olive trees on stony soil, wheatfields with eucharistic associations, and cypresses traditionally connected with death. He denied that he was interested in injecting specifically religious sentiment into his landscapes at this time but the group that includes the London *A Cornfield with Cypresses* (page 90) and the famous New York *Starry Night* (page 88) have often been seen as among the most strongly suggestive of all his works of a divinely and benevolently ordered nature and cosmos. In both canvases, clouds and cypresses are painted with whirling curves, an animated linearity derived from two sources. First, they are a rather delayed exploration of the use of continuous lines for emotional effect, as suggested by Seurat, and secondly, they are the most thoroughgoing utilization to date of the line of Hokusai.

In the first week of July 1889 Theo and Jo wrote informing him that they were to

have a child, that they hoped it would be a boy, and that they wanted Vincent to be the godfather. Although changed circumstances in Theo's life cannot be directly blamed for precipitating Van Gogh's various collapses, they do at times seem to have been linked. A particularly bad attack in the second week of July kept Vincent indoors and unable to paint until September. As a pattern to his major and minor mental collapses began to emerge, he was able to predict the approximate time, but not the duration, of his next attack, and to derive some consolation from the knowledge that after a severe bout there would be several months' remission.

The *Self Portrait* (page 93) painted almost immediately after his recovery, like the earlier *Self Portrait with a Bandaged Ear* (page 74) is once more both a summing up of current technical concerns, in this case oscillating line and a relatively simplified contrast of blue with its complementary orange, and at the same time a visual record of his physical condition. Here he emanates rather rude health, suggesting that the dull but regular hospital food and his limitation of alcohol to half a liter a day was having some effect.

Theo and Bernard kept him informed

about the accelerating splits and fusions among artists in Paris, in particular the new Symbolist 'Synthesist' grouping around Gauguin, who among other subjects were tackling biblical themes in a mystical fashion. When Bernard sent photographs of his paintings *The Garden of Gethsemane* and *The Birth of Christ*, Van Gogh was horrified at what he described as 'banalities'. His own grave pursuit of truth within nature, and his admiration of the ability of Millet and others to extract universal meanings from ordinary peasant life, made him contemptuous of these moody illustrative narratives. It had all, he wrote, been done better by Holman Hunt and the Pre-Raphaelites.

For himself he felt that only by an immersion in real nature would significant motifs emerge and he cited his recent pictures of olive groves (*Olive Trees*, page 83) as an example. He had painted these partly with the intention of 'giving an expression of anguish without aiming at the historic garden of Gethsemane'. The total group of fourteen olive orchard pictures are characterized by a deliberate limitation of his palette. The bleached treetrunk and silvery-white leaves of the olive makes it particularly receptive to the absorption and reflec-

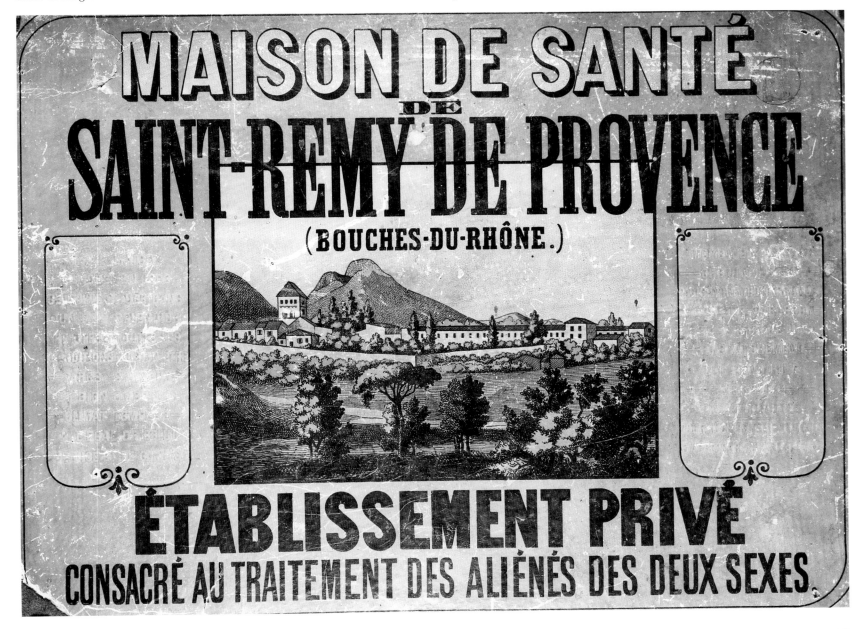

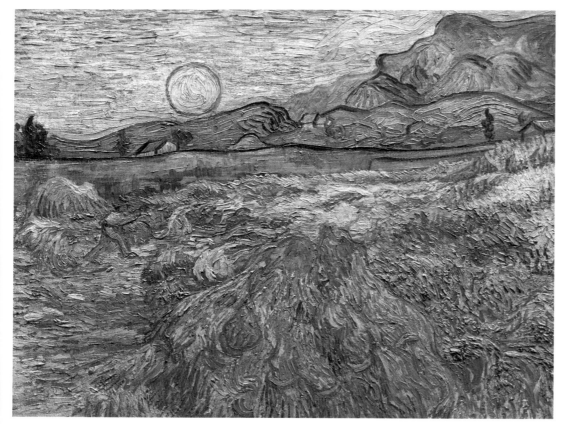

Top *The Reaper* of June 1889, one of the more optimistic works from the St Rémy period.
Above Van Gogh with Emile Bernard at Asnières in 1886; Bernard's enthusiasm was instrumental in advancing Van Gogh's reputation during his sojourn in the south.

tion of ambient color, whether of sky, vegetation or sunlight; Van Gogh was able to exploit this to create what are at times near-monochrome explorations of blue-green or yellow-orange.

The 'anguish' that Van Gogh felt could be expressed by olive orchards was never intended as despair. He recurrently stated that he wished his pictures to be 'consoling' and he was never interested in suspense, horror or any use of the typological archetypes of misery that Symbolists like Redon or Moreau

employed. Acceptance, resignation and the management of pain and anguish in shared human comfort was more characteristic of his disposition.

As the weather worsened and he was confined indoors, he fell back for inspiration on his collection of reproductions, in particular upon Millet's peasant pictures and New Testament subjects by Delacroix. From these he made paintings that he described as 'not copies but translations into another language'. The three pictures reproduced here from this group indicate that, despite what he said to Bernard, he was to some extent interested in biblical illustrations. His copy of Delacroix's *Pietà*, (page 92) is a general treatment of mankind's cruelty. A more specific con-

cern with human warmth and affection is seen in the two Millet copies. The *Two Peasants and a Child (after Millet)* (page 94), showing a self-absorbed couple delighting in the first step of their child, and *Noon (after Millet)* (page 96) depicting an exhausted couple peacefully asleep against each other under a midday sun, both dwell visually on Theo's good fortune, as do other related images of sleeping mothers with children and a cradle-guarding couple.

From September onward Vincent put pressure on Theo to allow him to return north, either to Paris or its nearby countryside. He wanted a fresh start, to paint again with a northern palette and to be close to his brother. Theo, with a heavily pregnant wife and increasing conflict with his superiors over his management of the Montmartre gallery, tried to accommodate Vincent's wishes. He asked help from Pissarro, with whom Vincent would have liked to live but it was not possible to fix up anything quickly. In early February Jo gave birth to her son after a difficult confinement. Just before going into labor she wrote to Vincent telling him how he should console Theo should she die. Shortly after, Vincent had another serious collapse from which he took two months to recover.

By April 1890 Theo had, at Pissarro's suggestion, fruitfully explored the possibility of Vincent's going to Auvers, a village northwest of Paris on the River Oise. Living in lodgings he could have a supervisory eye kept on him by Dr Gachet, a successful homeopathic doctor with a Parisian practice who counted Cézanne, Guillaumin and other Impressionists among his friends. Gathering his strength during his third Provençal spring, Vincent continued during April and May to paint from reproductions, from cut flowers arranged in vases and from occasional sorties into the countryside. More ominous is the reworking in oils of one of his own early prints *Worn Out* (page 100), which sums up the impotent despair and frustration of advancing age and was painted in May just prior to his leaving for Paris.

Paris/Auvers June–July 1890

During his two-year absence from Paris Van Gogh's reputation had advanced, fostered partly by Bernard's enthusiasm. In 1889 his pictures were exhibited at the Independents exhibition and he also showed by invitation at the XX Group in Brussels in January 1890, where he sold *The Red Vineyard* (page 68), the only painting bought in his lifetime. The critic Aurier wrote a fulsome, if rather inaccurate, eulogy of his work and intentions in a Symbolist periodical. Although he did not have the status that

Gauguin had acquired from his retreat to the Pacific, Van Gogh's sojourn in the depths of Provence and his innovative motifs were admired by several younger French Symbolist painters.

After meeting old friends, his sister-in-law and new nephew at Theo's apartment and being confronted by the sheer volume of pictures that he had been sending back from Provence, Vincent took up lodgings at Auvers, at first in an hotel, then in a cheaper more homely café. His arm's-length care by Dr Gachet was of limited success; Gachet rather optimistically described his symptoms as 'Midi disease' and suggested an excess of turpentine fumes as a possible cause of illness. Vincent trusted him, sought out his company when Gachet was not in Paris, used the printing press in his home that had been earlier used by Cézanne, and painted portraits of the Gachet family.

In the 80 or more paintings that Van Gogh painted in his last two months in Auvers there is no lessening in the intensity of color, despite earlier stated intentions of returning to a northern palette. However, the quality of this final phase is uneven. His brushwork sometimes becomes brittle, less connected to form, more arbitrary. Figures and objects at times billow and move with a gelatinous quiver as though touched by the wind (*The Church at Auvers*, page 102, *Portrait of Dr Gachet*, page 101). He sought out motifs that he could fit into familiar pictorial structures like the magnificent *Landscape with Cart and Train* (page 104) which, as with earlier high panoramic viewpoints of the plain of La Crau (page 78), shows small fields of varied local crops. An innovation was the adoption of long, thin canvases, wrap-around views of the vast space of the Auvers prairie (*Crows over a Cornfield*, page 108). These empty vistas, devoid of human content, whose dark clouds and crows suggest menace, have most frequently been connected with Van Gogh's final suicidal despair.

His return to Paris brought Vincent into uncomfortable contact with many of Theo's problems: the restrictions that his superiors were placing upon his freedom; mounting expenses; his own illness and that of his baby son. Vincent was ill-equipped to give adequate comfort; his preferred solution was that they should all leave Paris and come to Auvers, ostensibly for the health of the baby. He also saw clearly that he was a financial burden, especially when Theo had difficulty paying him his allowance and then had to cancel a summer holiday planned in Auvers and replace it with a visit to his wife's family in Holland. Vincent had not had an attack since February, and may also have felt the

physical symptoms that suggested the build-up to another collapse.

On July 27 Vincent shot himself in a field, with a revolver borrowed from his landlord to kill crows, then walked back to his room and went to bed. After he failed to appear at dinner Dr Gachet was summoned. It now seems possible that his life could have been saved but Gachet chose not to remove the bullet. During the next day Vincent remained conscious and calm, talking to Theo. He died early on the morning of July 29; at the death that he wanted he at last had his brother to himself. Theo's own death occurred a few months later in an asylum in Utrecht in circumstances that are still far from clear.

After the death of her husband and brother-in-law, Johanna Bongers took on the role of priestess to the Van Gogh memory, keeping together the paintings, encouraging their exhibition, publishing the (edited) letters in 1914. Her son, Vincent's godson, inherited the same task and until his death in 1976 there is scarcely an exhibition catalogue of Van Gogh's work that does not contain his preface. As Vincent's reputation advanced, increasing demands were made upon the family to loan their pictures, which they rarely refused. In the 1950s there were three major Van Gogh exhibitions in Britain alone.

Above *Vincent Van Gogh on his Deathbed* by Dr Gachet; Vincent took 36 hours to die after shooting himself and Gachet decided not to remove the bullet.

It may seem surprising that, despite the enormous quantity of letters that survive from Vincent, there are so few from Theo and virtually none from his parents. There was a seamlessness about the Johanna and Vincent Van Gogh the Younger presentation that was voluminous yet somehow partial, and made it very difficult for biographers to get at further relevant information about Vincent's childhood and family medical history. Despite Van Gogh's being among the most popular and, in his centenary year of 1990 certainly the most expensive, artist in the world, there is still a considerable amount of research needed on his life and work. It is almost as though there has been too much readily useable information in the letters, so that the kind of contextual fact-grubbing characteristic of research into less well-documented artists has not been carried out. The strength of his personality, the romanticized torment of his doomed life, the typecasting of him as the isolated, naive genius-cum-madman has made it difficult to produce less subjective, less highly colored accounts of his work and life.

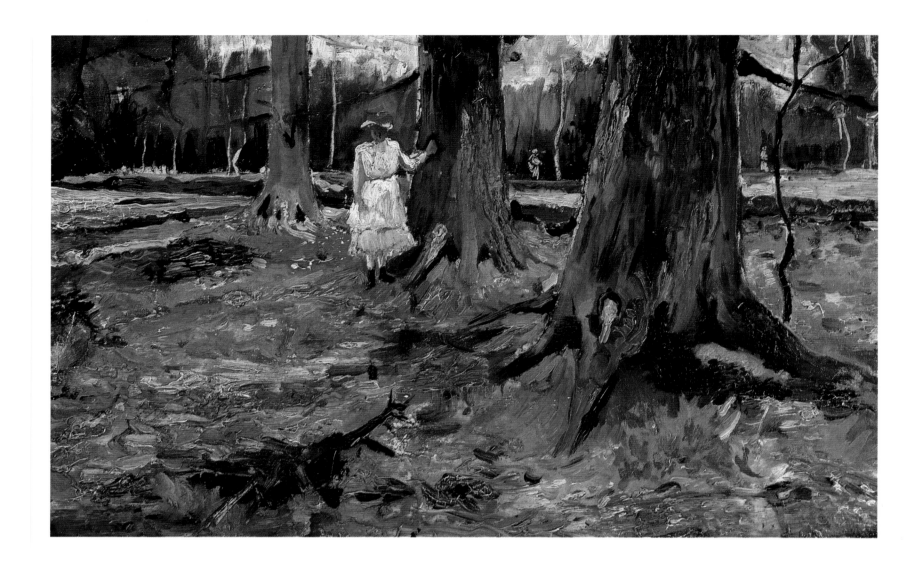

Girl Under Trees late summer
1882
Oil on canvas
14¼×23¼ inches (39×59 cm)
Collection State Museum Kröller-Müller,
Otterlo, The Netherlands

Weaver 1884
Oil on canvas
24⅝×33¼ inches (62.5×84.4 cm)
Museum of Fine Arts, Boston

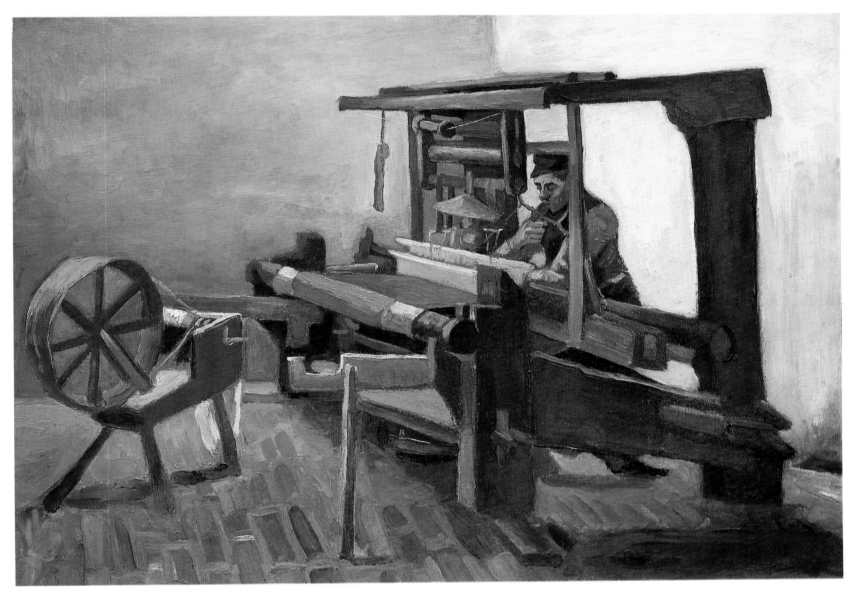

The Potato Eaters April 1885
Oil on canvas
32¼×45 inches (82×114 cm)
Rijksmuseum Vincent van Gogh, Amsterdam

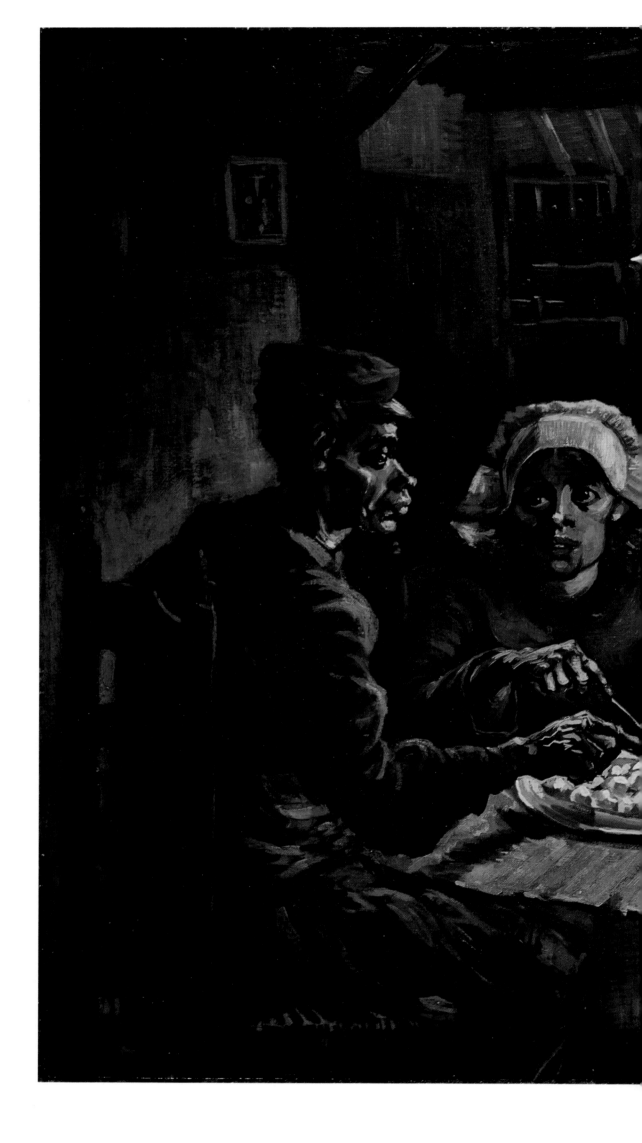

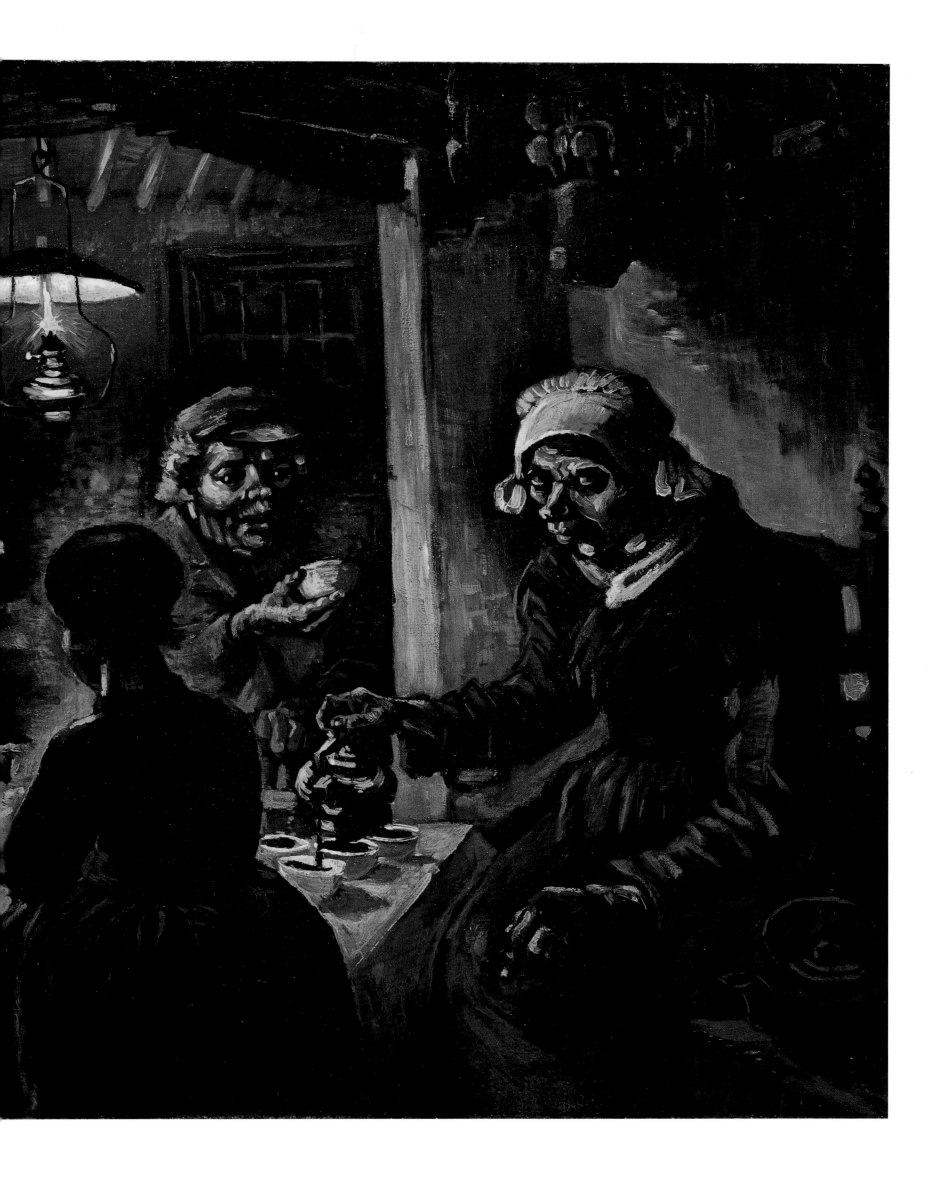

Still Life with Open Bible, Extinguished Candle and Zola's 'Joie de Vivre' October 1885
Oil on canvas
25½×30¾ inches (65×78 cm)
Rijksmuseum Vincent van Gogh, Amsterdam

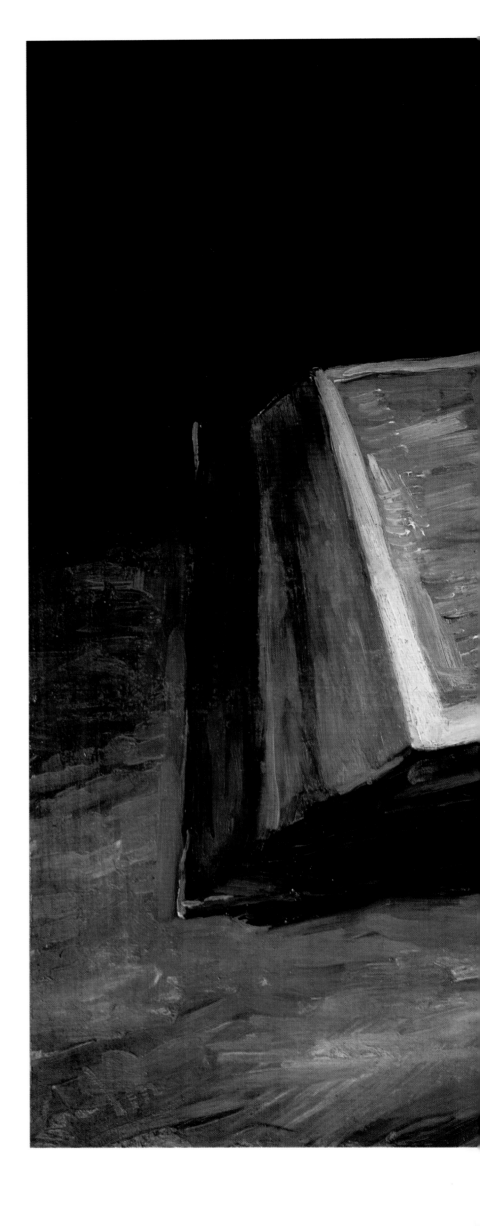

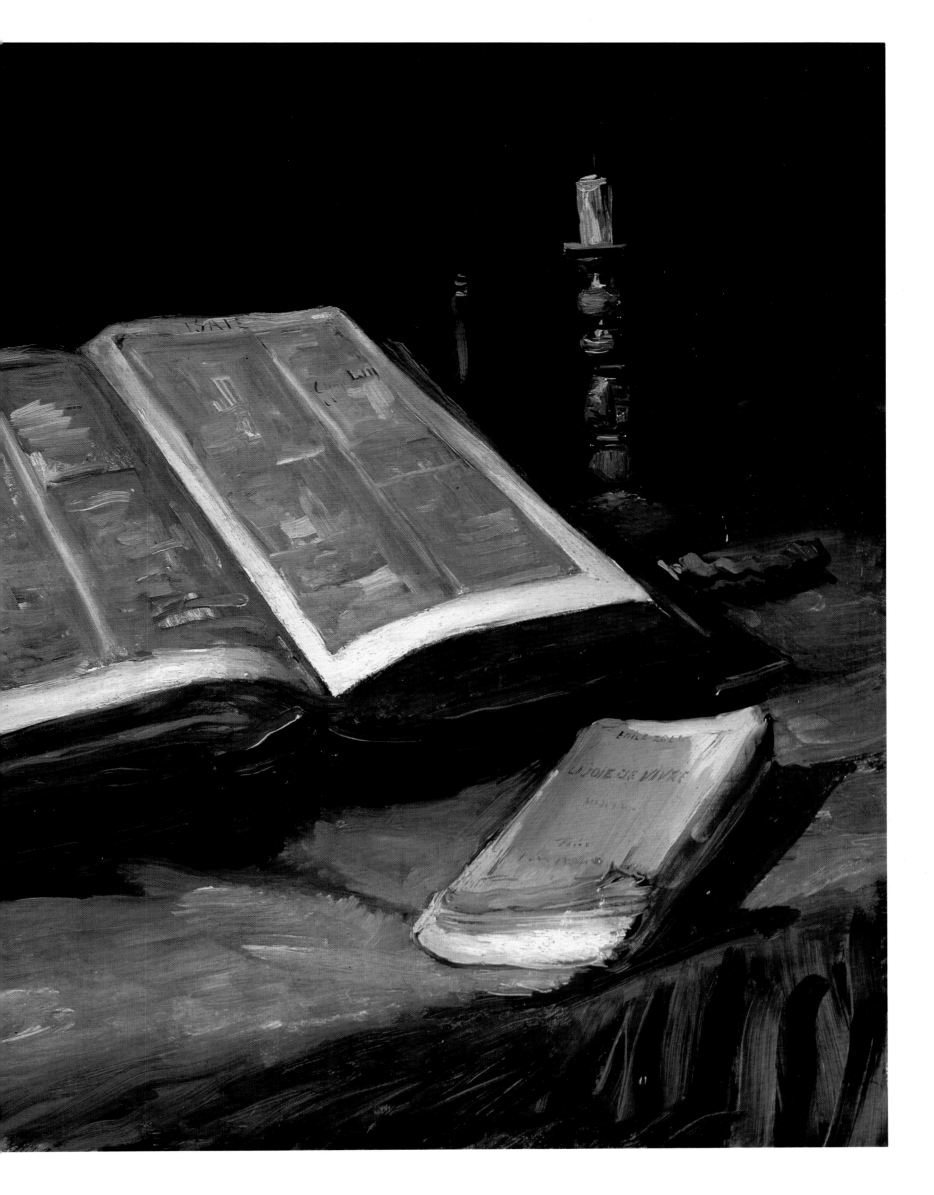

31

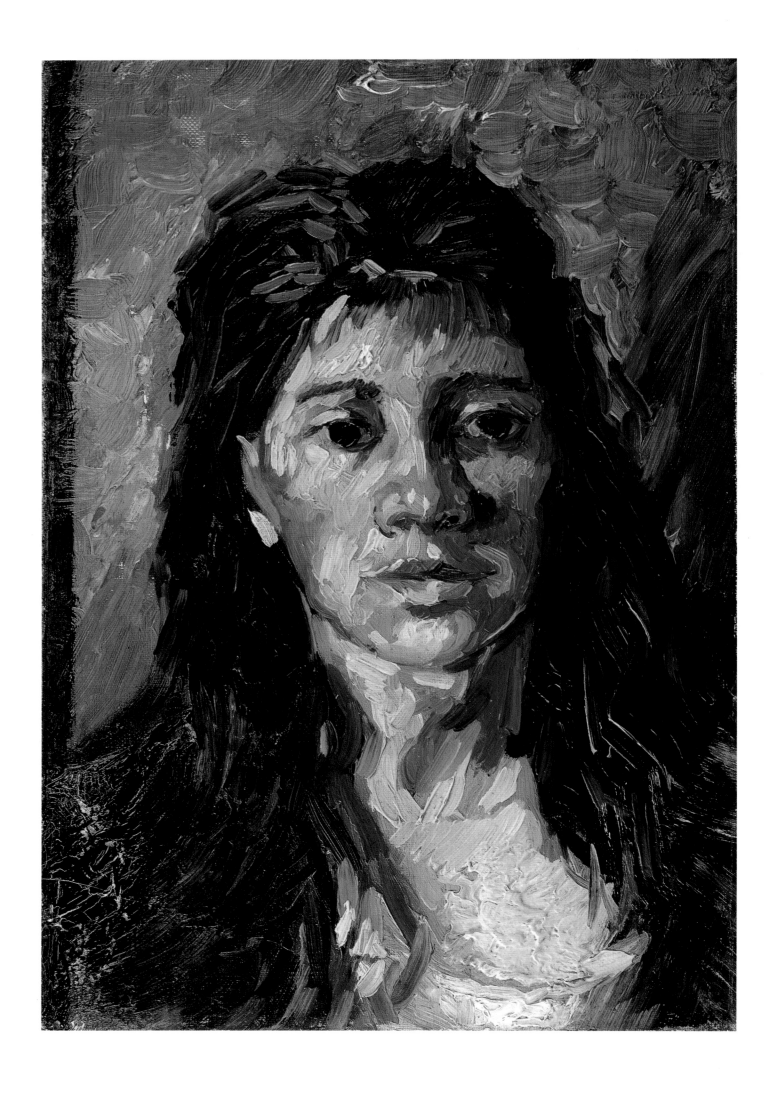

Head of a Woman December 1885

Oil on canvas
13¼×9½ inches (35×24 cm)
*Rijksmuseum Vincent van Gogh,
Amsterdam*

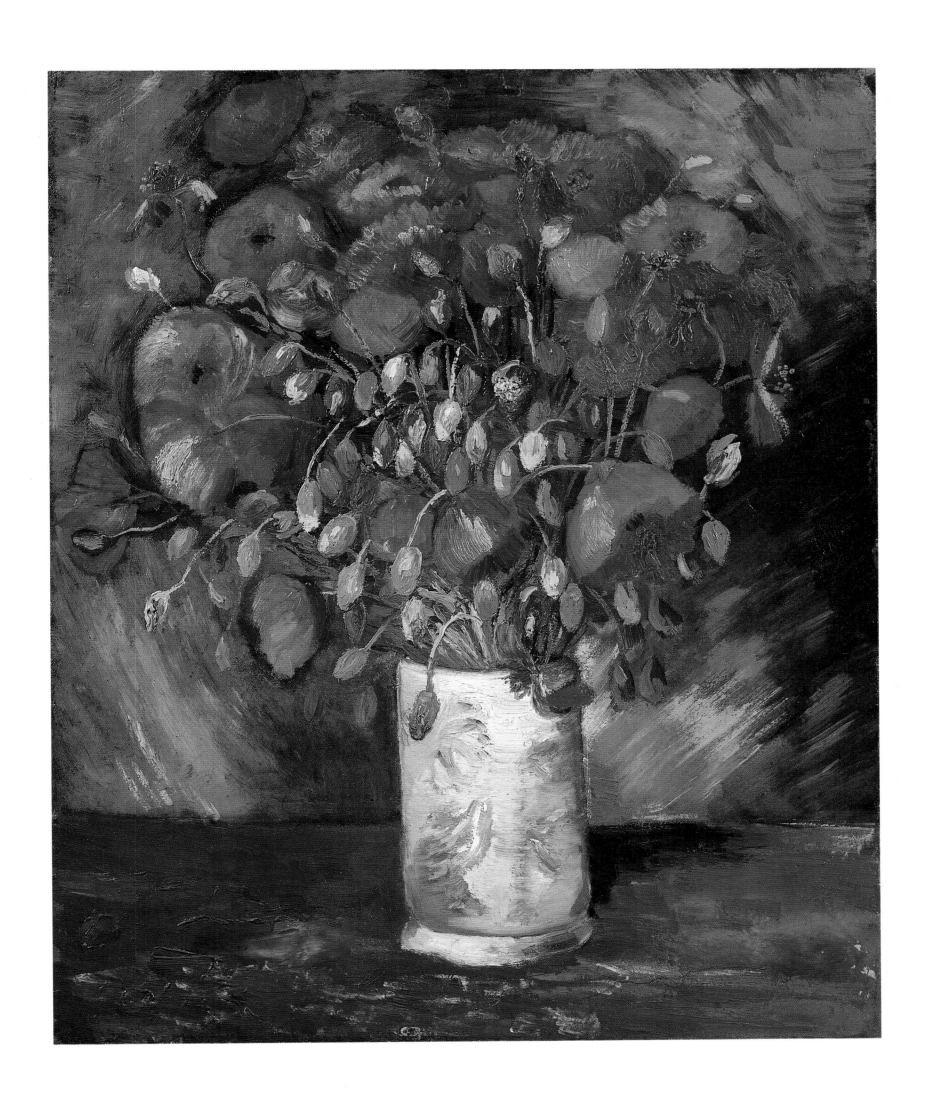

Poppies May 1886
Oil on canvas
21½×17¾ inches (56×46.5 cm)
Wadsworth Atheneum, Hartford, Connecticut

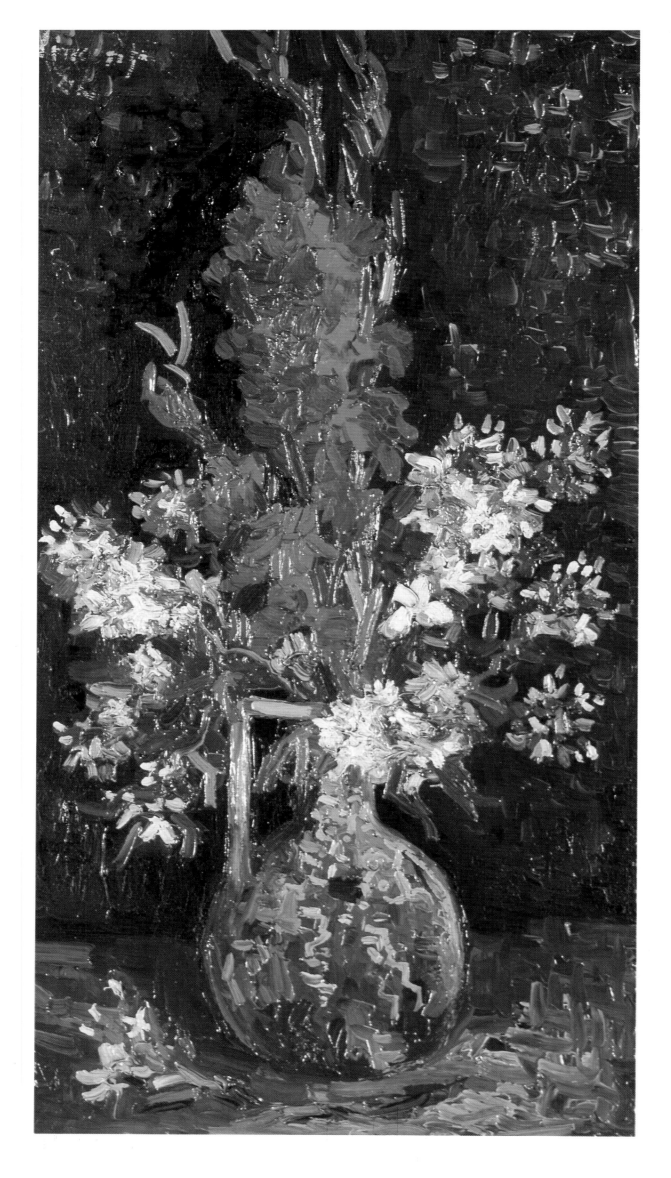

Vase with Physostegia, Gladiolus and Lychnis
late summer 1886
Oil on canvas
25¾×13¾ inches
(65.5×35 cm)
Museum Boymans-van Beuningen, Rotterdam

34

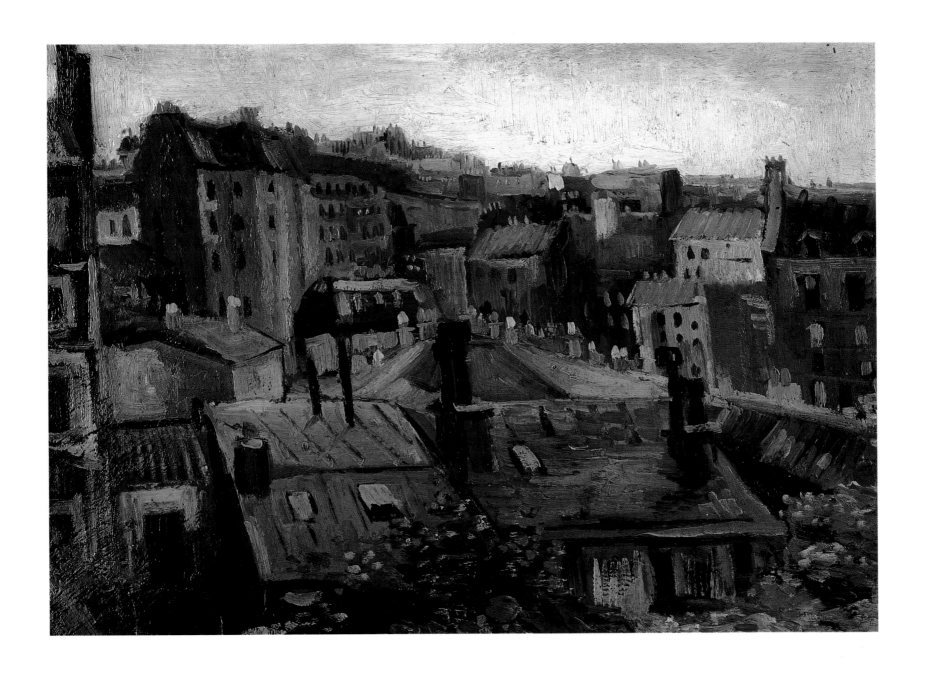

View of Paris Rooftops
May/June 1886
Oil on canvas
11¾×16 inches (30×41 cm)
Rijksmuseum Vincent van Gogh, Amsterdam

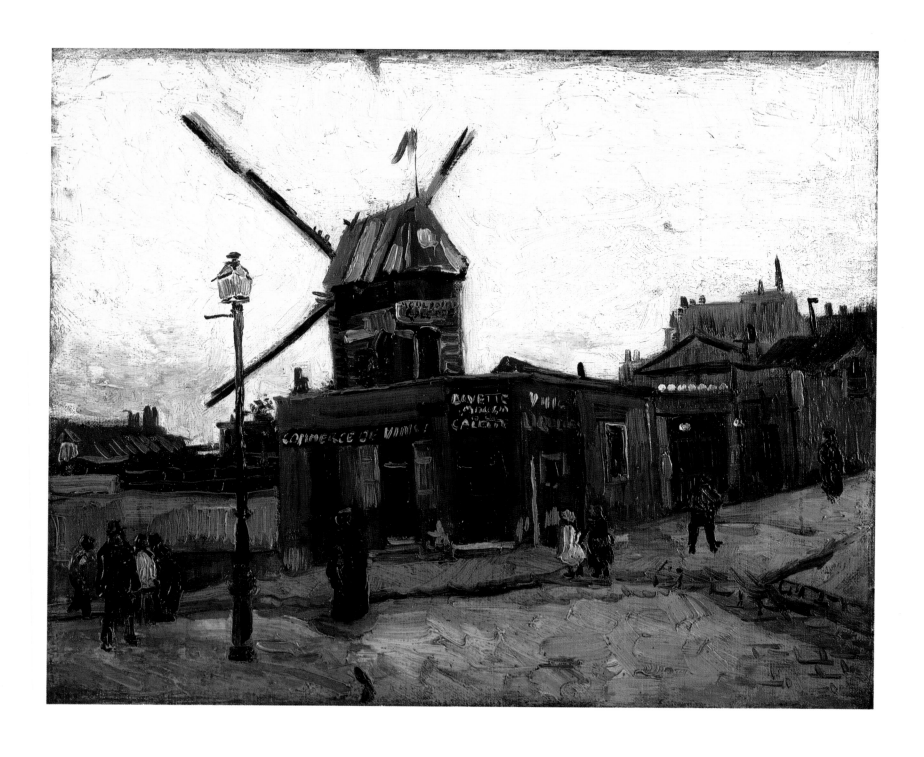

The Moulin de la Galette
c. October 1886
Oil on canvas
15×18 inches (38.5×46 cm)
Collection State Museum Kröller-Müller,
Otterlo, The Netherlands

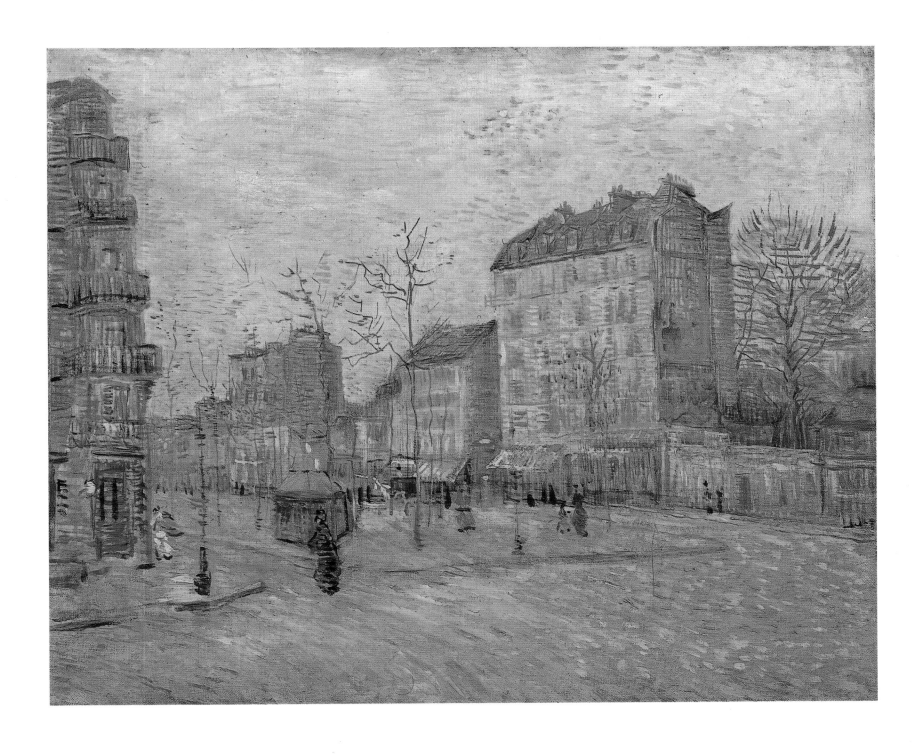

The Boulevard de Clichy
February/March 1887
Oil on canvas
18×21½ inches (46.5×55 cm)
Rijksmuseum Vincent van Gogh, Amsterdam

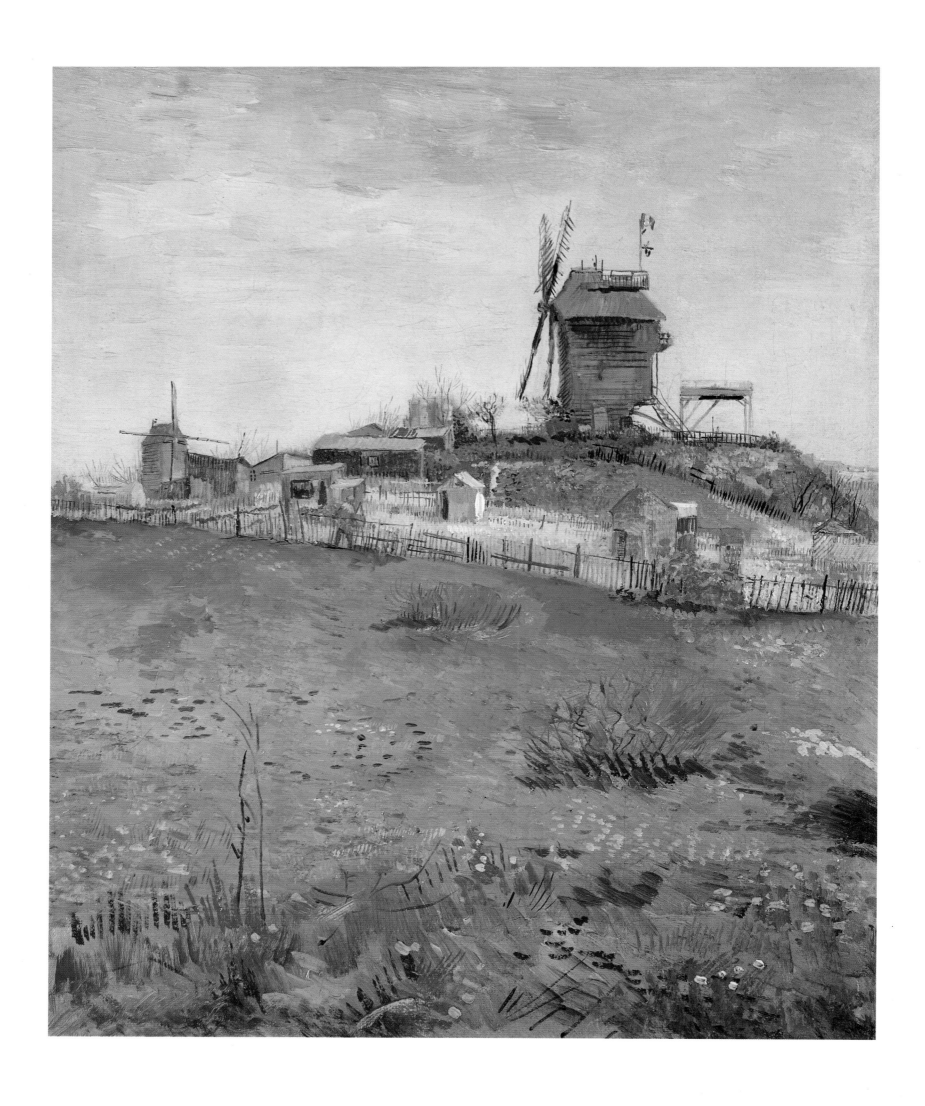

**The Moulin du Blute-Fin,
Montmartre** March 1887
Oil on canvas
18½×15½ inches (47×39.4 cm)
The Carnegie Museum of Art, Pittsburg

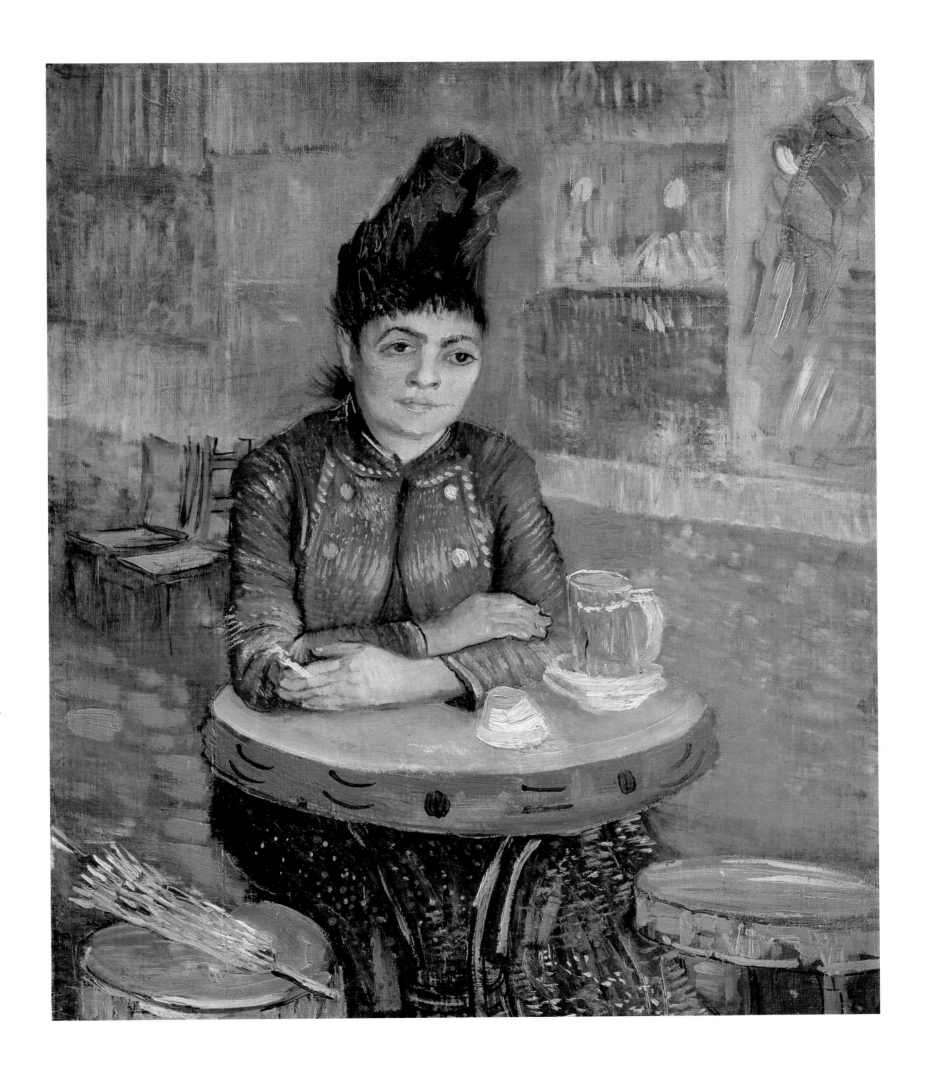

Woman at the Café du Tambourin (Agostina Segatori) spring 1887
Oil on canvas
21¾×18¼ inches (55.5×46.5 cm)
Rijksmuseum Vincent van Gogh, Amsterdam

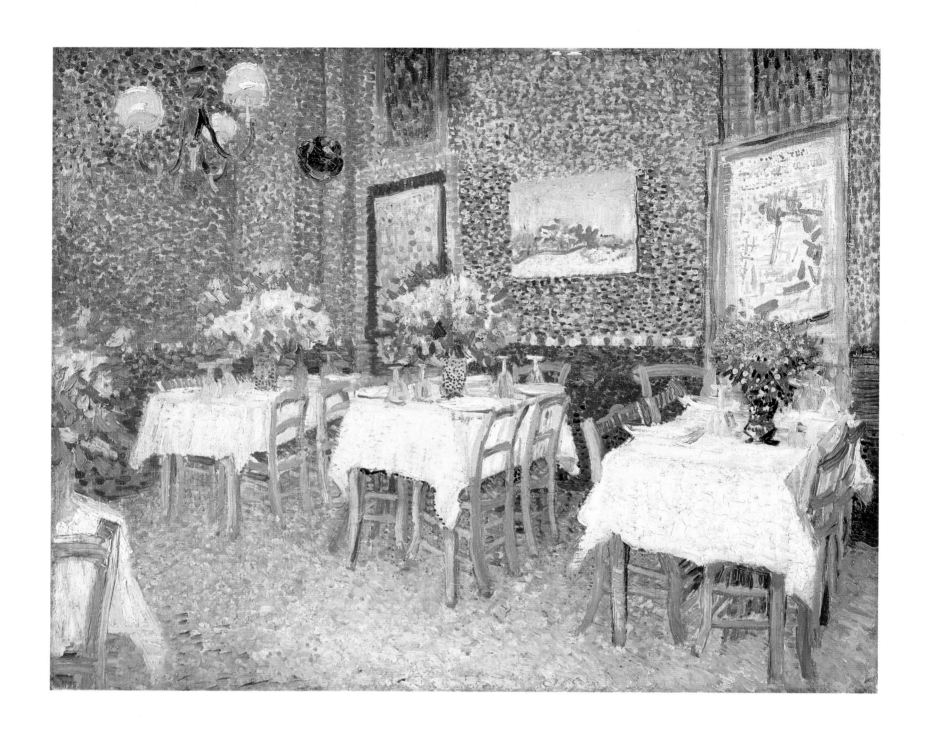

Interior of a Restaurant
summer 1887
Oil on canvas
17¾×22 inches (45.5×56.5 cm)
Collection State Museum Kröller-Müller,
Otterlo, The Netherlands

**The Restaurant de la Sirène
at Asnières** 1887
Oil on canvas
21×25⅜ inches (54×65 cm)
Musée d'Orsay, Paris

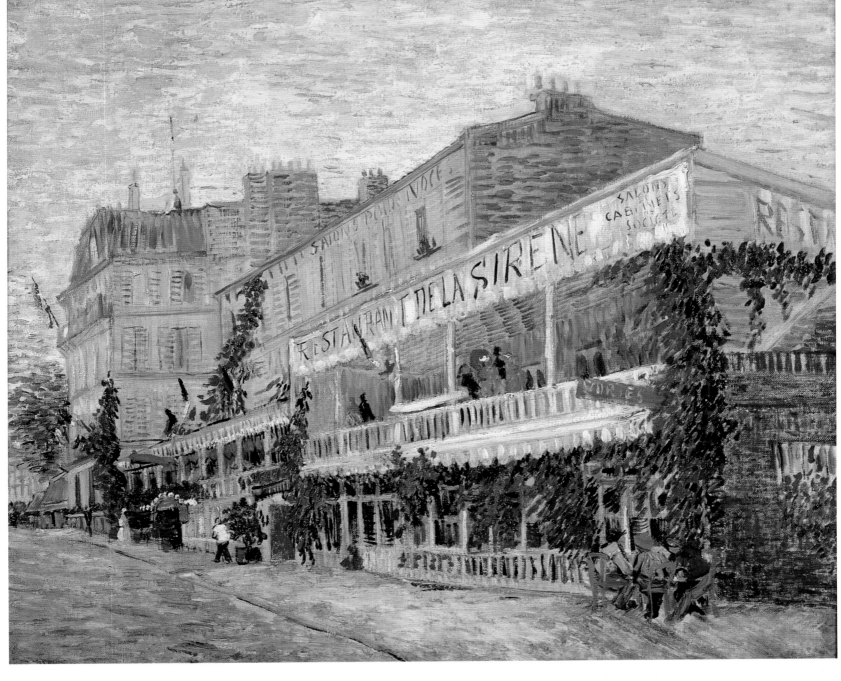

Riverbank in Springtime

summer 1887
Oil on canvas
19×22½ inches (50×60 cm)
Dallas Museum of Arts

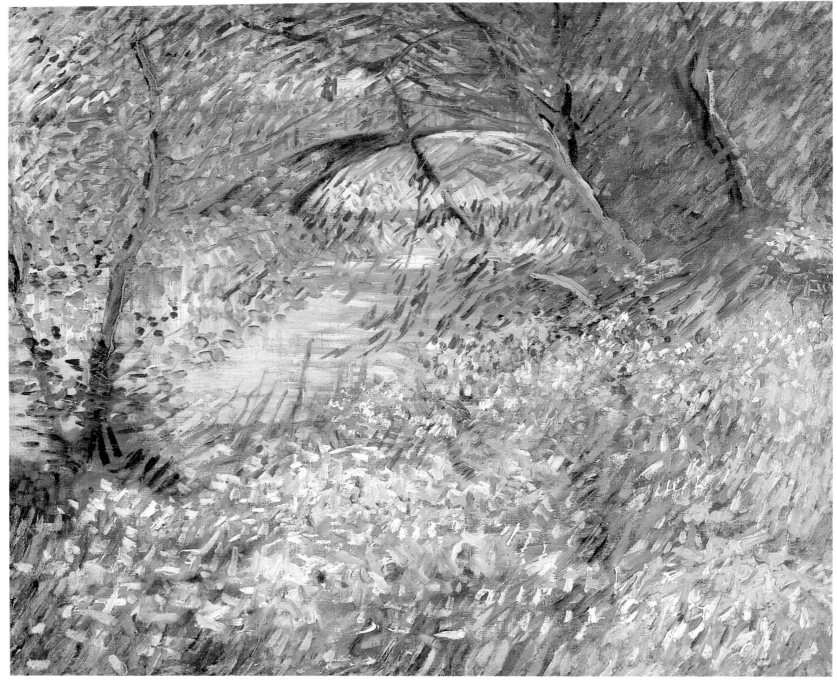

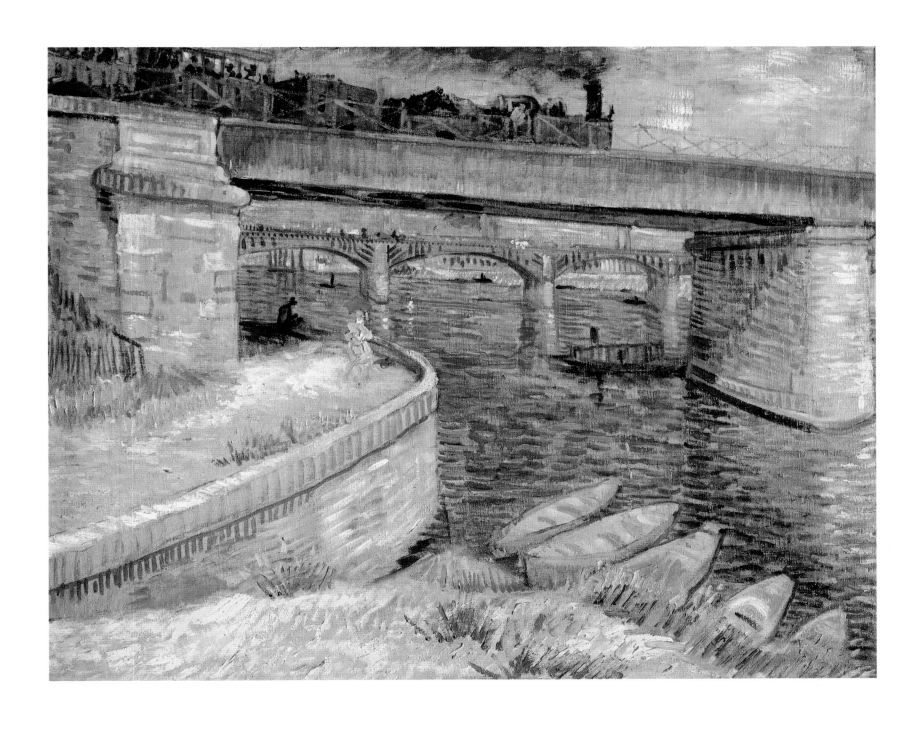

Bridges at Asnières summer
1887
Oil on canvas
20½×25½ inches (52×65 cm)
Foundation E G Bührle, Collection Zurich

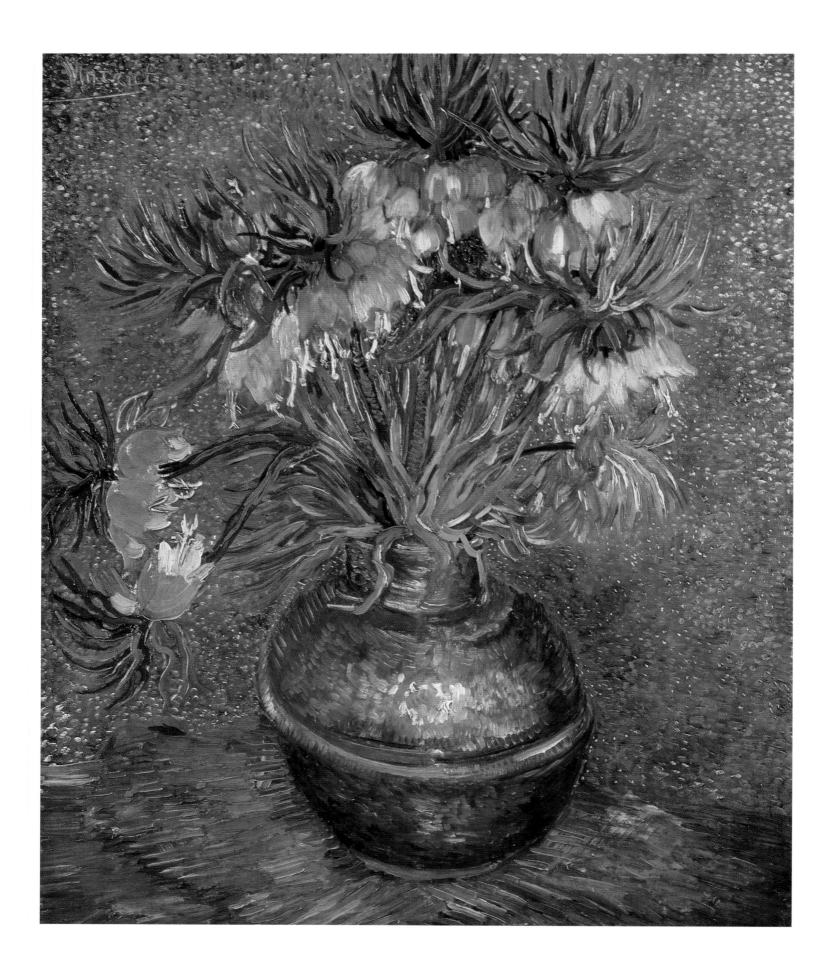

Fritillaries in a Copper Vase
summer 1887
Oil on canvas
29×23¾ inches (73.5×60.5 cm)
Musée d'Orsay, Paris

Portrait of Père Tanguy
autumn 1887
Oil on canvas
36¼×18¾ inches (93×73 cm)
Musée Rodin, Paris

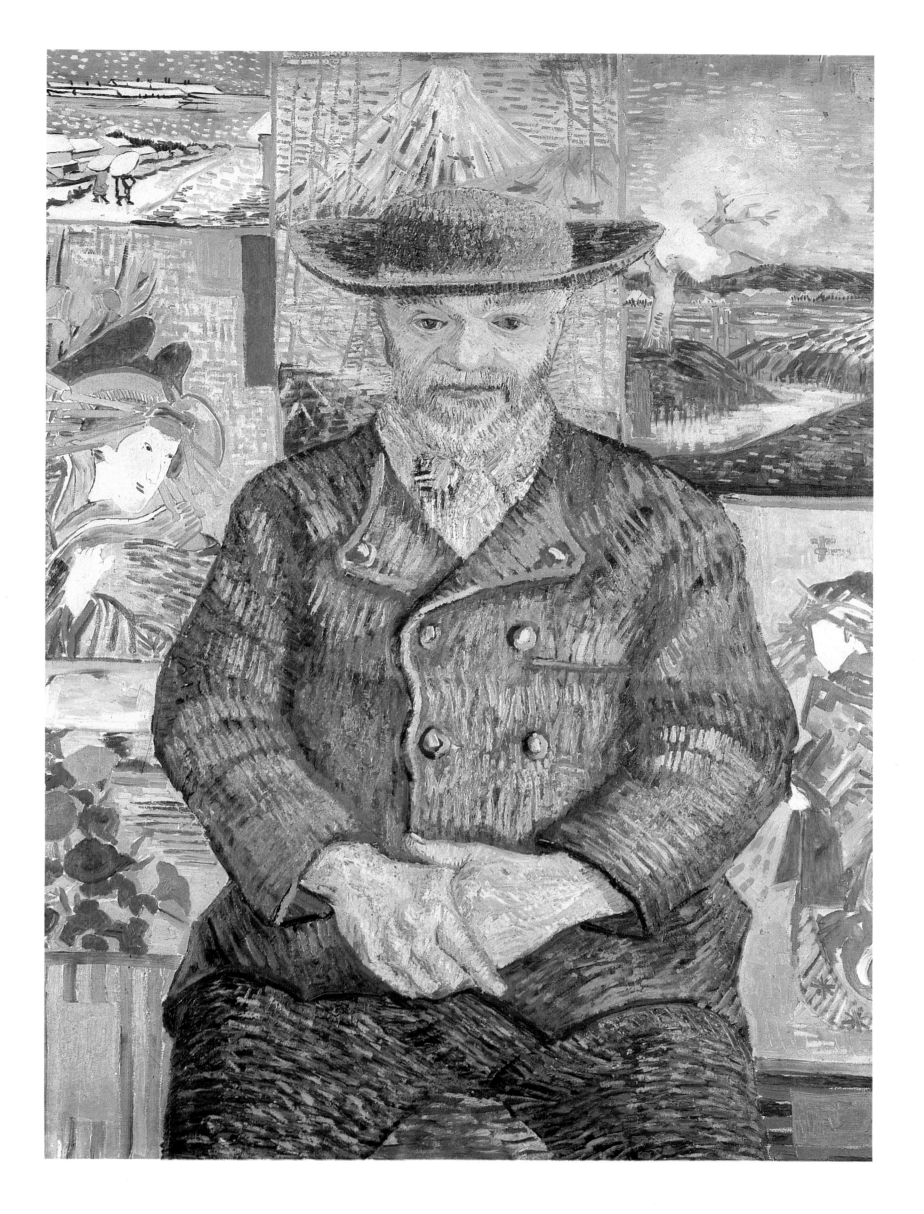

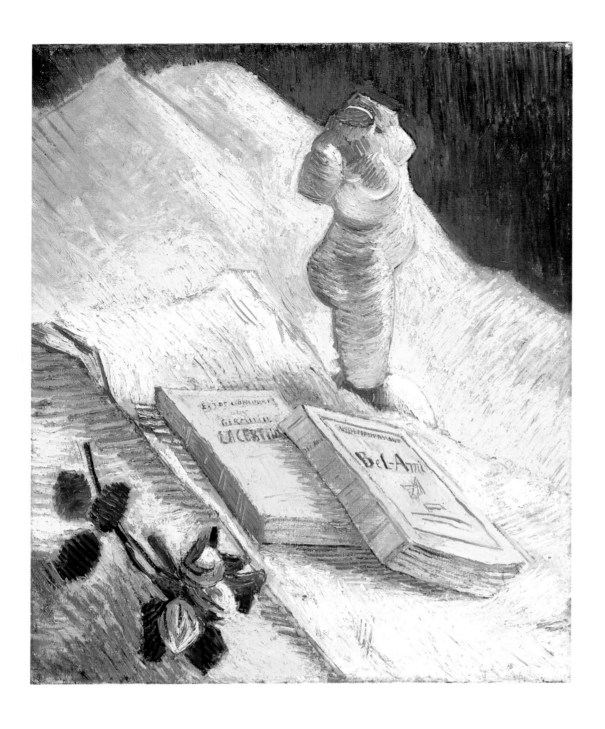

**Still Life with Plaster
Statuette and Two Novels**
autumn 1887
Oil on canvas
21¾×18¼ inches (55×46.5 cm)
*Collection State Museum Kröller-Müller,
Otterlo, The Netherlands*

**Japonaiserie – Bridge in the
Rain (after Hiroshige)** late 1887
Oil on canvas
28¾×21¼ inches (73×54 cm)
Rijksmuseum Vincent van Gogh, Amsterdam

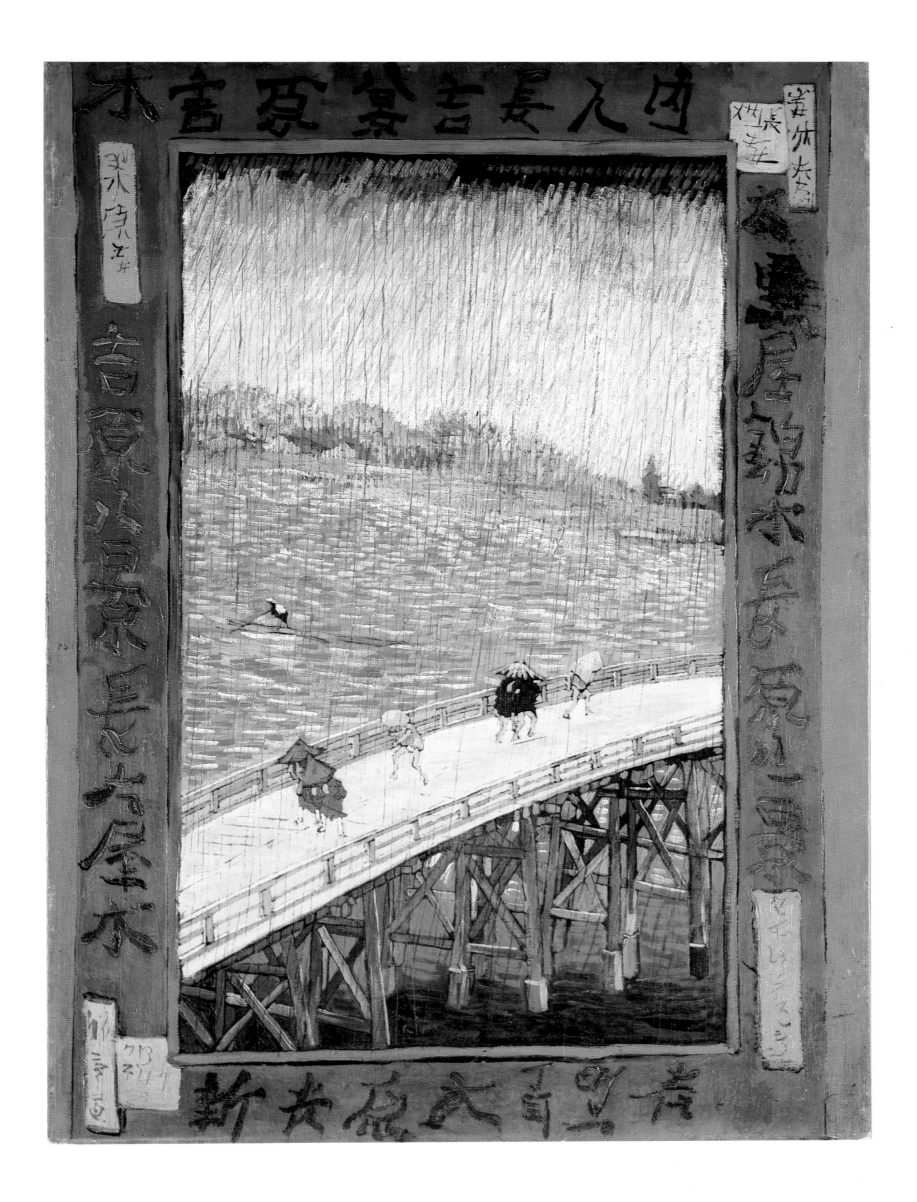

47

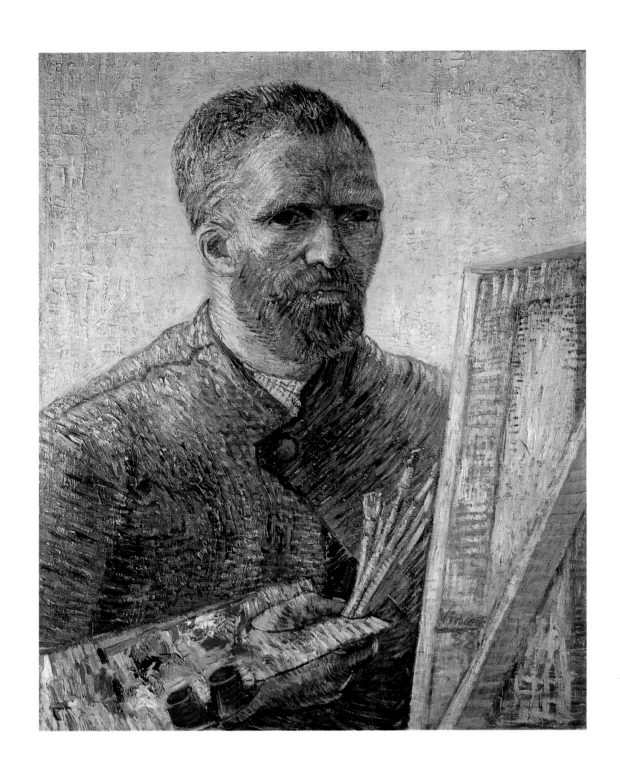

Self-Portrait with Easel early
1888
Oil on canvas
25½×20 inches (65×50.5 cm)
Rijksmuseum Vincent van Gogh, Amsterdam

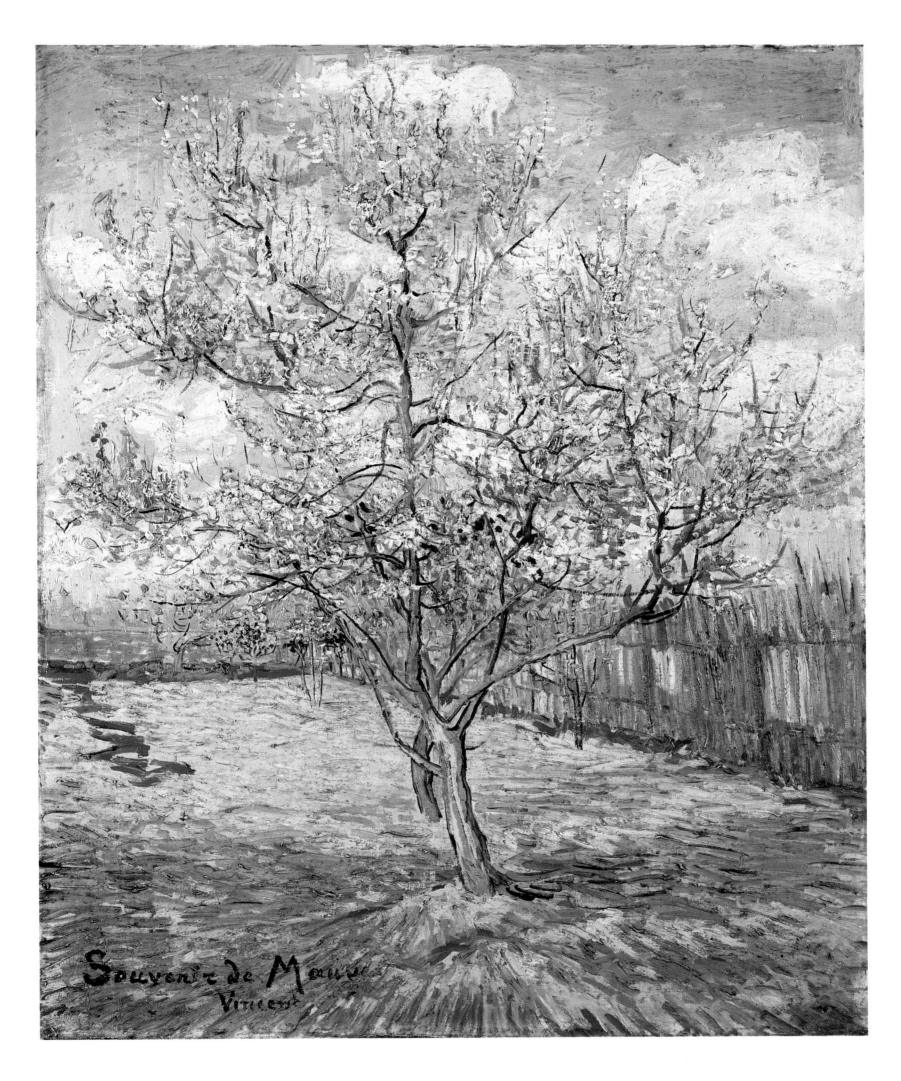

**Pink Peach Tree in Blossom
(In Memory of Mauve)** March
1888
Oil on canvas
28¾×23½ inches (73×59.5 cm)
Rijksmuseum Vincent van Gogh, Amsterdam

The Langlois Bridge with Women Washing March 1888
Oil on canvas
21¼×25½ inches (54×65 cm)
Collection State Museum Kröller-Müller,
Otterlo, The Netherlands

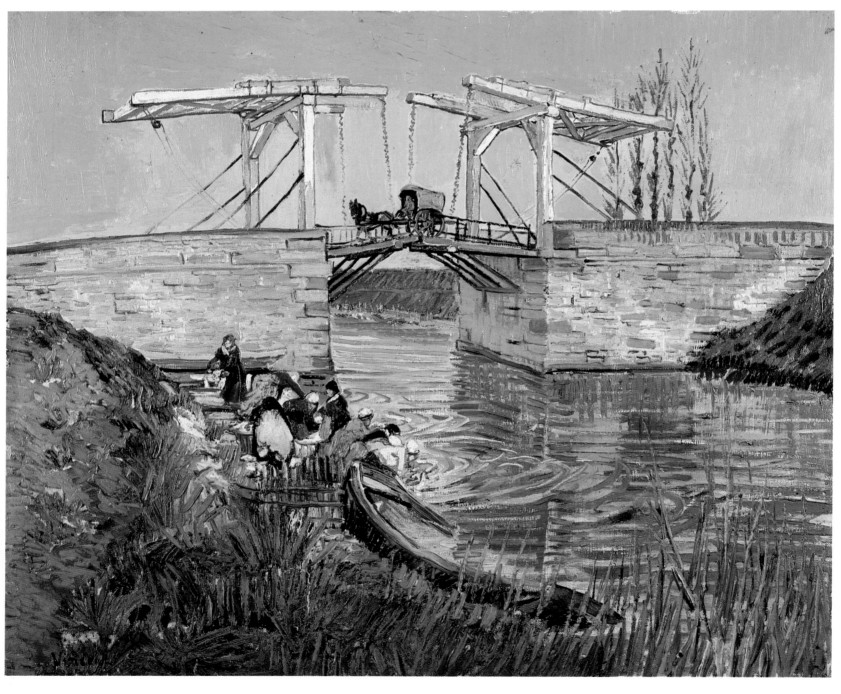

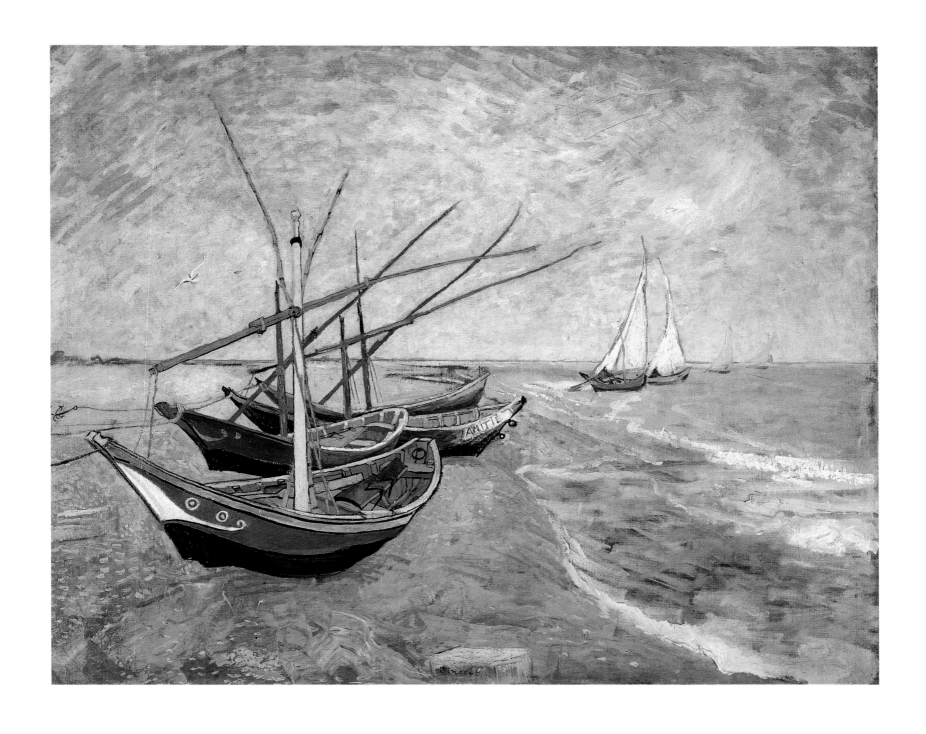

**Boats on the Beach at
Saintes-Maries** June 1888
Oil on canvas
25½×31¾ inches (64.5×81 cm)
Rijksmuseum Vincent van Gogh, Amsterdam

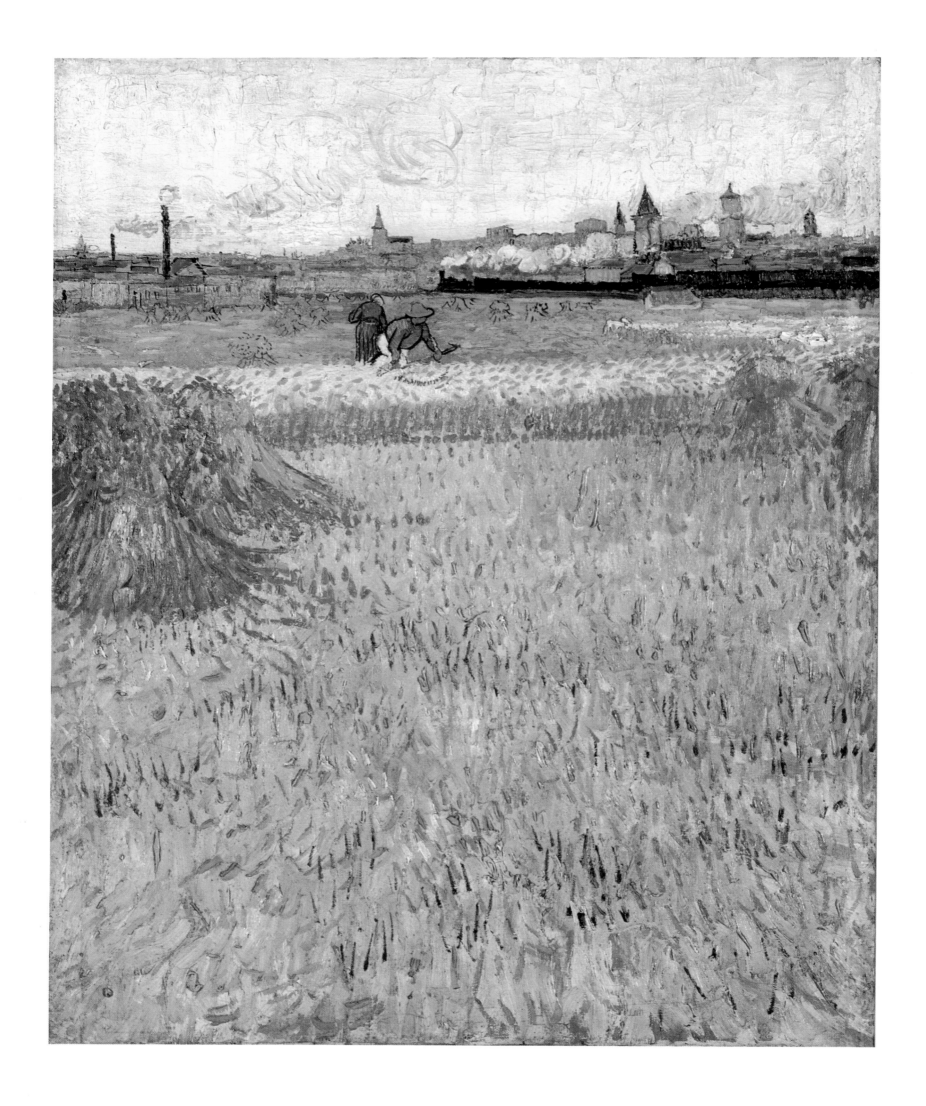

**The Mowers, Arles in the
Background** June 1888
Oil on canvas
28¾×21¼ inches (73×54 cm)
Musée Rodin, Paris

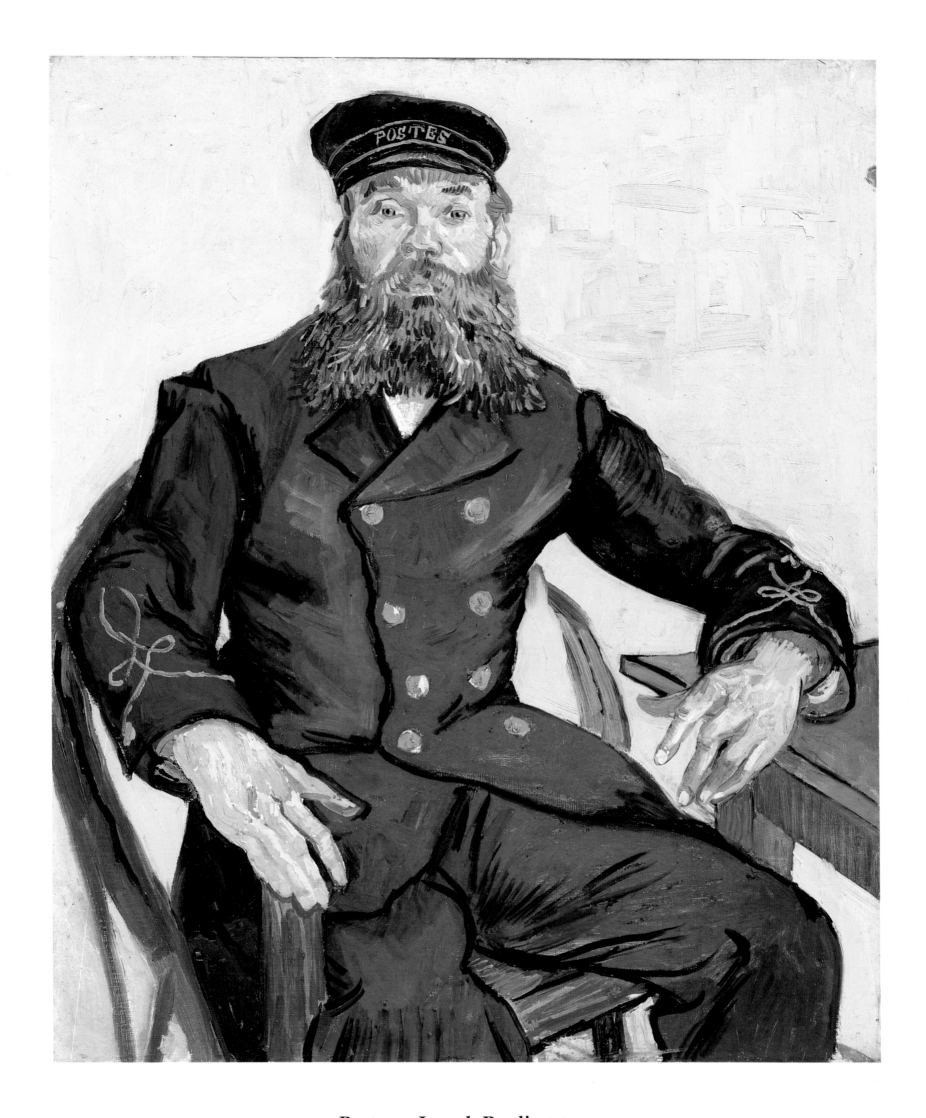

Postman Joseph Roulin July
1888
Oil on canvas
32×25¾ inches (81.2×65.3 cm)
Museum of Fine Arts, Boston

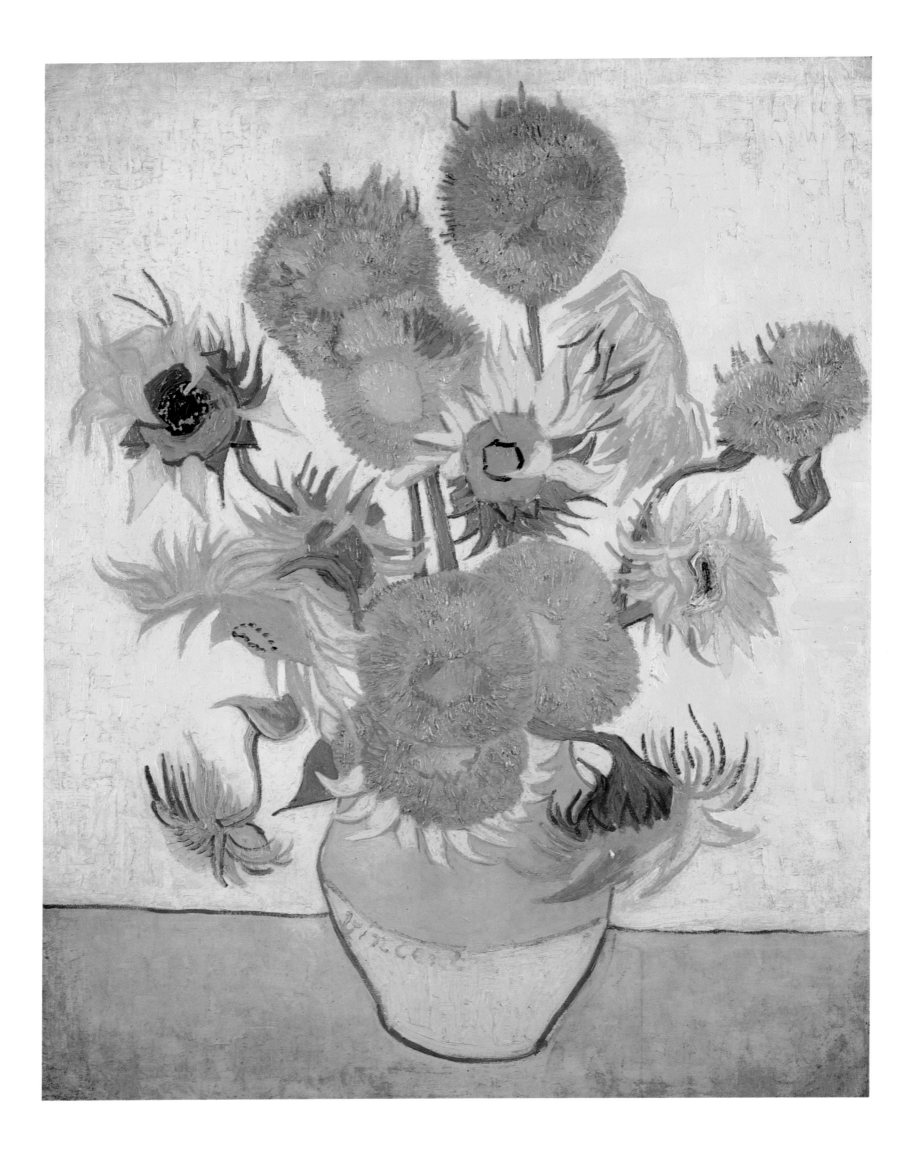

Fourteen Sunflowers August
1888
Oil on canvas
36½×28¾ inches (93×73 cm)
*Courtesy of the Trustees of the National
Gallery, London*

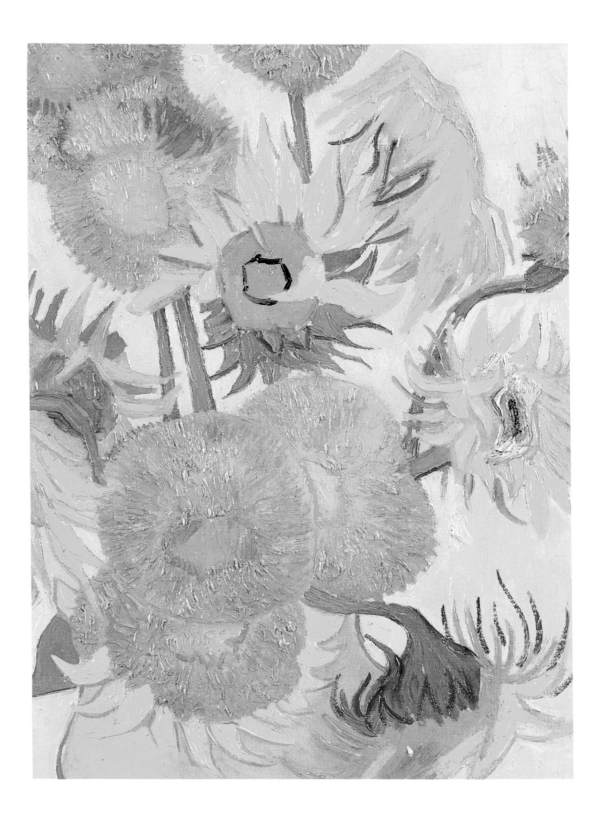

Haystacks in Provence June
1888
Oil on canvas
28¾×36 inches (73×92.5 cm)
Collection State Museum Kröller-Müller,
Otterlo, The Netherlands

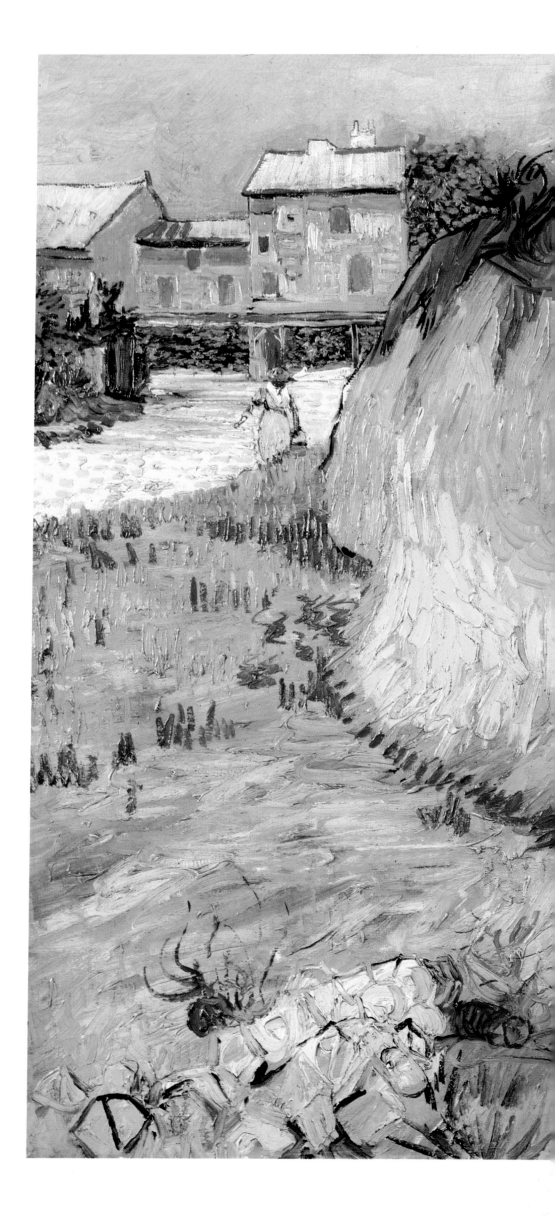

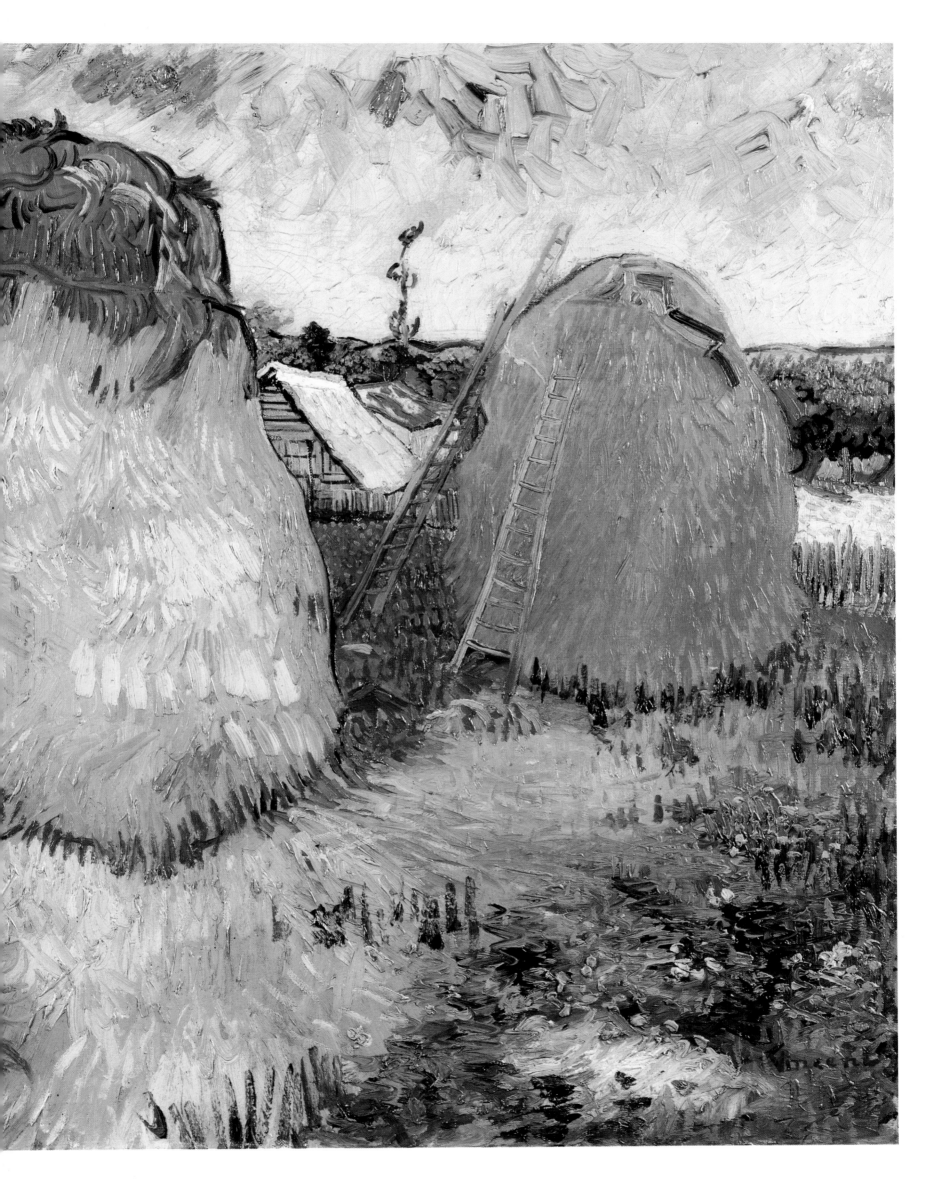

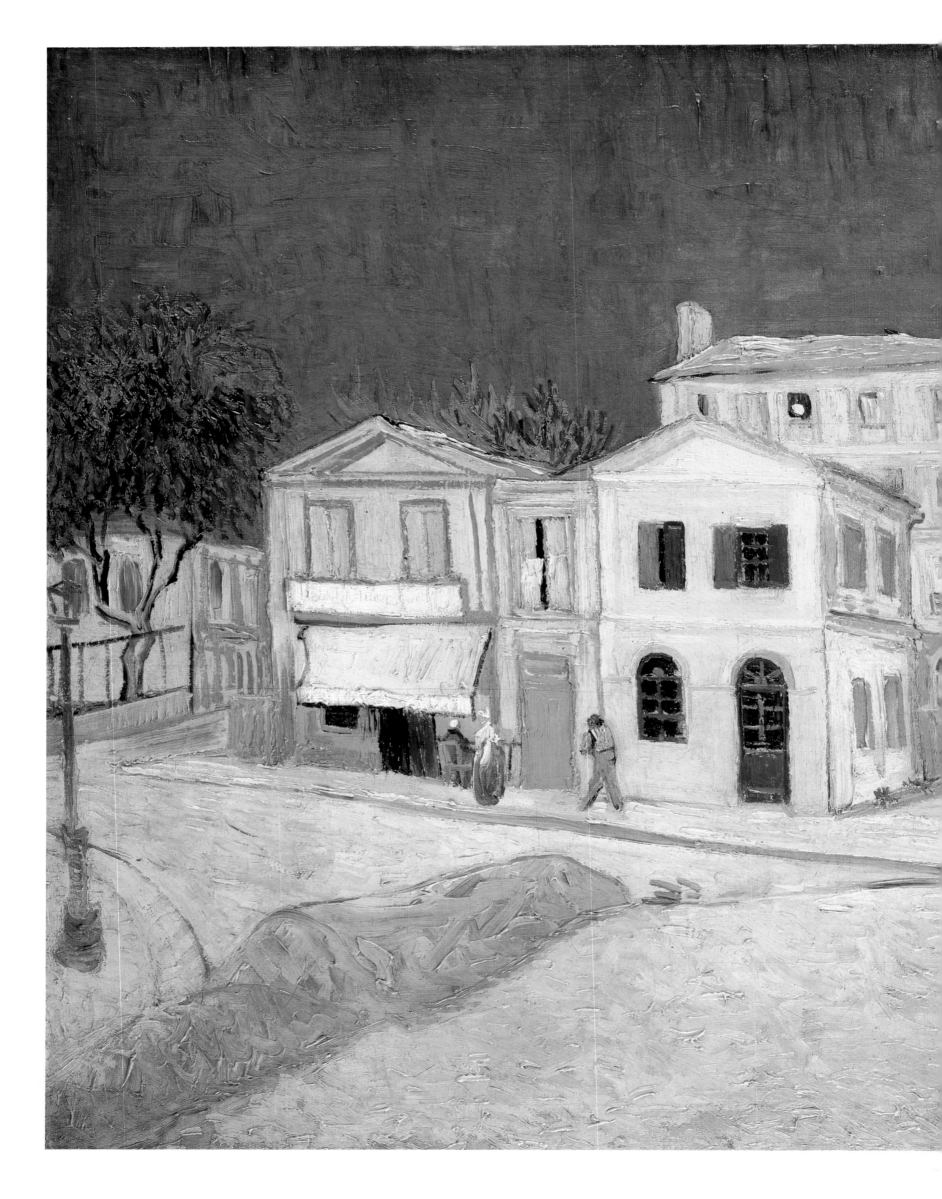

The Yellow House in Arles
September 1888
Oil on canvas
30×37 inches (76×94 cm)
Rijksmuseum Vincent van Gogh, Amsterdam

The Night Café September 1888
Oil on canvas
27½×35 inches (70×89 cm)
Yale University Art Gallery, New Haven,
Connecticut

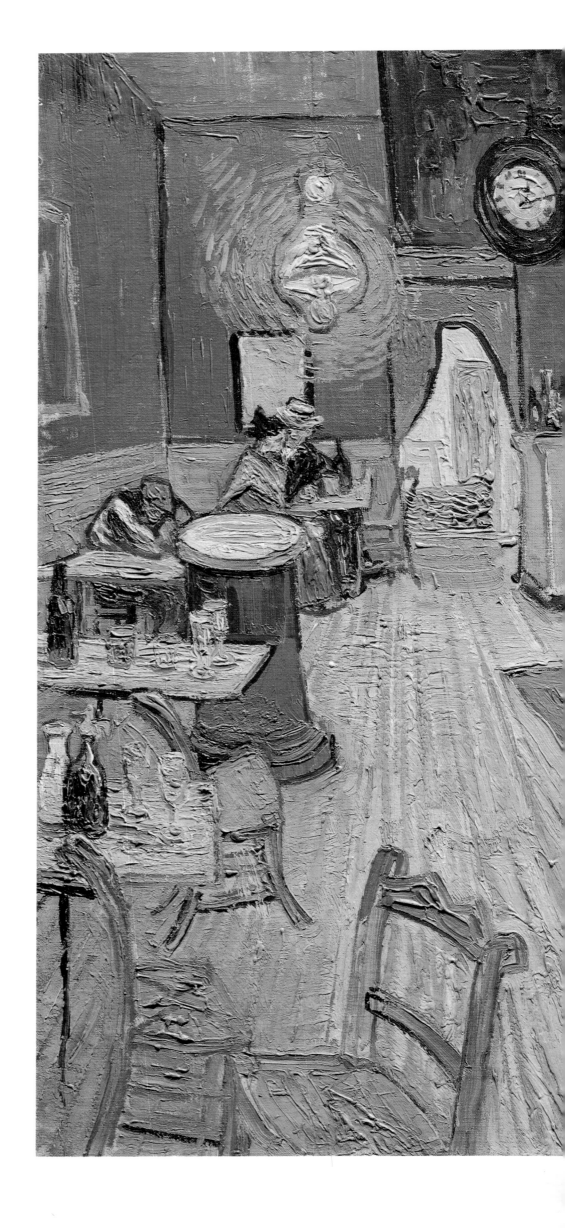

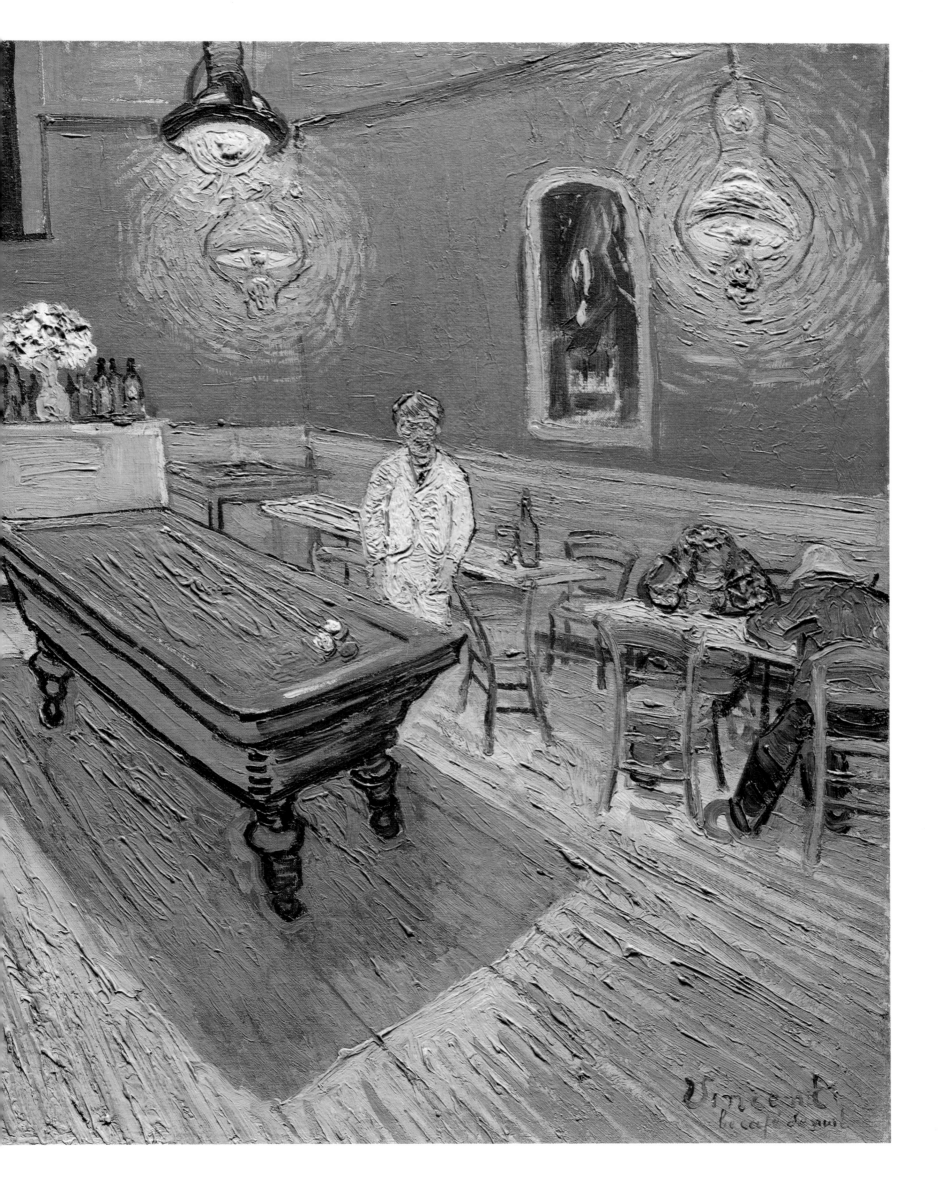

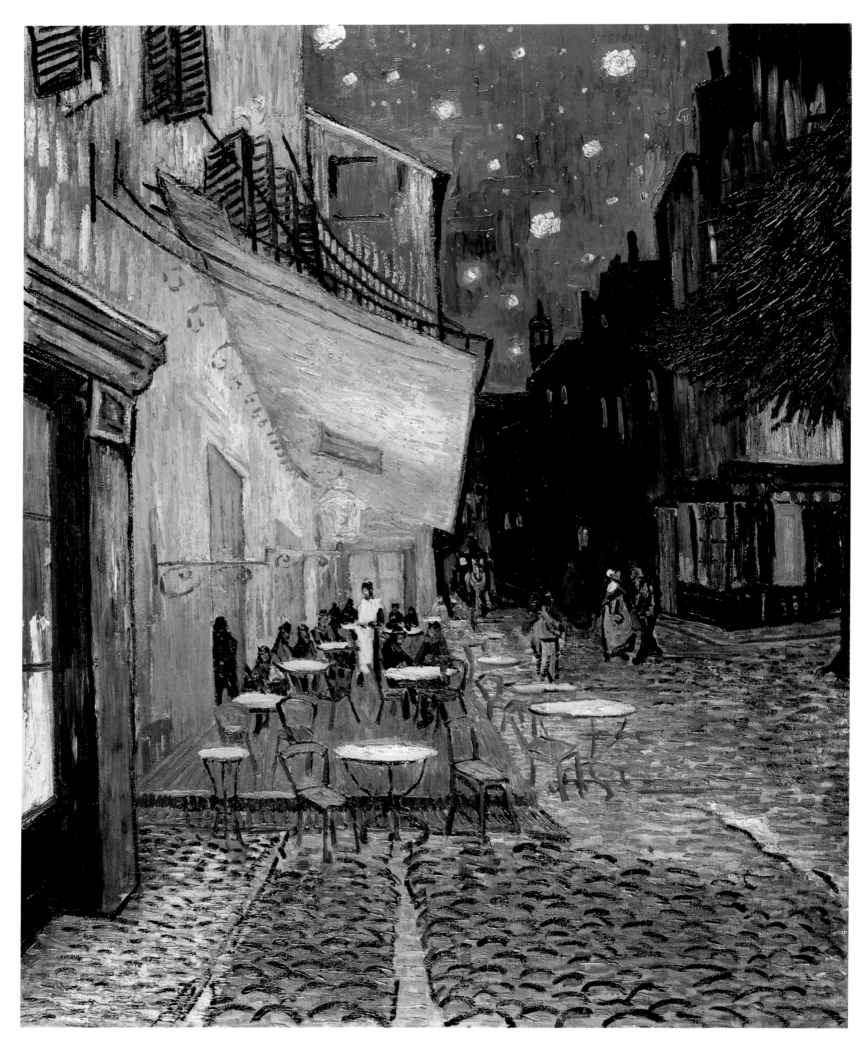

**The Café Terrace, Arles at
Night** September 1888
Oil on canvas
32×25¾ inches (81×64.5 cm)
*Collection State Museum Kröller-Müller,
Otterlo, The Netherlands*

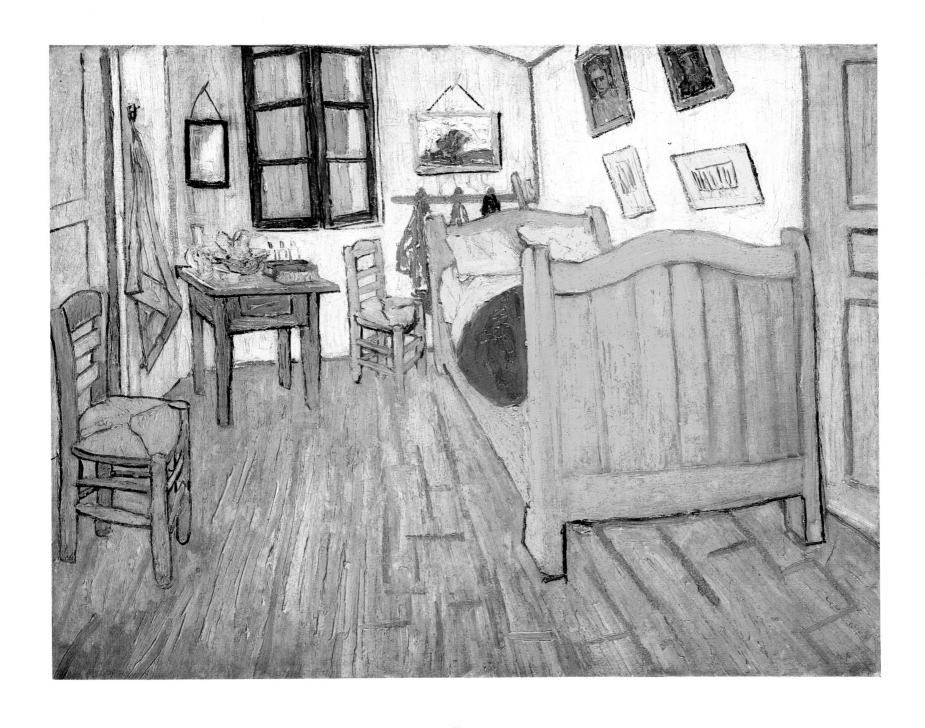

Van Gogh's Bedroom October
1888
Oil on canvas
28¼×35½ inches (72×90 cm)
Rijksmuseum Vincent van Gogh, Amsterdam

The Sower November 1888
Oil on canvas
12½×15¾ inches (32×40 cm)
Rijksmuseum Vincent van Gogh, Amsterdam

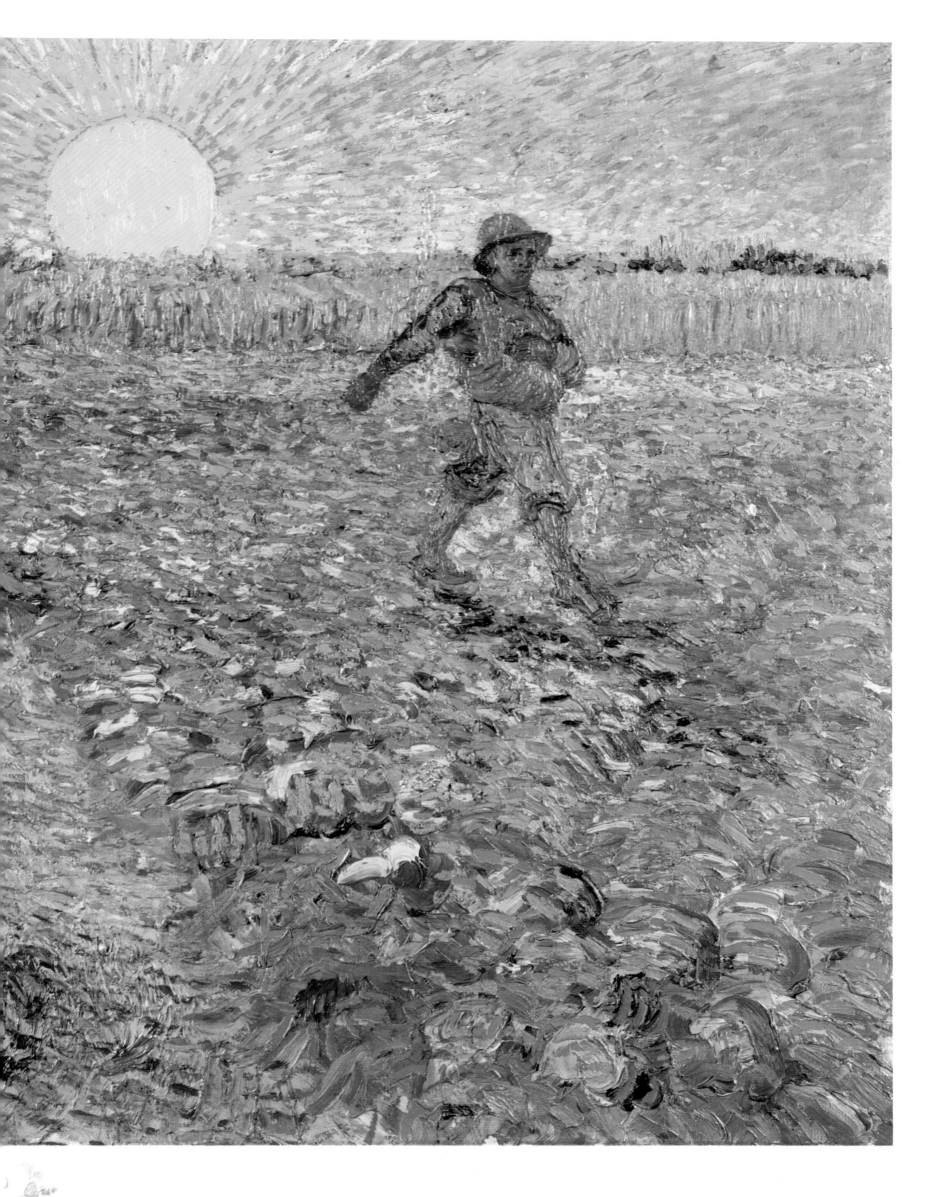

Les Alyscamps November 1888
Oil on canvas
28¾×36¼ inches (73×92 cm)
Collection State Museum Kröller-Müller,
Otterlo, The Netherlands

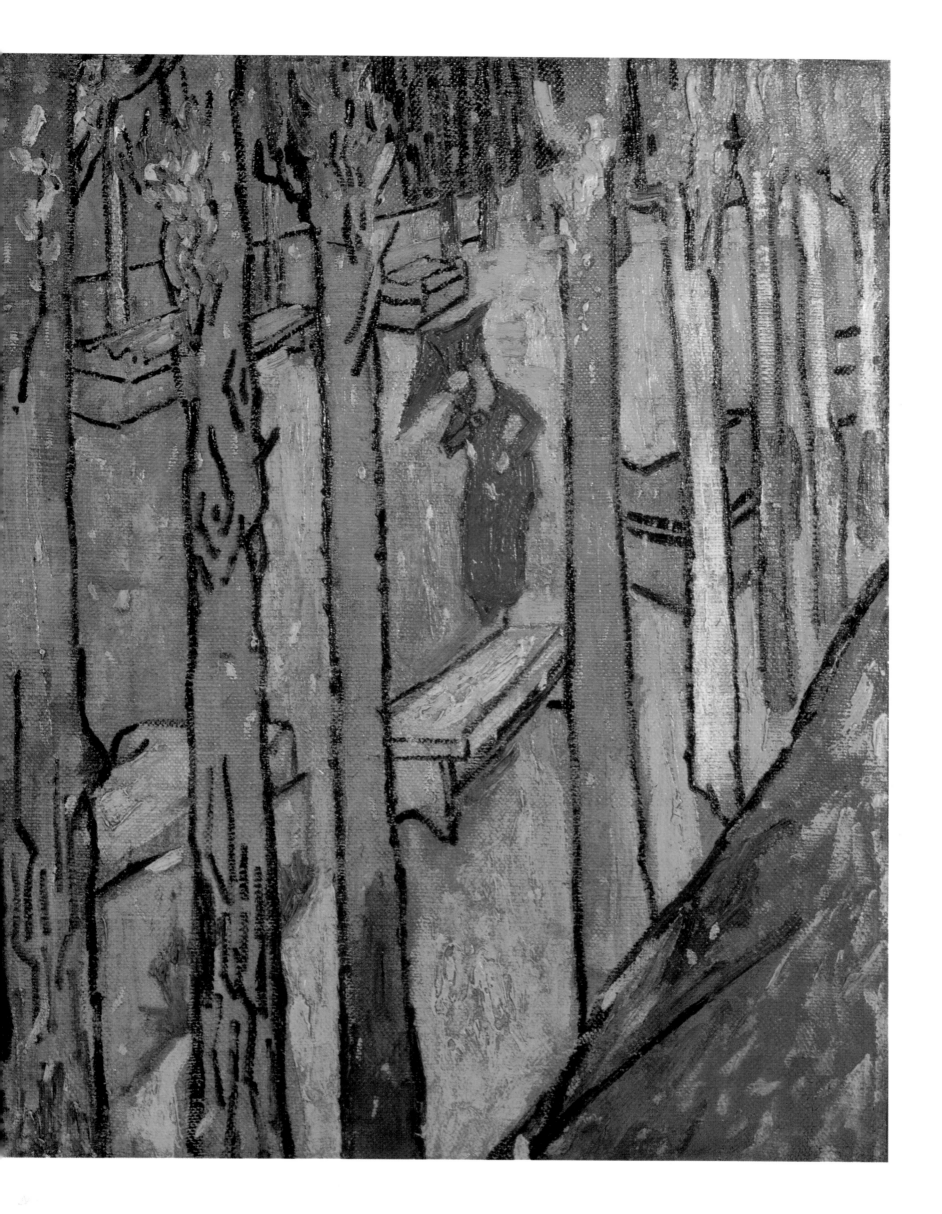

The Red Vineyard November
1888
Oil on canvas
29½×36½ inches (75×93 cm)
Pushkin Museum of Fine Art, Moscow

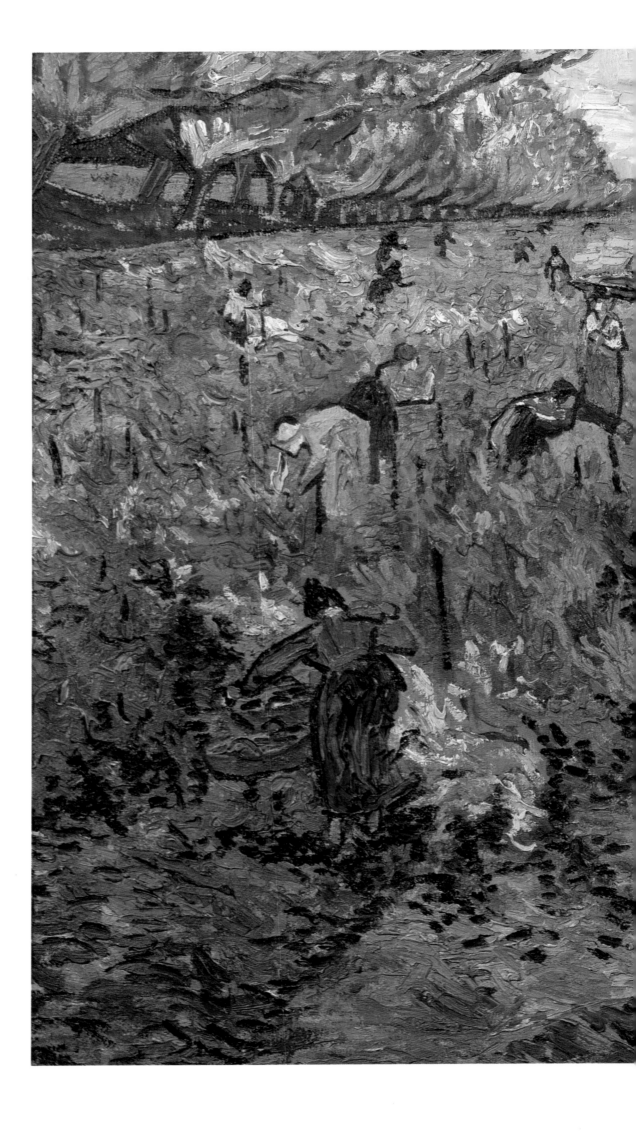

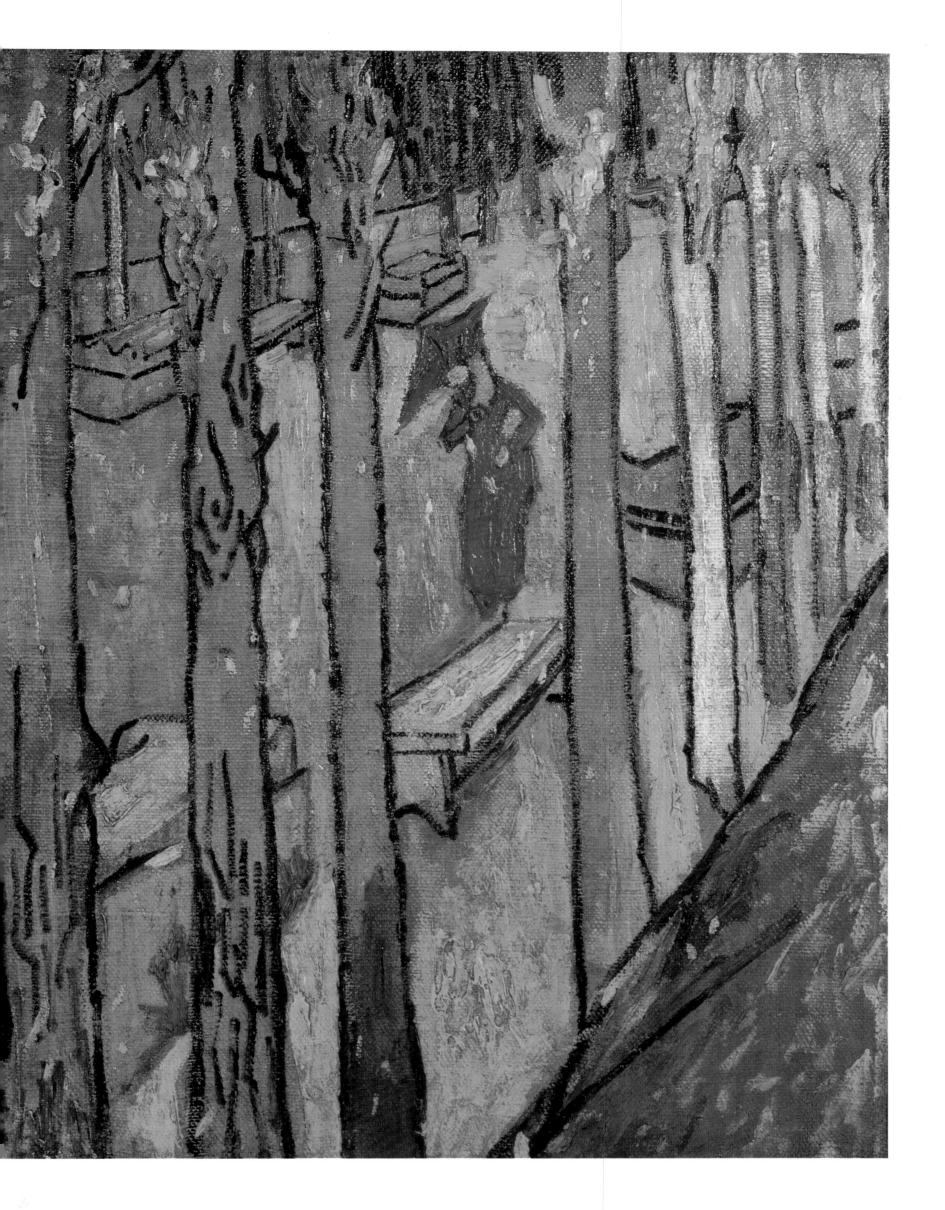

The Red Vineyard November
1888
Oil on canvas
29½×36½ inches (75×93 cm)
Pushkin Museum of Fine Art, Moscow

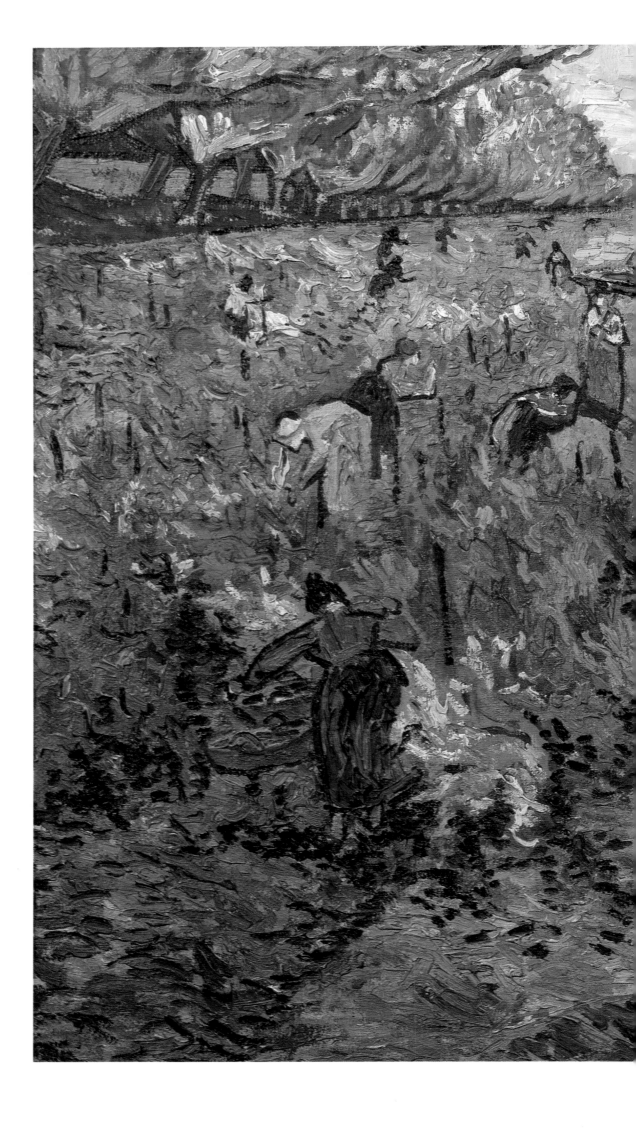

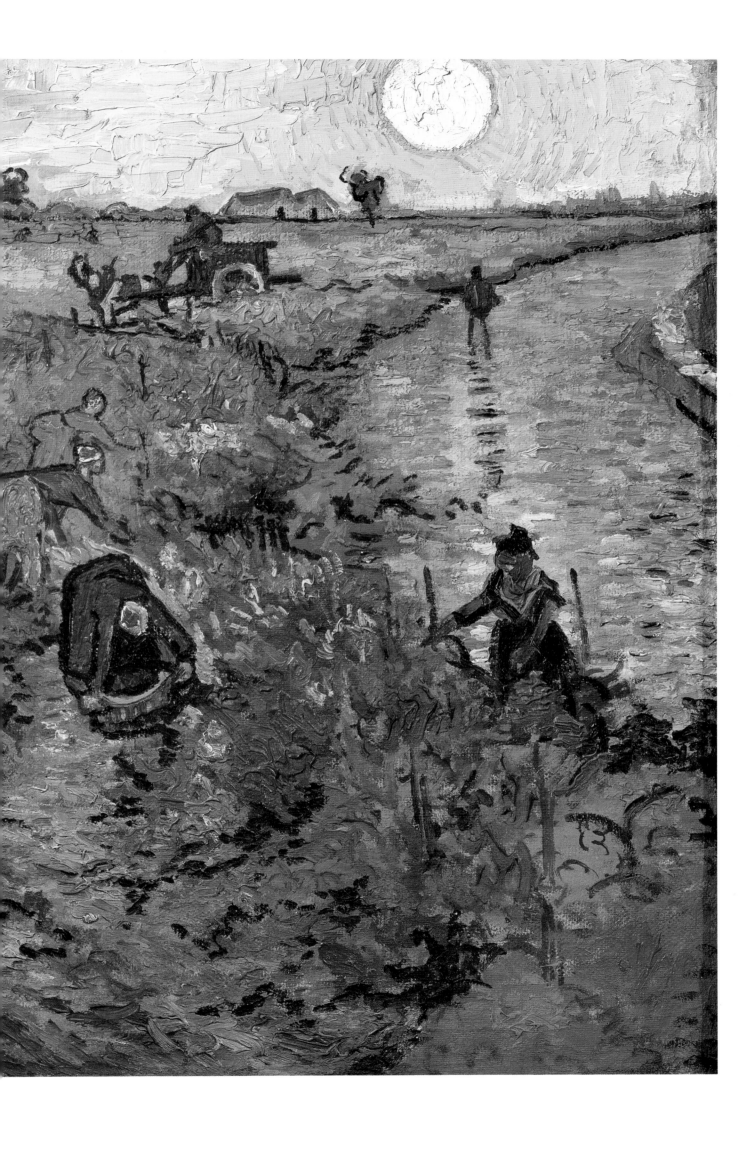

**Promenade at Arles: Memory
of the Garden at Etten**
November 1888
Oil on canvas
29×36½ inches (73.5×92.5 cm)
The Hermitage Museum, Leningrad

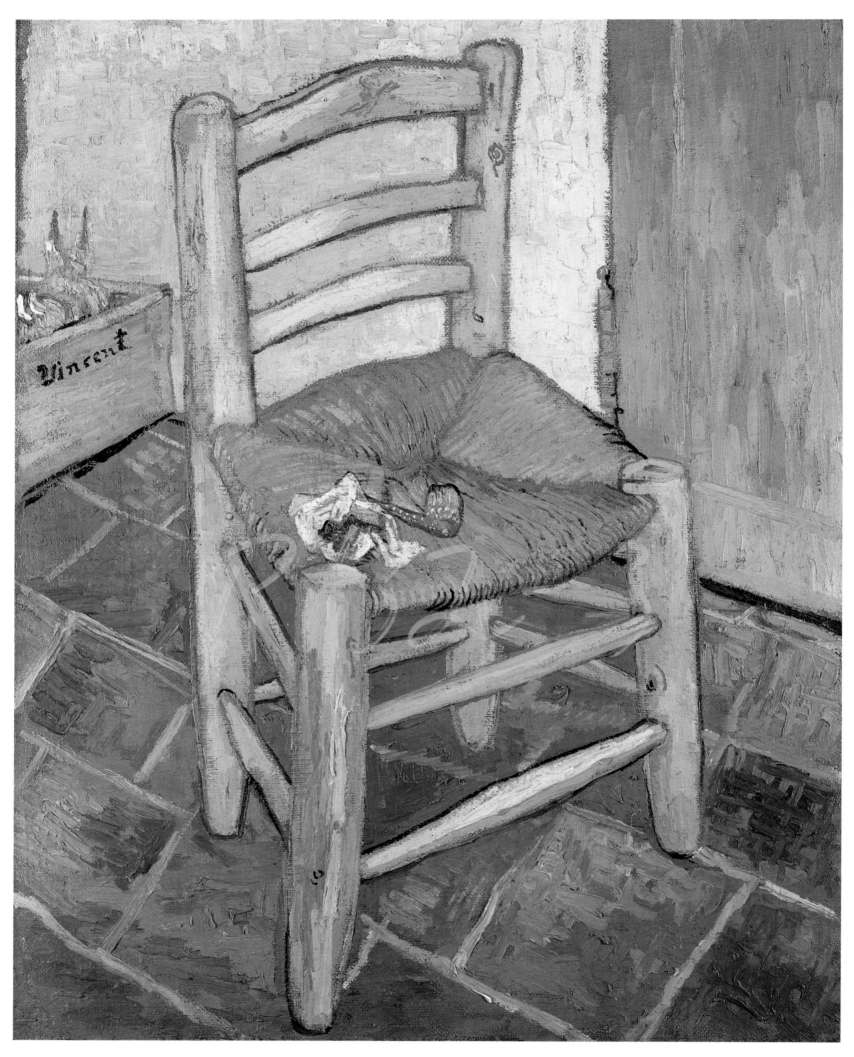

Van Gogh's Chair December
1888
Oil on canvas
36½×29 inches (93×73.5 cm)
*Courtesy of the Trustees of the National
Gallery, London*

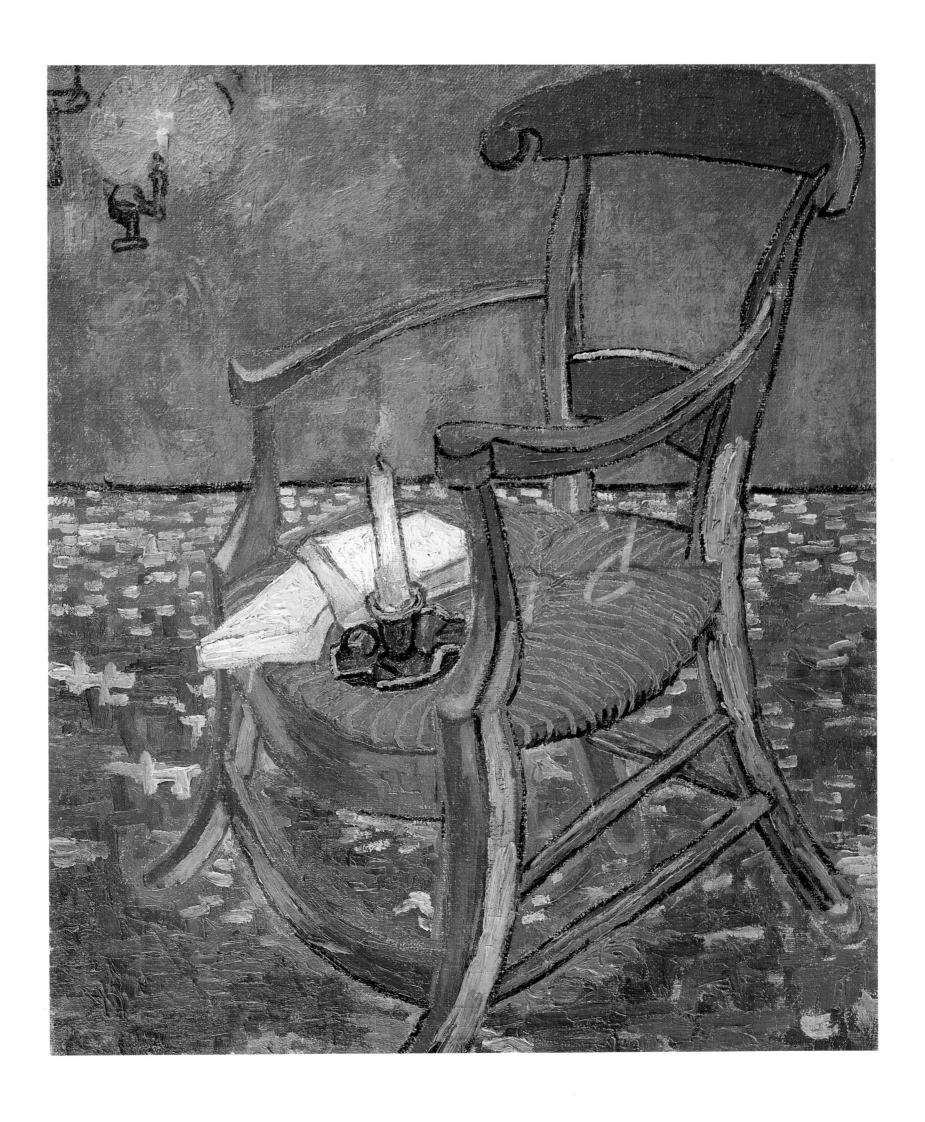

Gauguin's Chair December 1888
Oil on canvas
36½×28¼ inches (90.5×72 cm)
Rijksmuseum Vincent van Gogh, Amsterdam

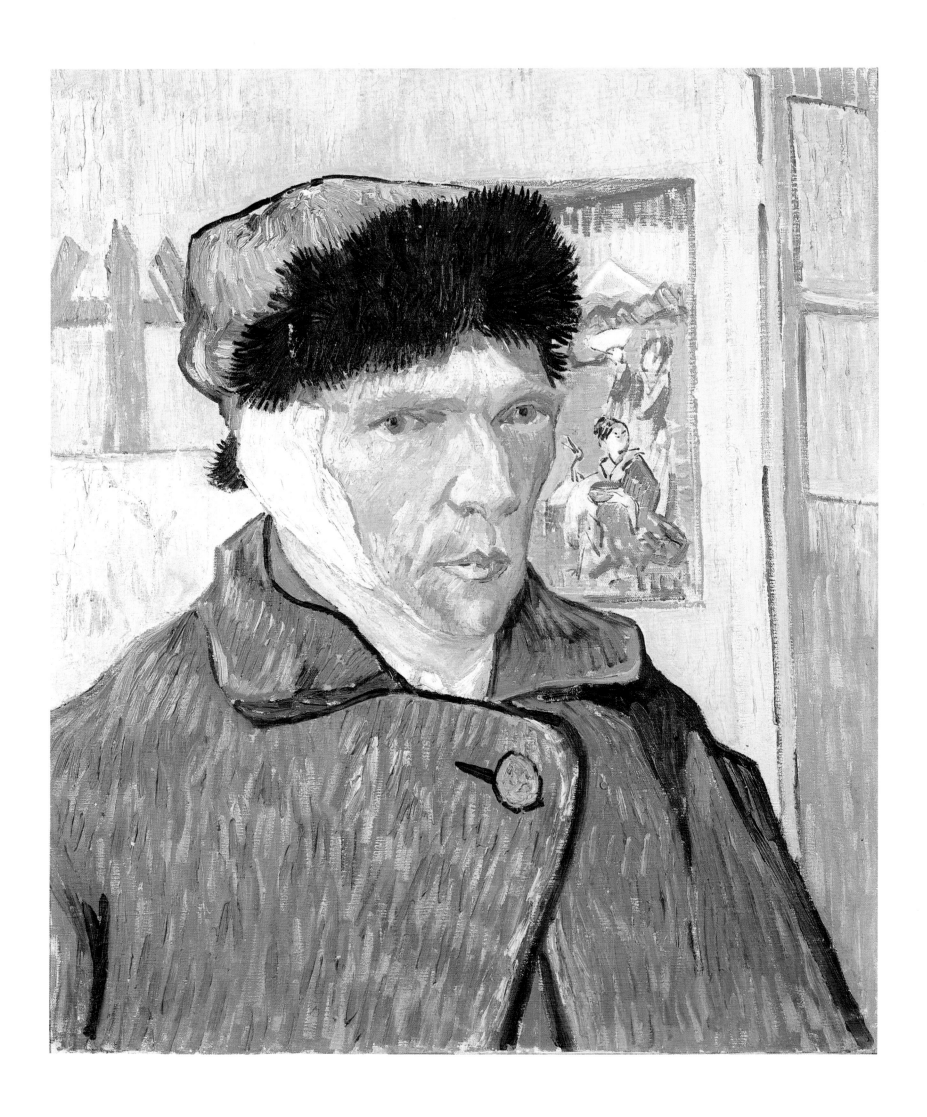

**Self-Portrait with Bandaged
Ear** January 1889
Oil on canvas
23½×19¼ inches (60×49 cm)
Courtauld Institute Galleries, London

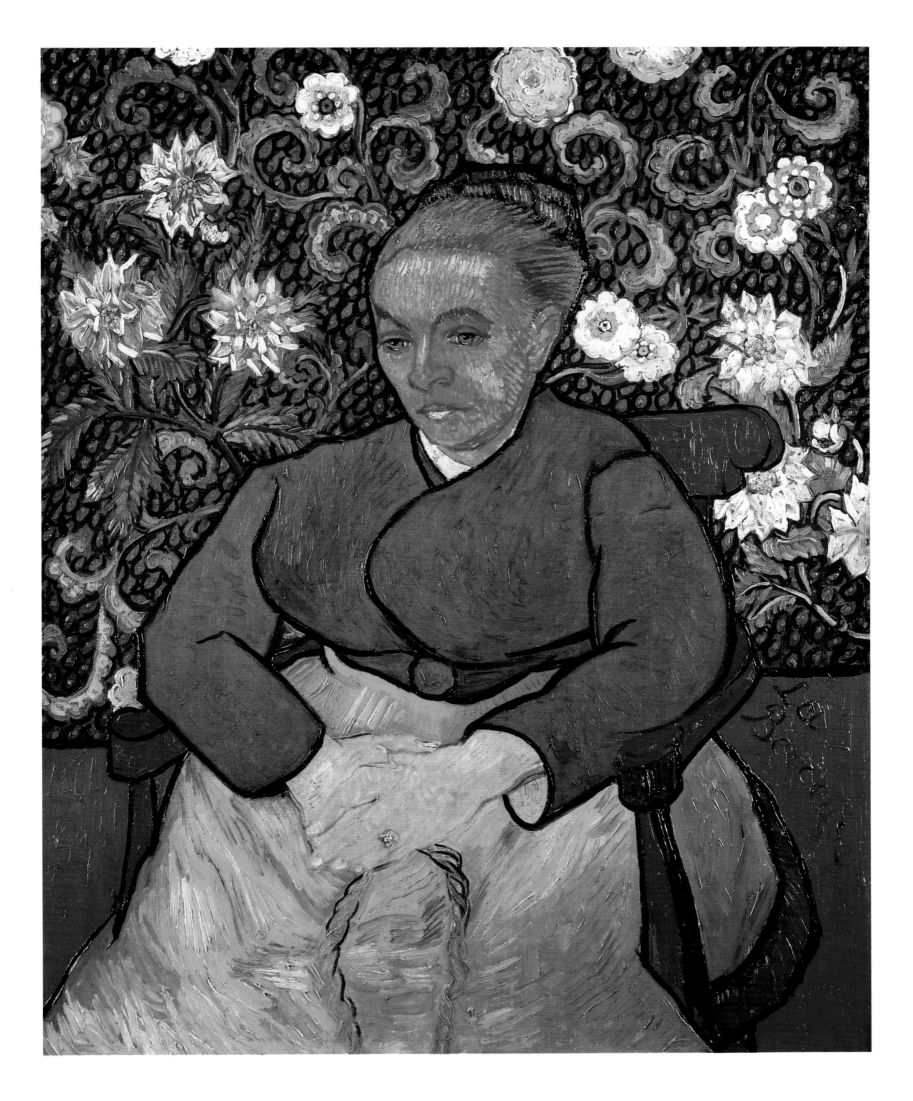

**La Berceuse: Madame
Augustine Roulin** January 1889
Oil on canvas
36¼×28¾ inches (92×73 cm)
Rijksmuseum Kröller-Müller, Otterlo

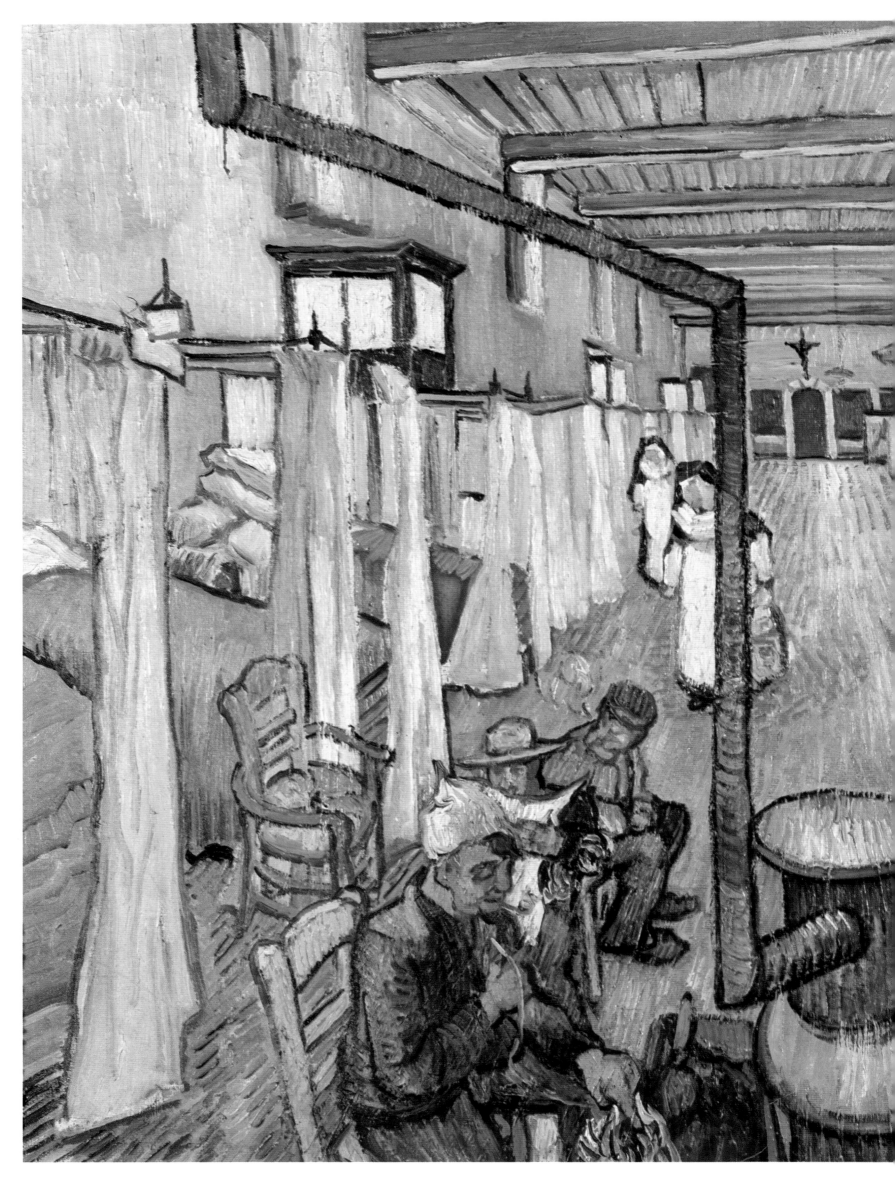

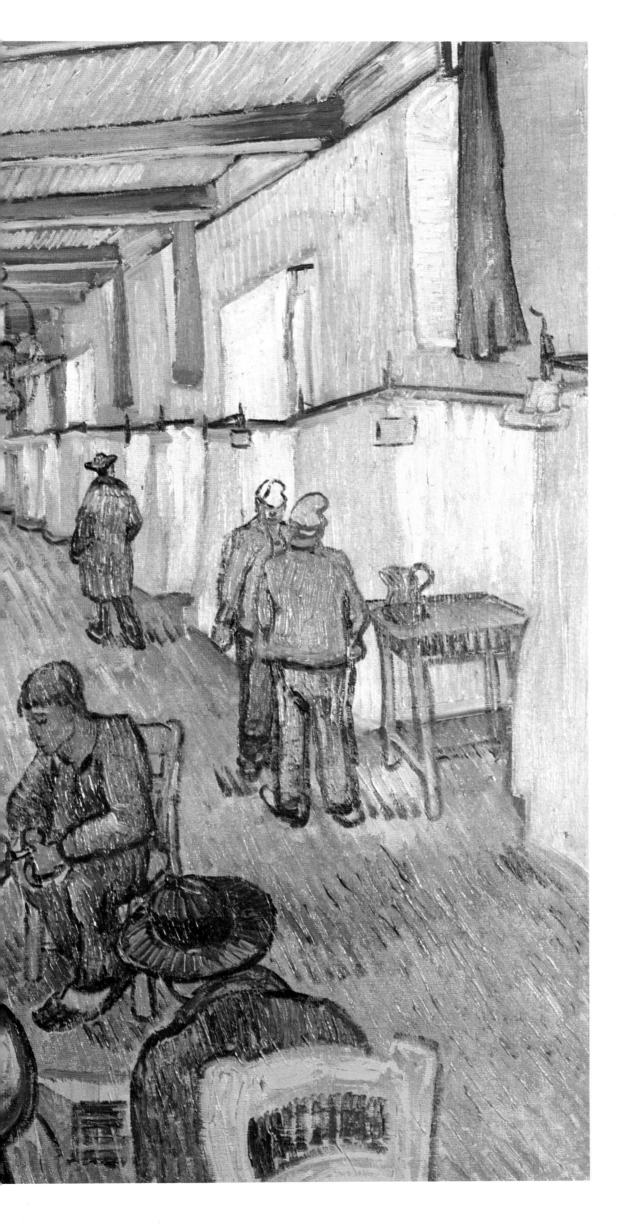

The Hospital in Arles
April/October 1889
Oil on canvas
29¼×36¼ inches (74×92 cm)
Oskar Reinhart Collection 'Am Römerholz',
Winterthur

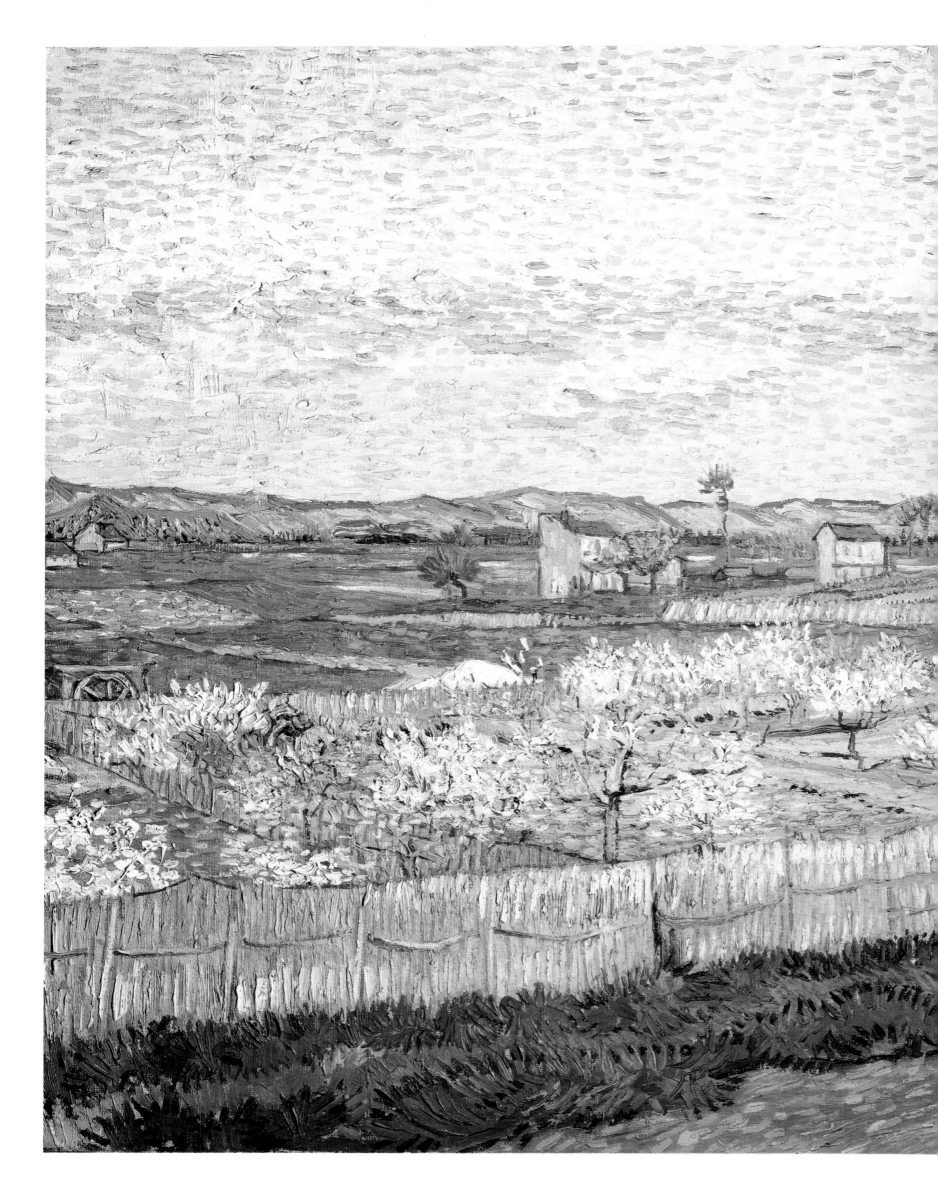

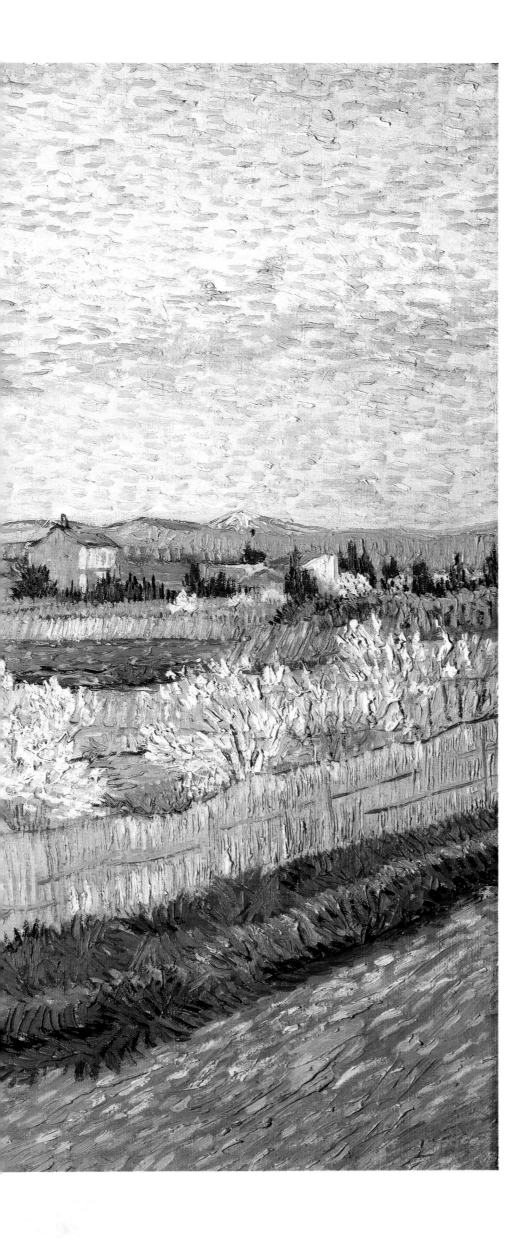

The Plain of La Crau with Peach Trees in Blossom April
1889
Oil on canvas
25¾×32 inches (65.6×81.5 cm)
Courtauld Institute Galleries, London

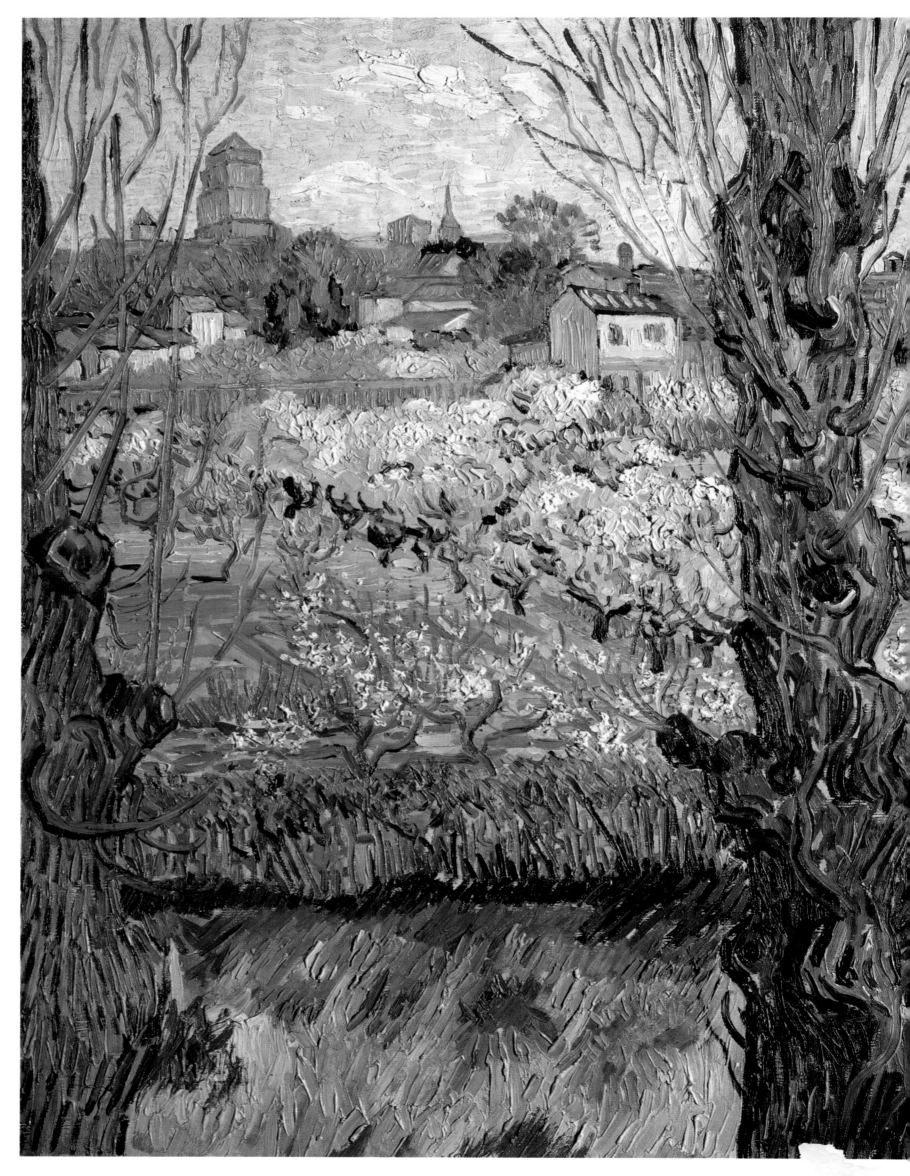

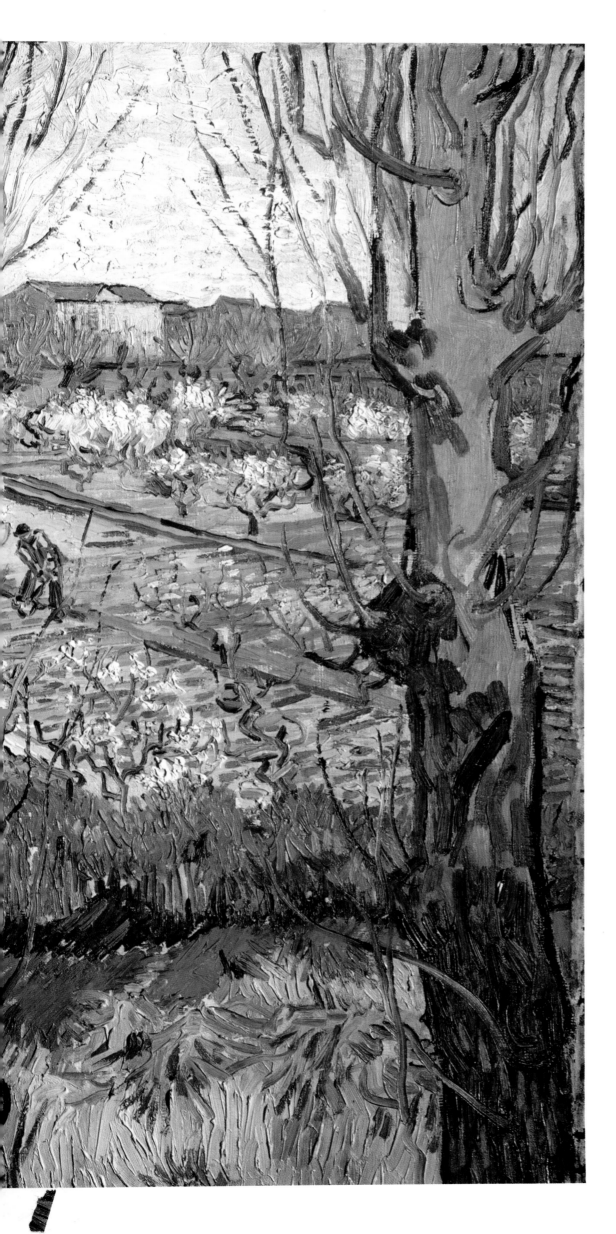

A View of Arles April 1889
Oil on canvas
28¼×36¼ inches (72×92 cm)
Neue Pinakothek, Munich

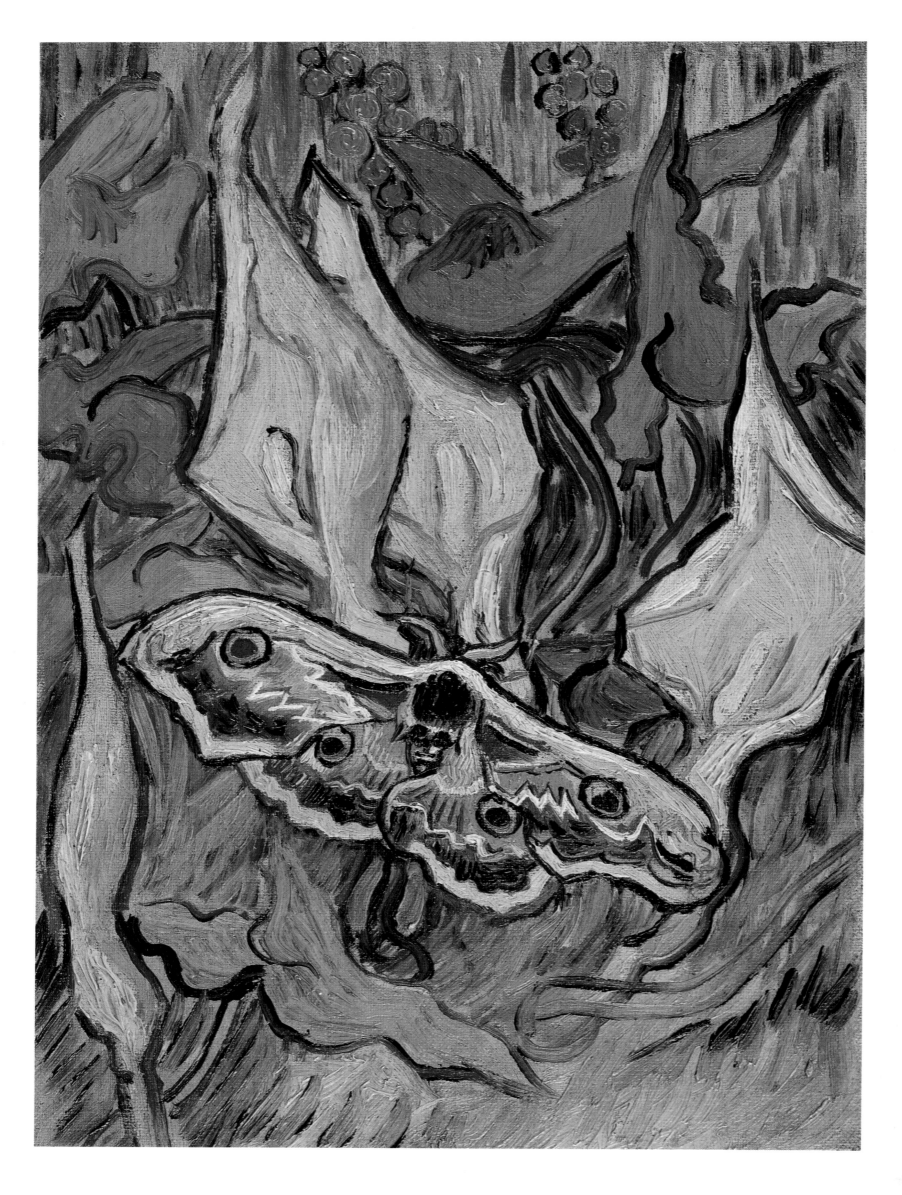

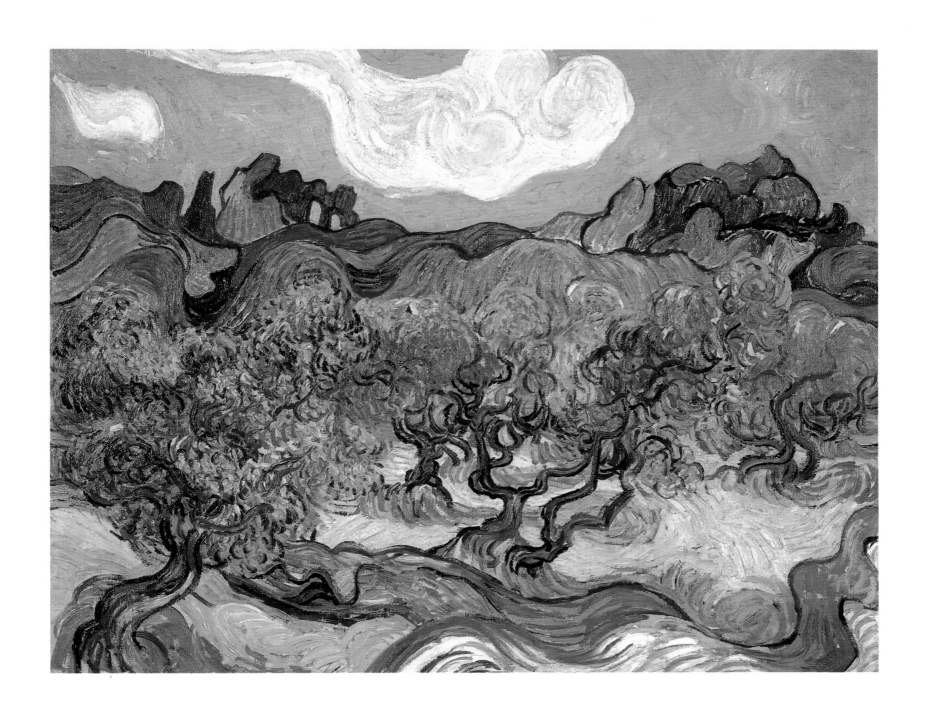

**Olive Trees with the Alpilles
in the Background** June 1889
Oil on canvas
28½×36¼ inches (72.5×92 cm)
*Collection of Mr and Mrs John Hay Whitney,
New York*

Death's Head Moth May 1889
Oil on canvas
13×9½ inches (33×24 cm)
Rijksmuseum Vincent van Gogh, Amsterdam

Irises May 1889
Oil on canvas
28×37 inches (71×93 cm)
J Paul Getty Museum, Malibu

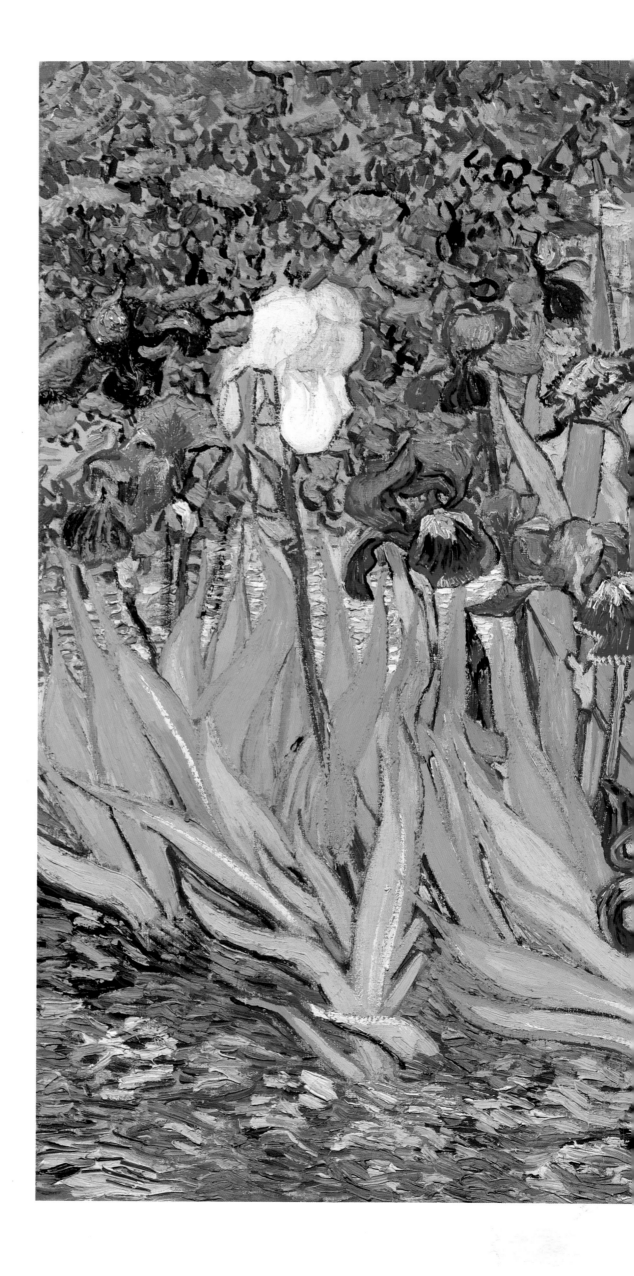

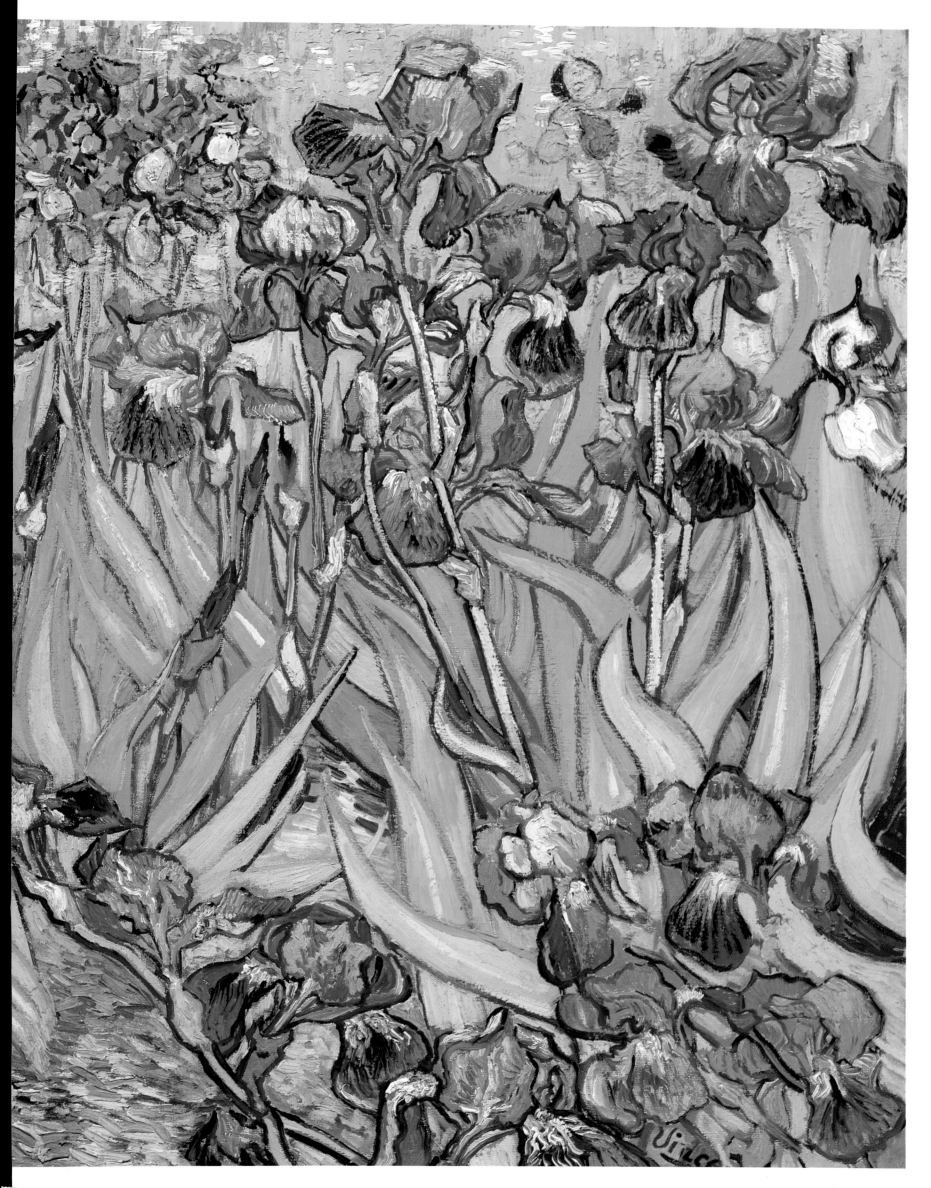

**Mountainous Landscape
(View from St Paul's
Hospital)** May 1889
Oil on canvas
27½×34½ inches (70.5×88.5 cm)
Ny Carlsberg Glyptotek, Copenhagen

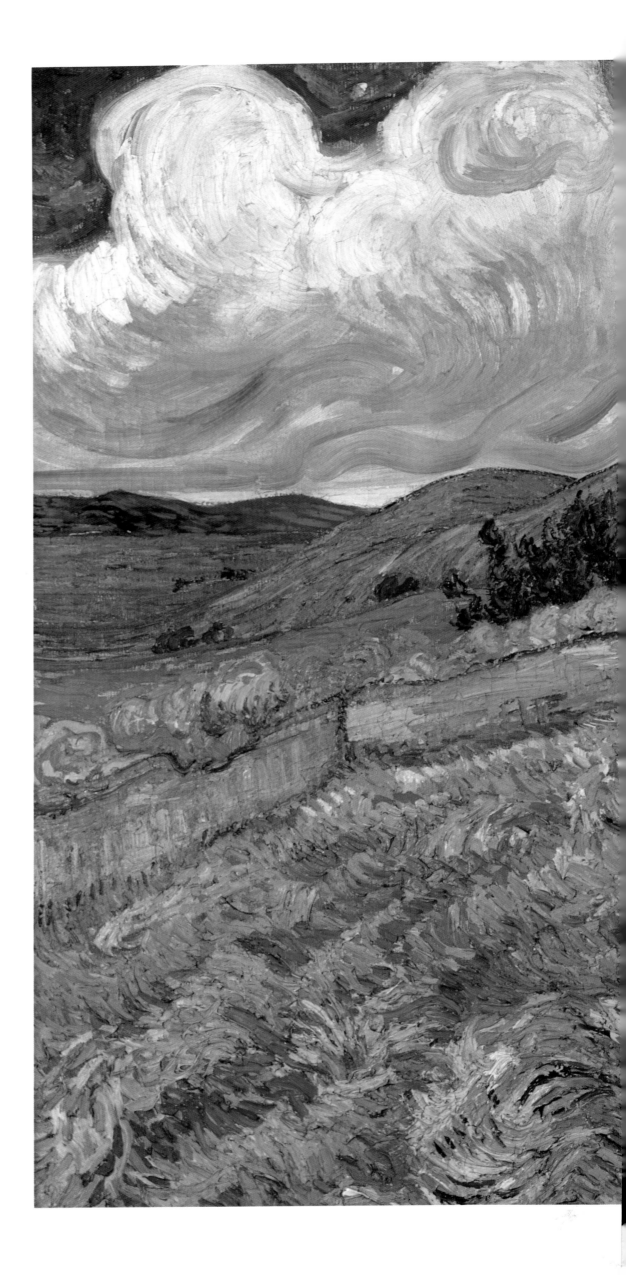

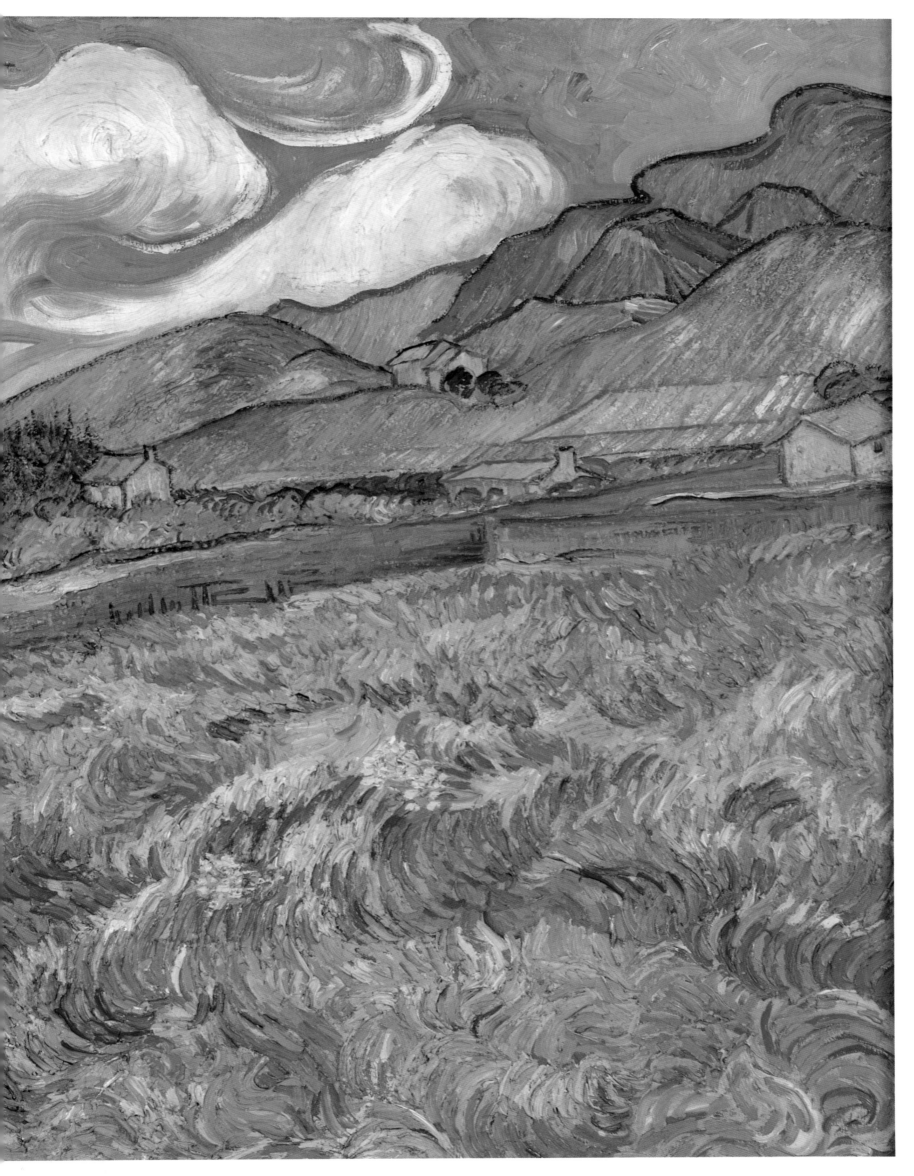

The Starry Night June 1889
Oil on canvas
29×36¼ inches (74×92 cm)
The Collection of the Museum of Modern Art,
New York

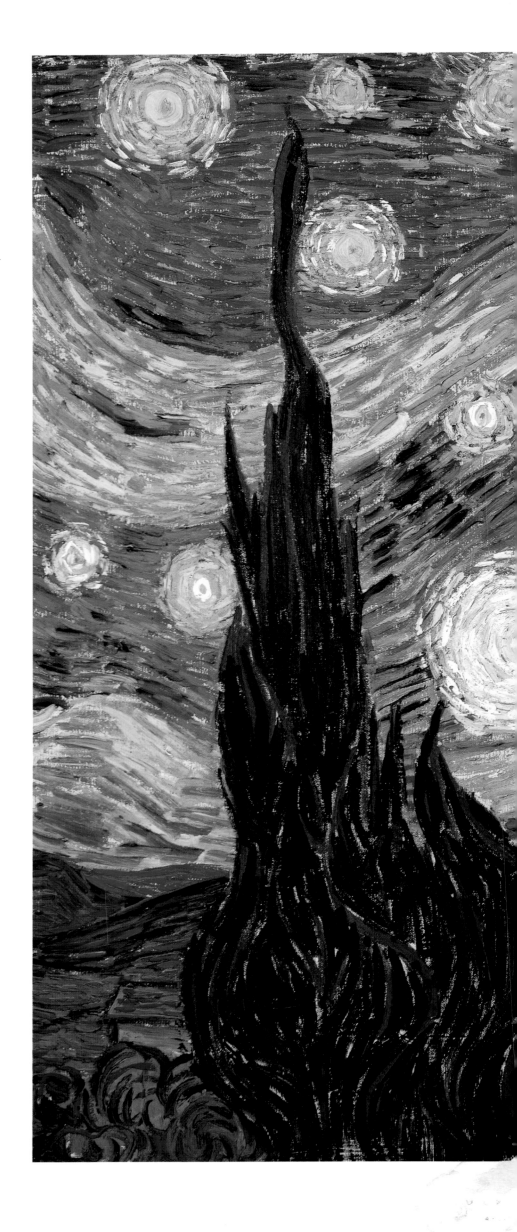

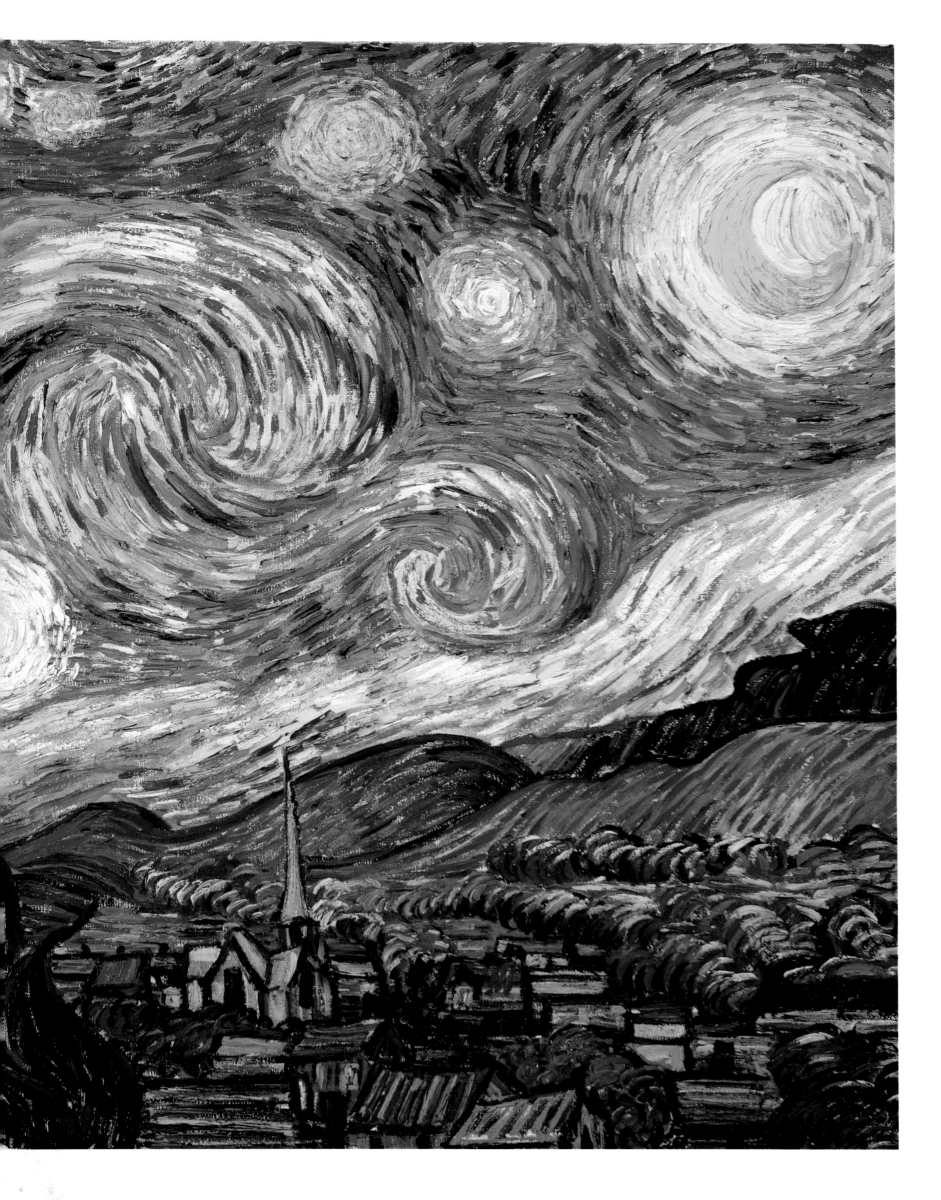

A Cornfield with Cypresses
July 1889
Oil on canvas
28½×36¼ inches (72×91 cm)
*Courtesy of the Trustees of the National
Gallery, London*

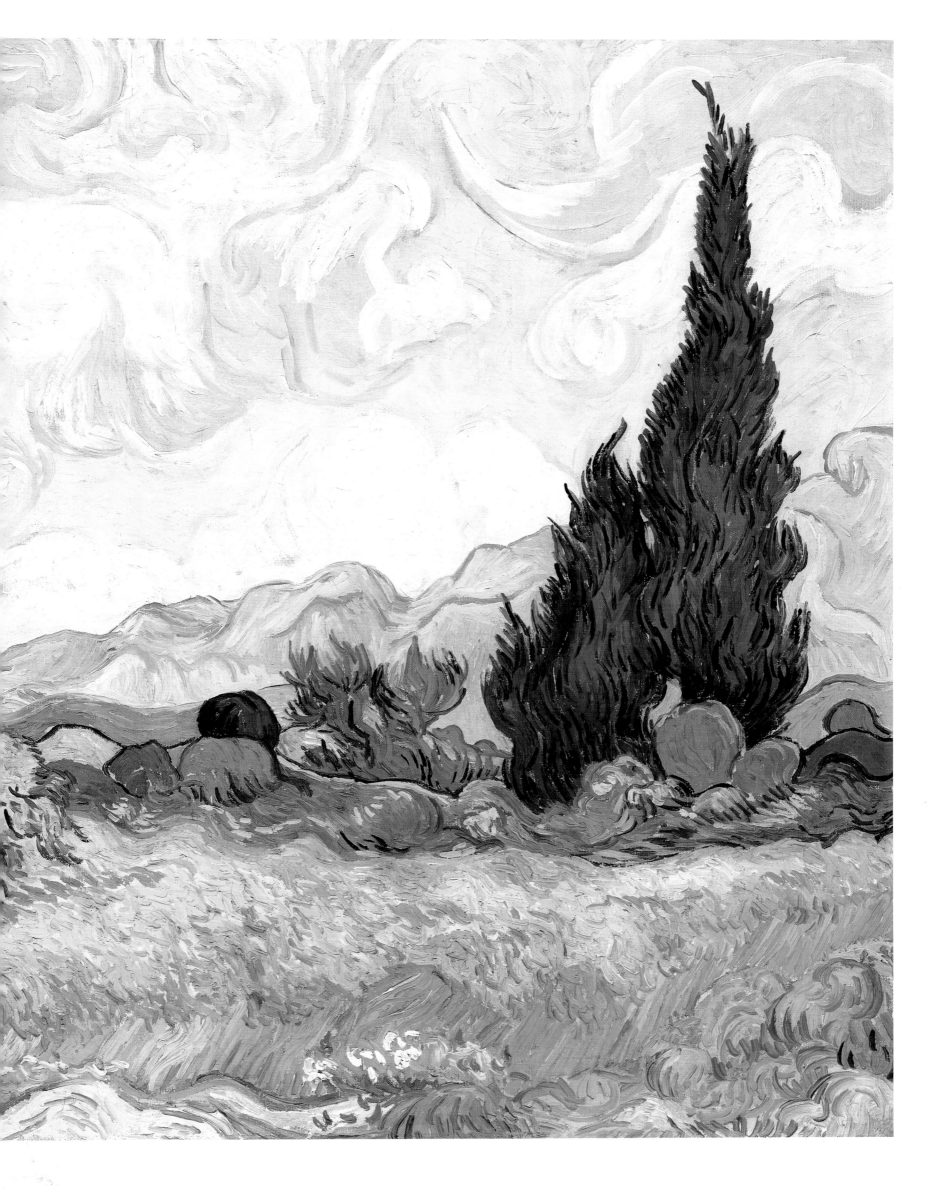

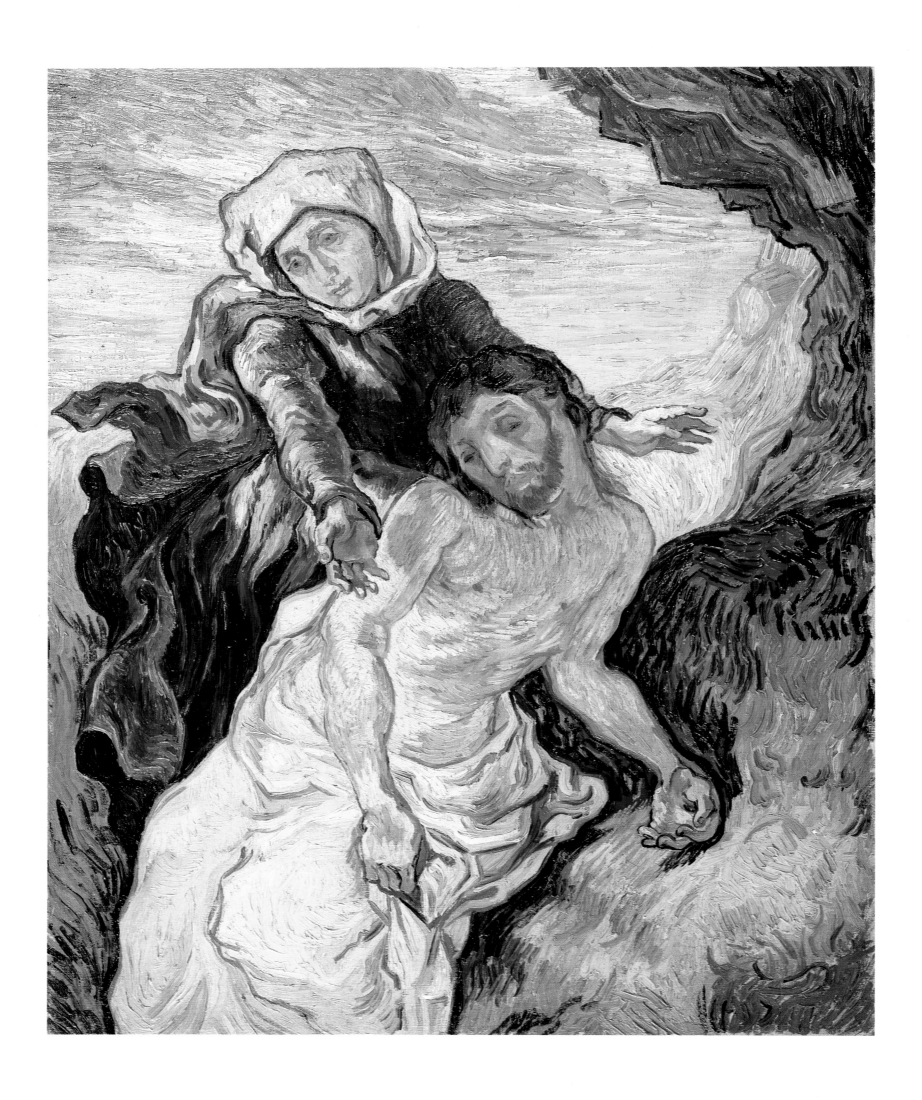

Pietà (after Delacroix)
September 1889
Oil on canvas
28¾×23¾ inches (73×60.5 cm)
Rijksmuseum Vincent van Gogh, Amsterdam

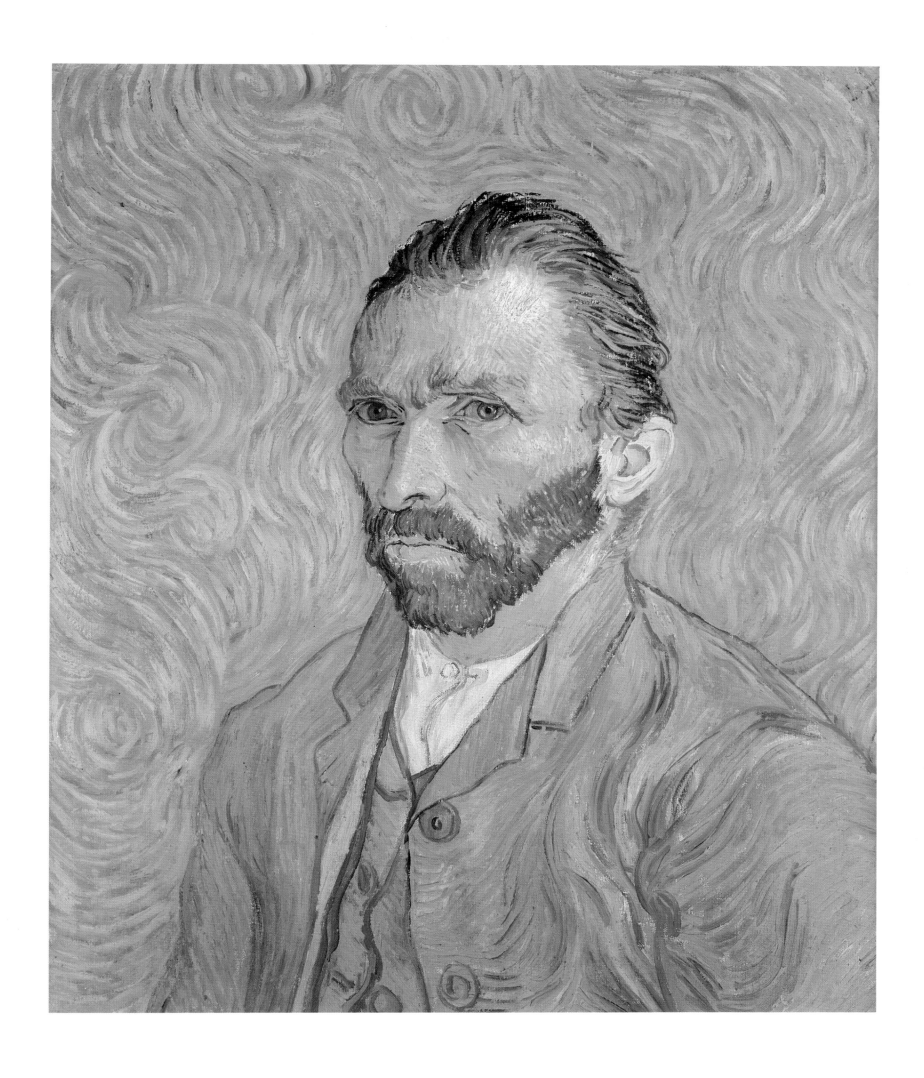

Self-Portrait September 1889
Oil on canvas
25½×21¼ inches (65×54 cm)
Musée d'Orsay, Paris

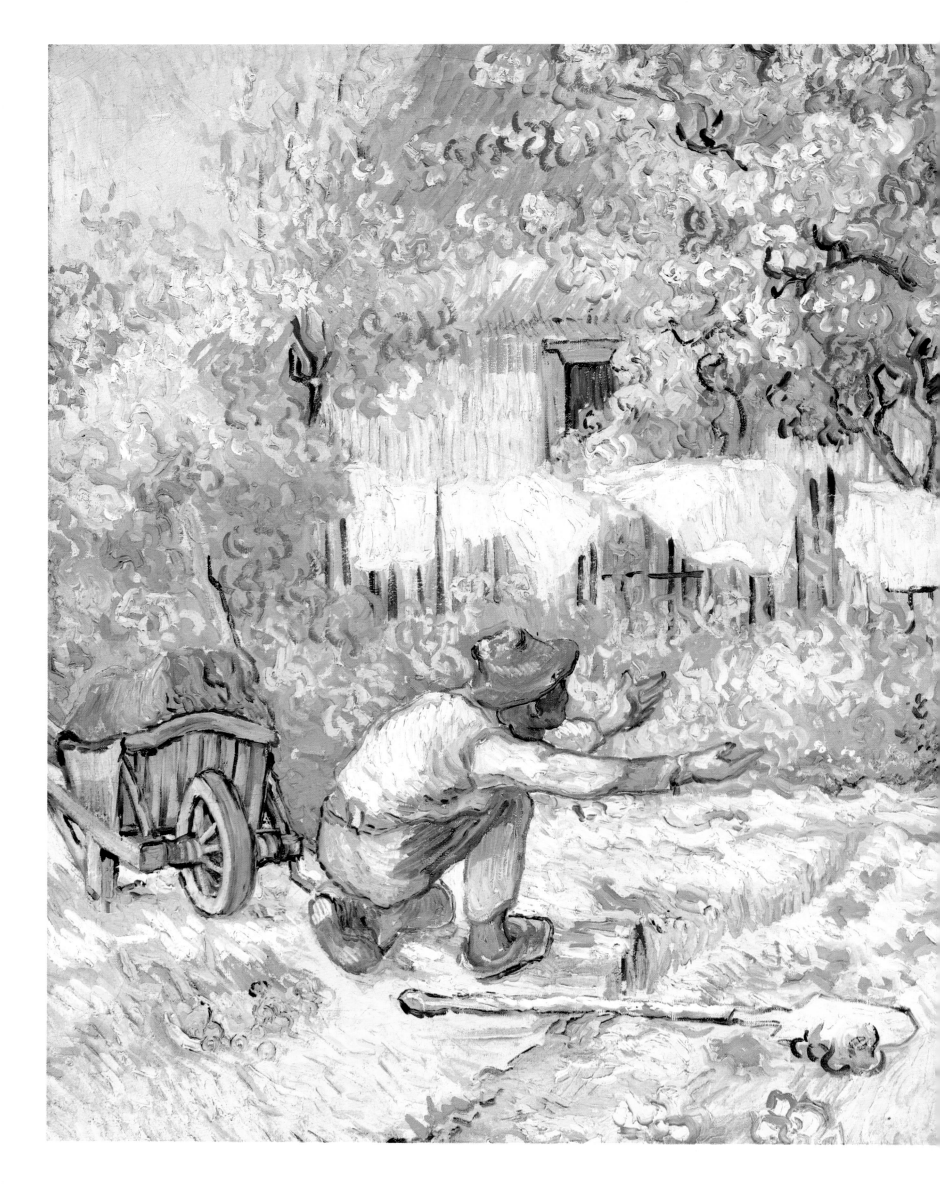

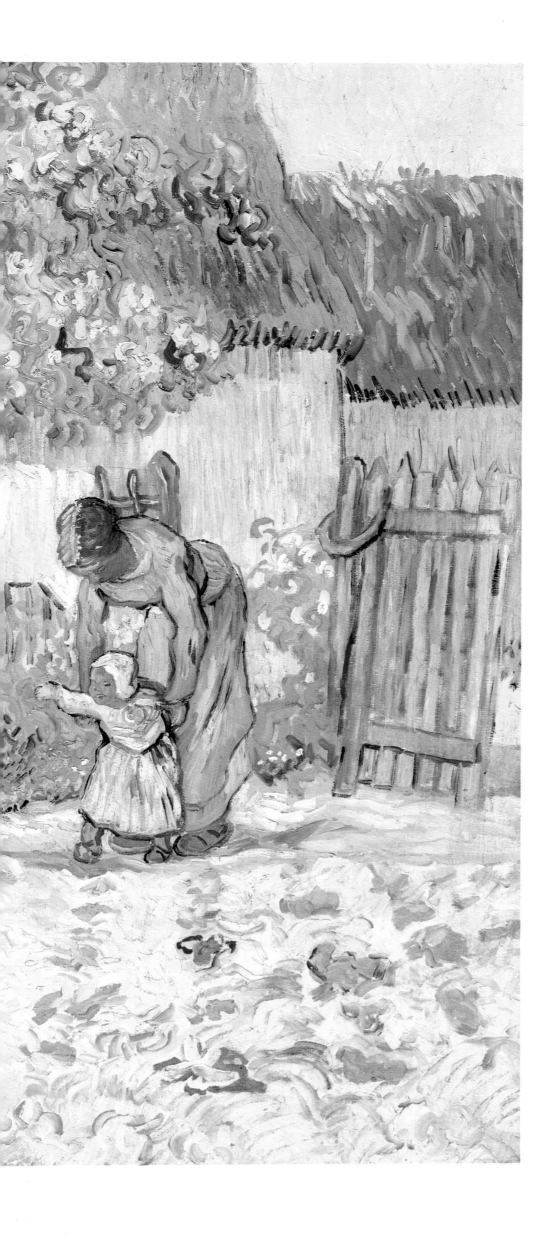

**Two Peasants and a Child
(after Millet's 'Les Premiers
Pas')** January 1890
Oil on canvas
28½×36 inches (72.4×91.2 cm)
The Metropolitan Museum of Art, New York

Noon or the Siesta (after Millet) January 1890
Oil on canvas
28½×35½ inches (73×91 cm)
Musée d'Orsay, Paris

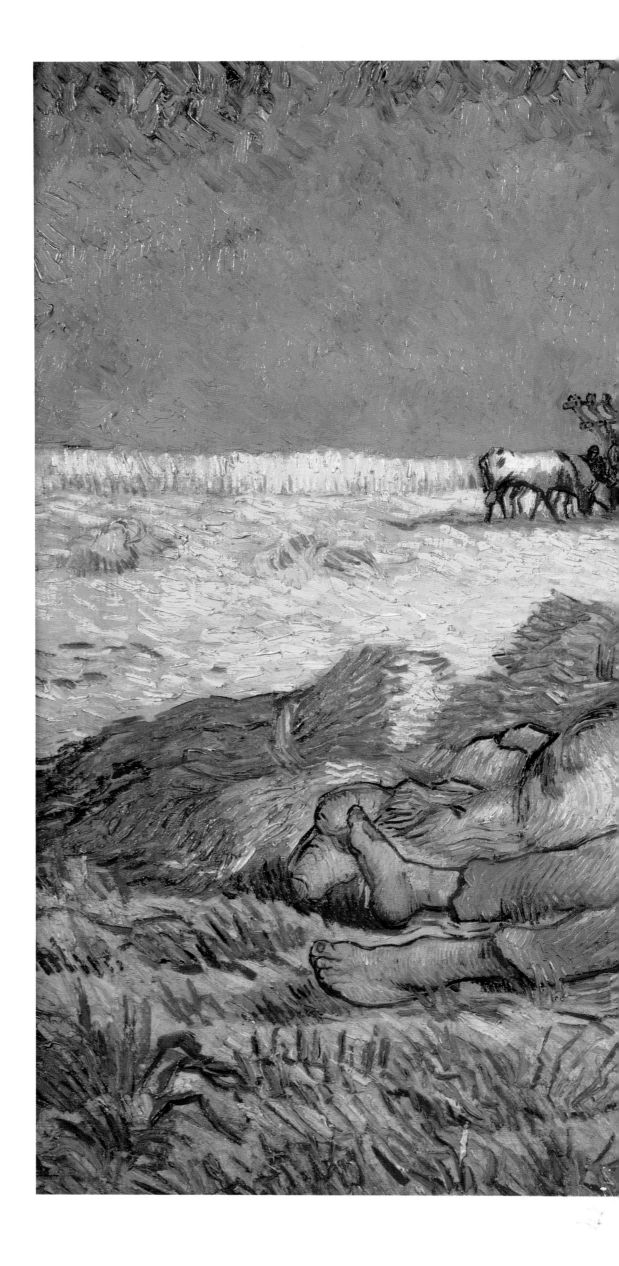

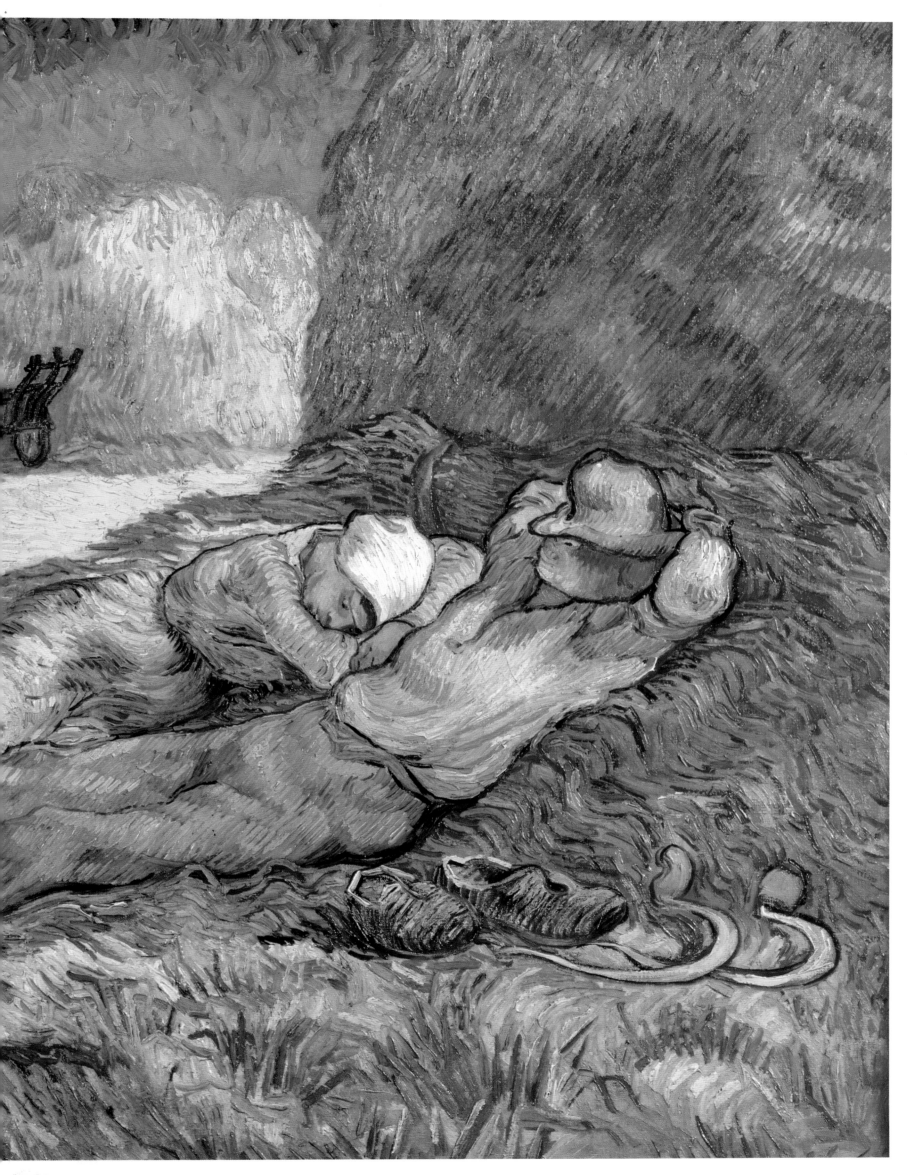

The Road Menders at St Rémy November 1889
Oil on canvas
29×36¼ inches (74×93 cm)
Cleveland Museum of Art, Ohio

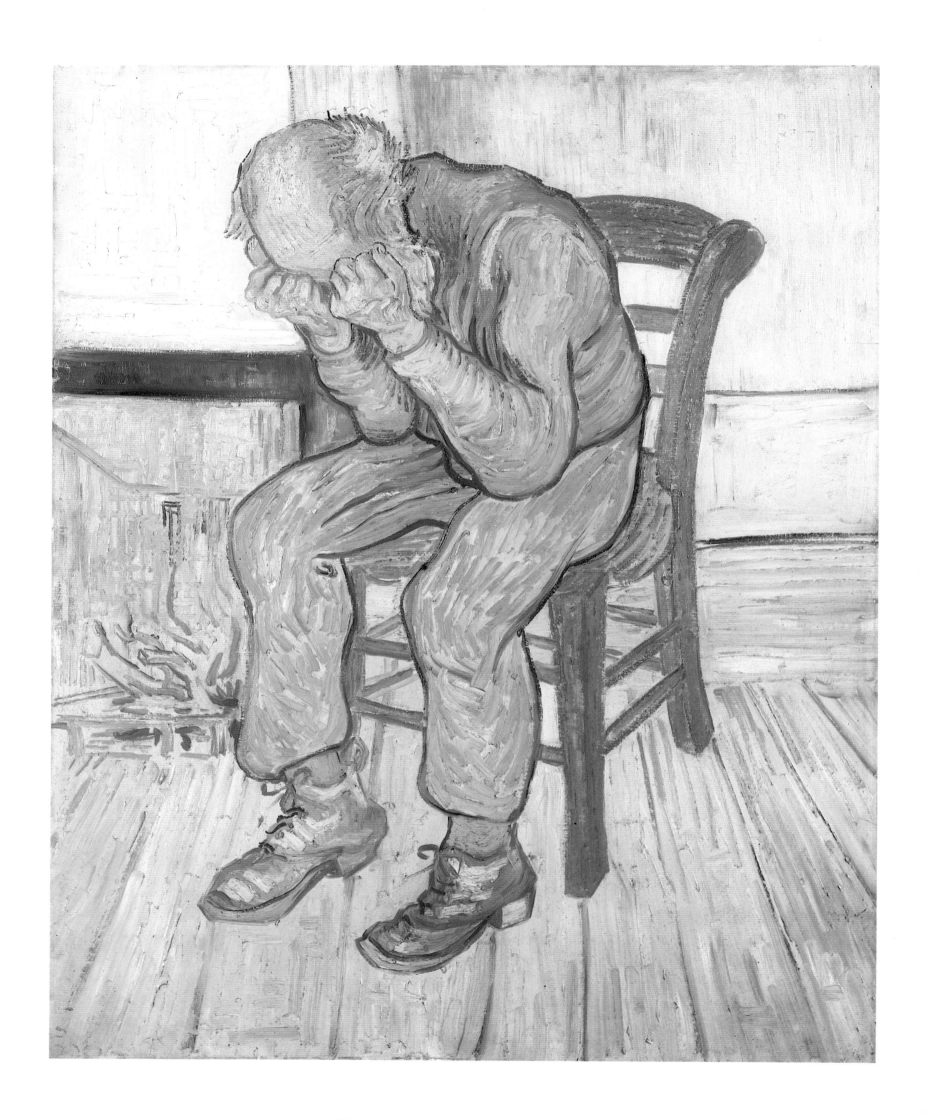

Worn Out May 1890
Oil on canvas
32×25½ inches (81×65 cm)
Collection State Museum Kröller-Müller,
Otterlo, The Netherlands

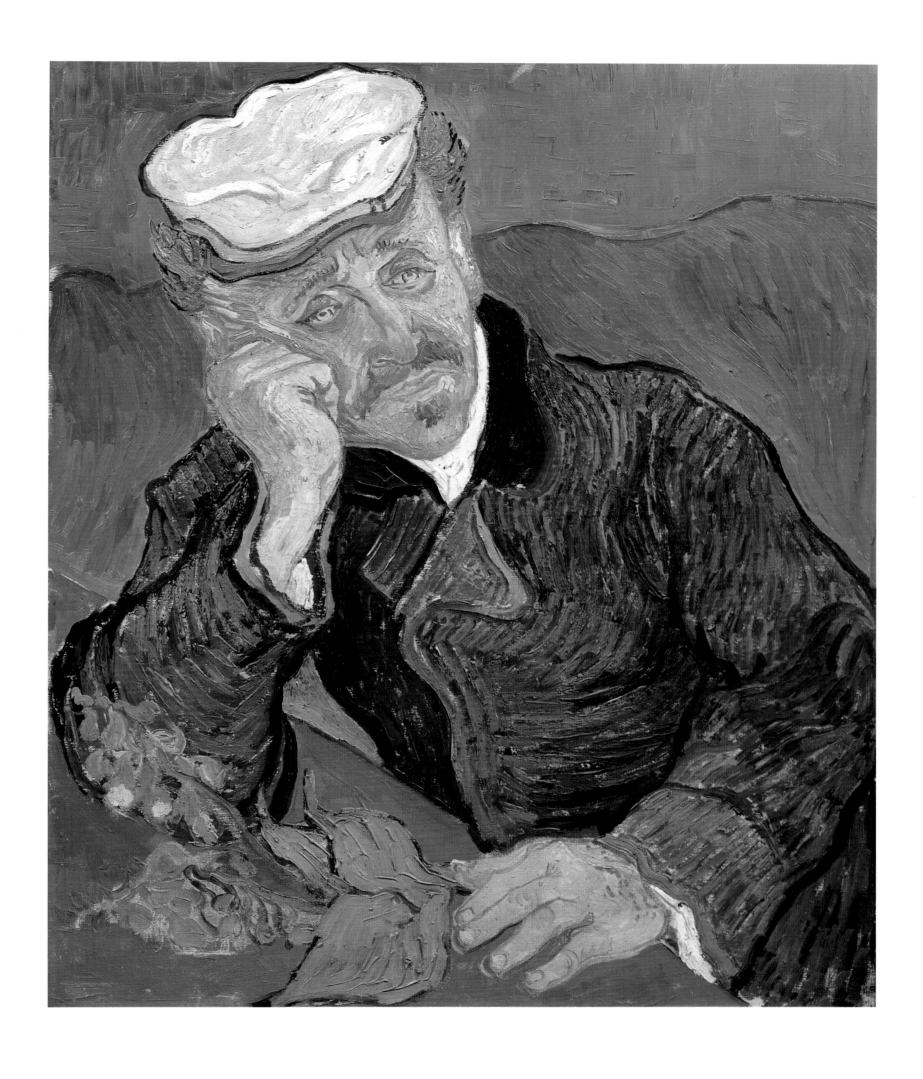

Portrait of Dr Gachet June 1890
Oil on canvas
26¾×22½ inches (68×57 cm)
Musée d'Orsay, Paris

The Church at Auvers June
1890
Oil on canvas
37×29¾ inches (94×75.4 cm)
Musée d'Orsay, Paris

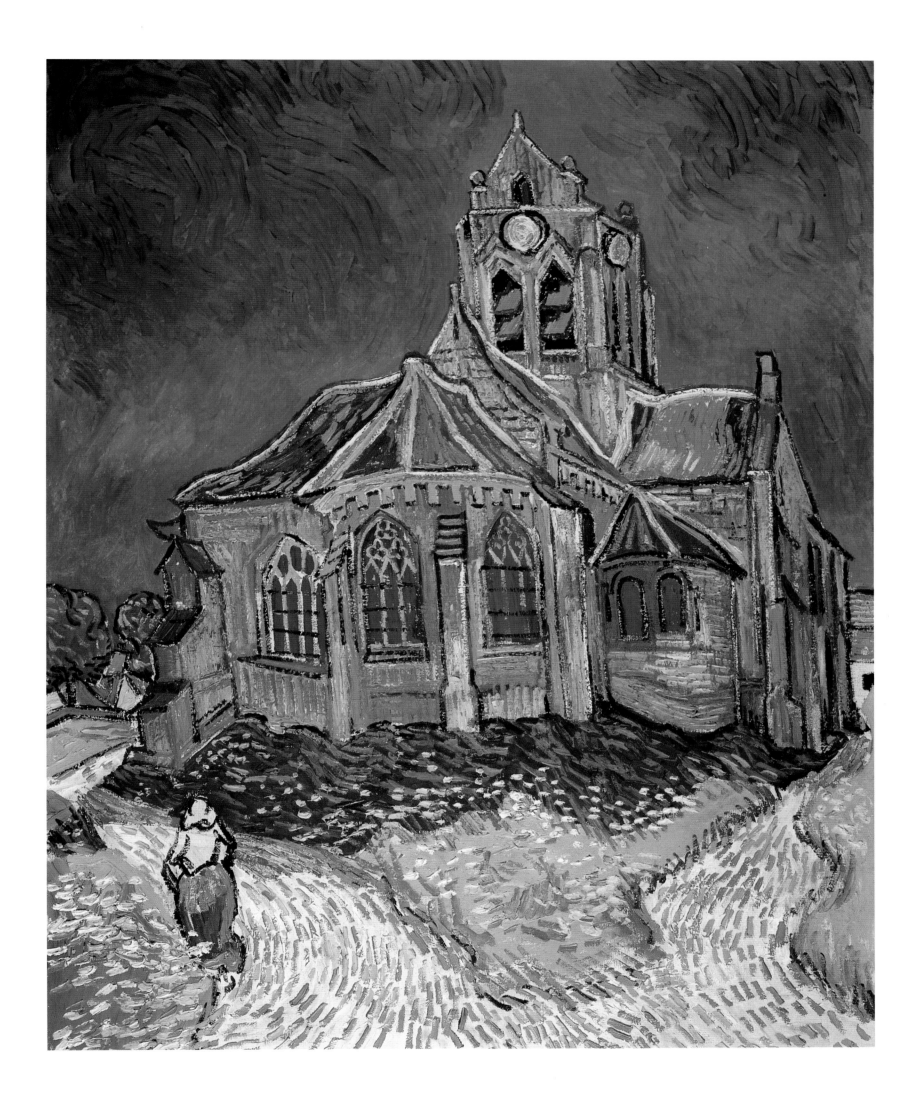

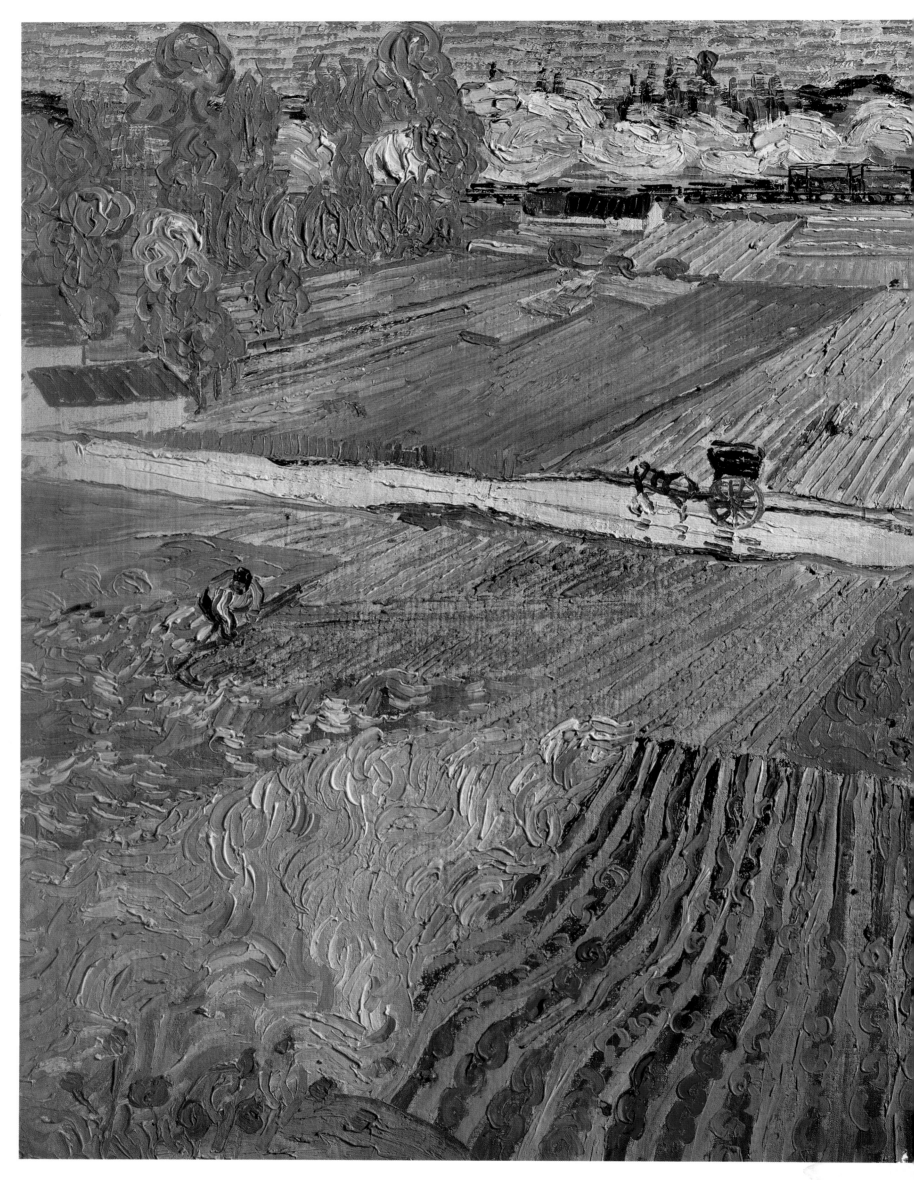

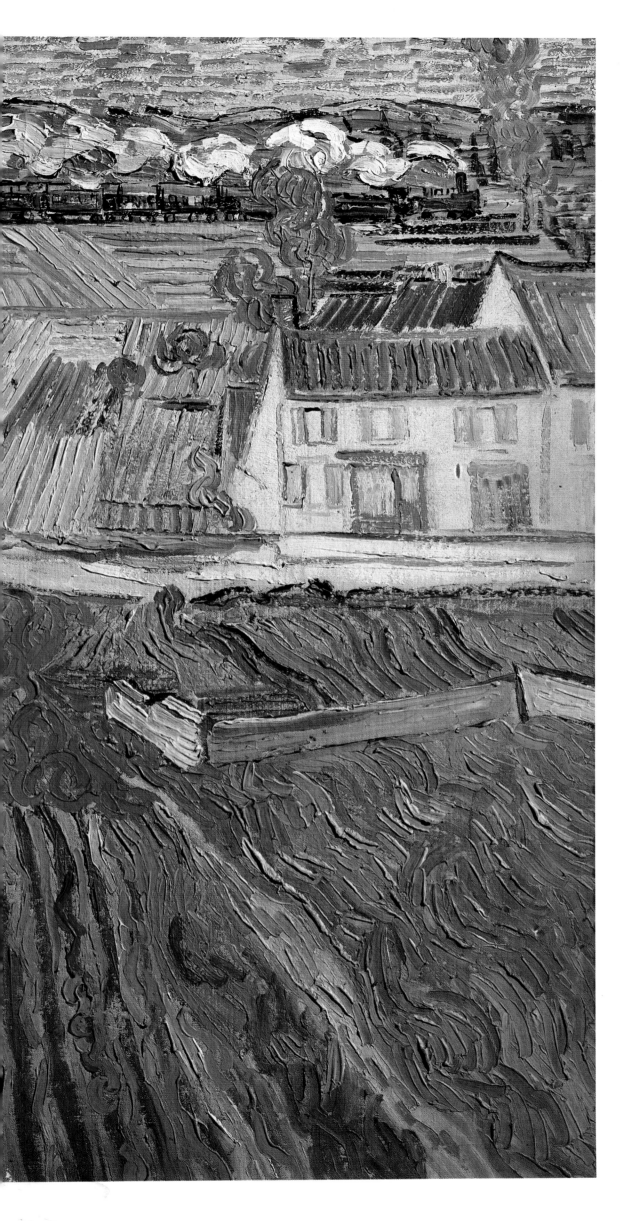

Landscape with Cart and Train June 1890
Oil on canvas
28¼×35½ inches (72×90 cm)
Pushkin Museum of Fine Arts, Moscow

Young Girl in White June 1890
Oil on canvas
26⅛×17⅞ inches (66.3×45.3 cm)
National Gallery of Art, Washington

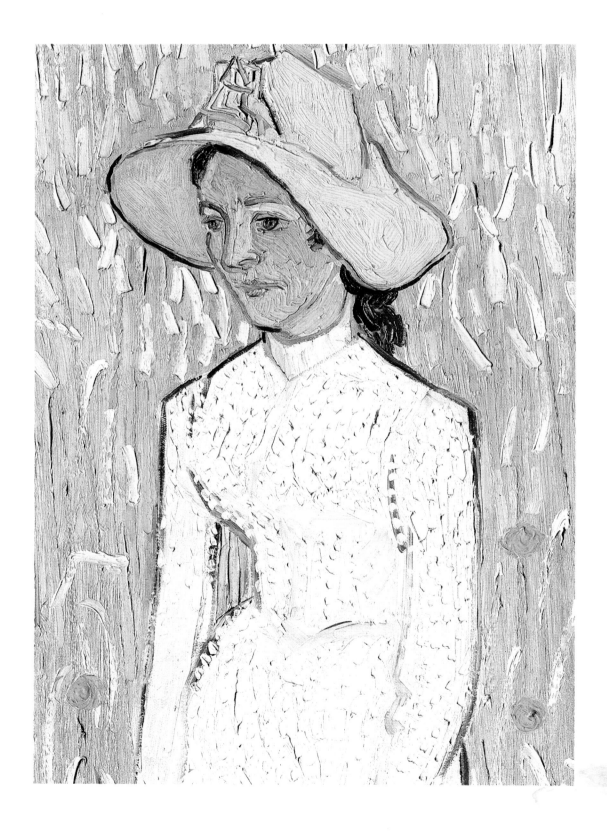

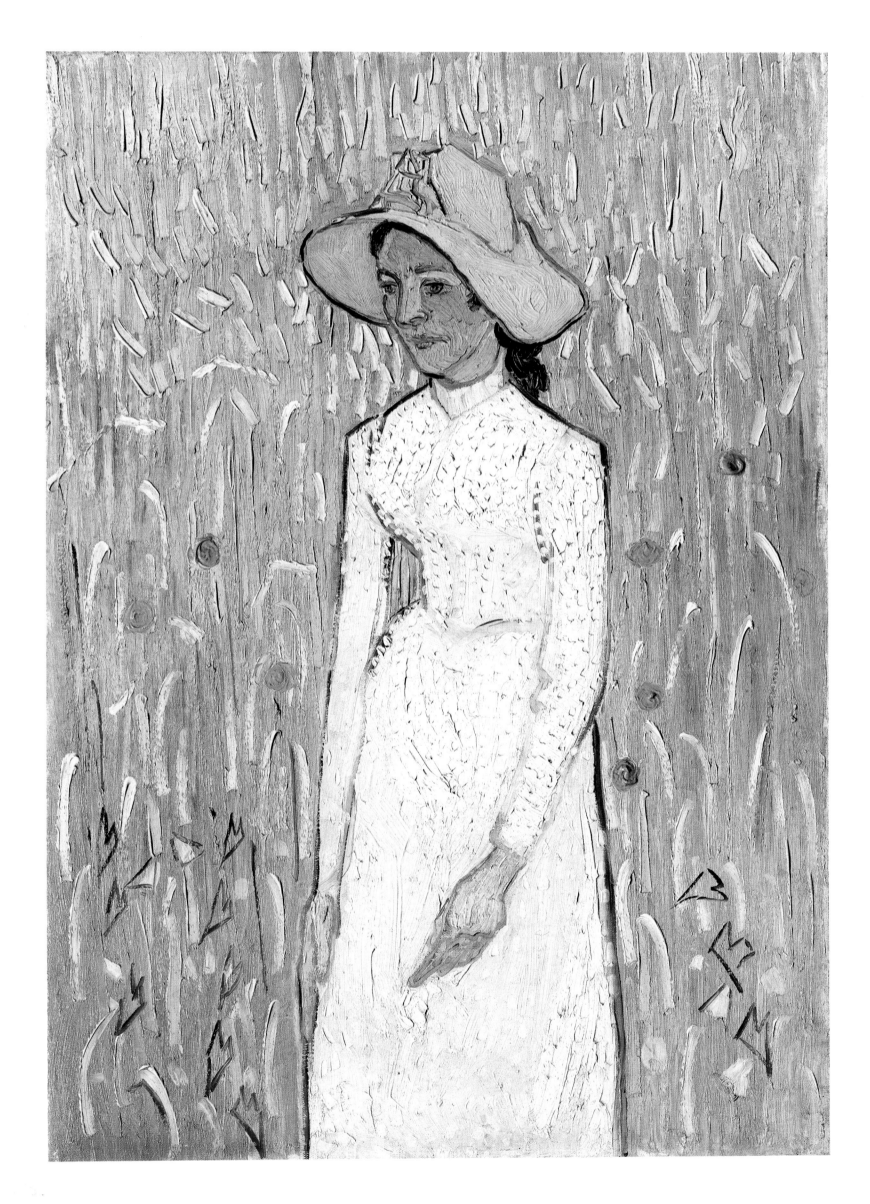

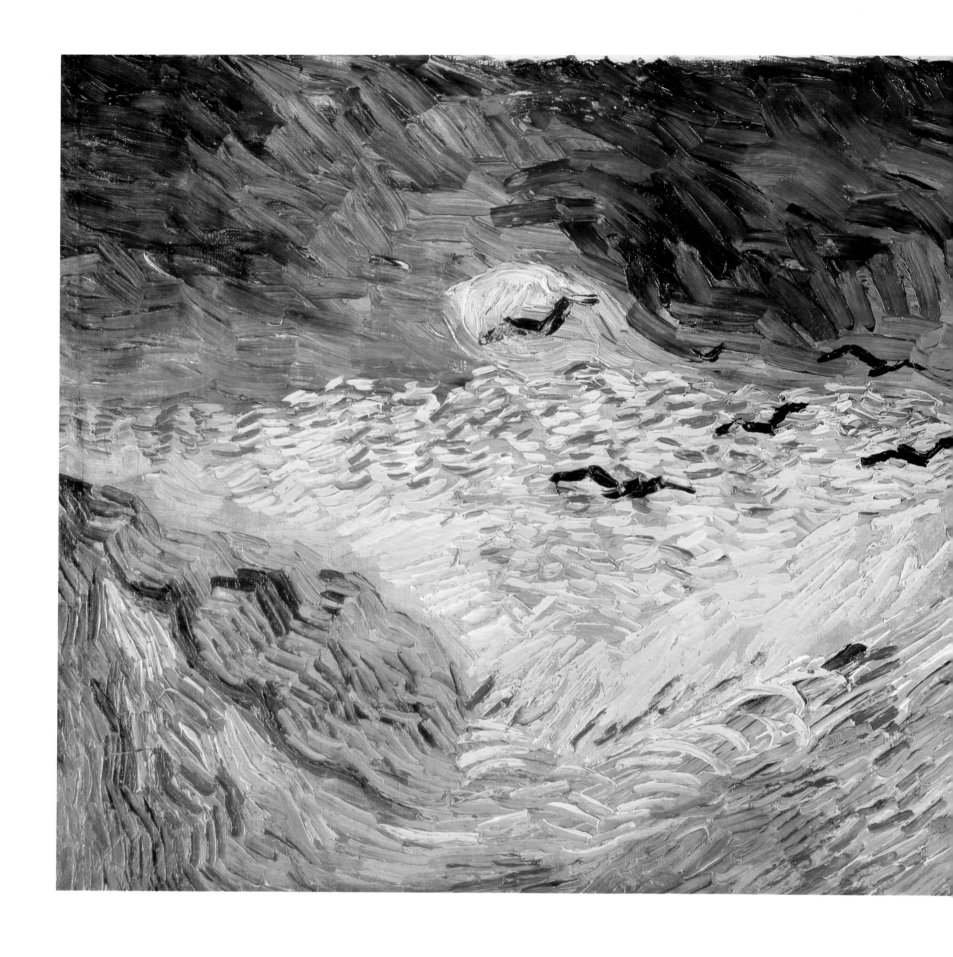

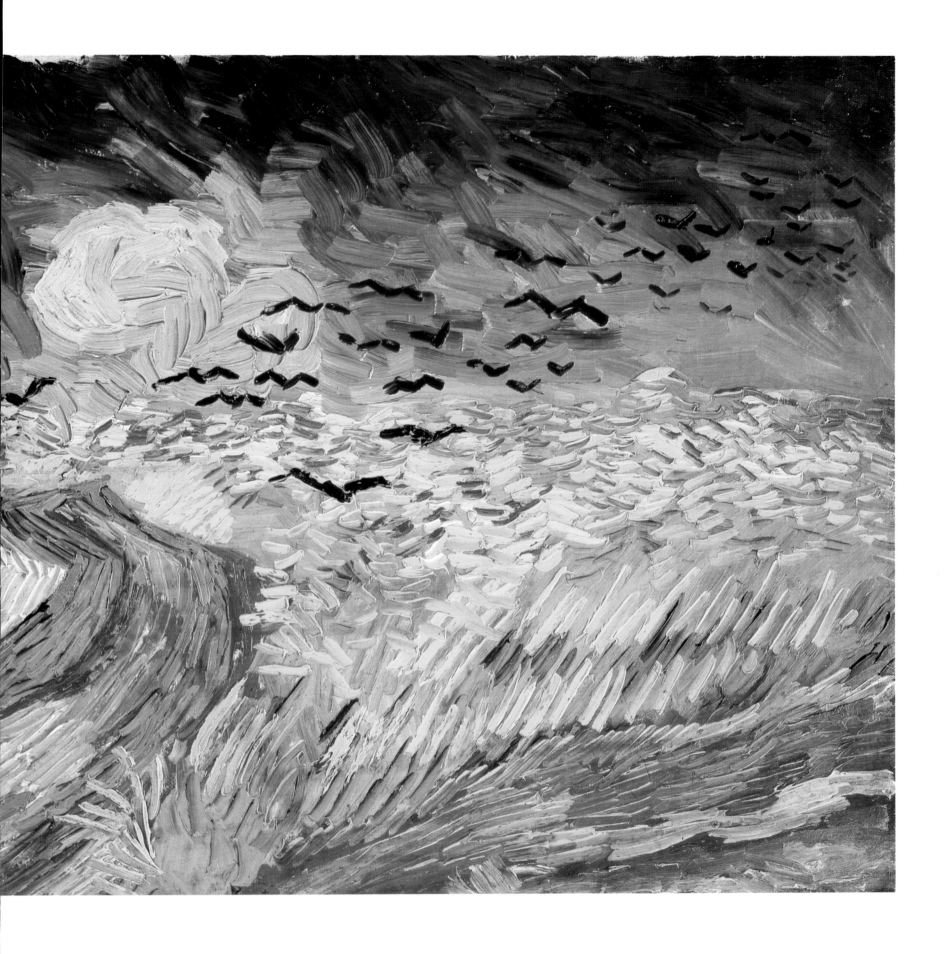

Crows over a Cornfield July
1890
Oil on canvas
19¾×39½ inches (50.5×100.5 cm)
Rijksmuseum Vincent van Gogh, Amsterdam

Index

Acknowledgments

The author would like to thank Helen Scott for all her help in producing the text. The publisher would like to thank Sue Rose, who designed the book; Maria Costantino, the picture researcher; Jessica Orebi Gann, the editor; and Alison Davies, who supplied the maps. Thanks are also due to the following institutions, agencies and individuals for permission to reproduce the illustrations.

Ashmolean Museum, Oxford: page 15(bottom)
Museum of Fine Arts, Boston: pages 27, 53
Museum Boymans-van Beuningen, Rotterdam: page 8(top), 34
Foundation E G Bührle Collection: page 43
Carnegie Museum of Art, Pittsburgh: page 38 (acquired through the generosity of the Sarah Mellon Scaife family, 1967)
Cleveland Museum of Art, Ohio: pages 98/99
Courtauld Institute Galleries (Courtauld Collection): pages 74, 78/79
Dallas Museum of Arts: page 42 (The Eugene and Margaret McDermott Fund in memory of Arthur Berger)
Collection of the J Paul Getty Museum, Malibu, California: pages 84/85
Glasgow Museums and Art Galleries: page 12(top)
Groningen Museum/photo John Stoel: page 13(top)
Collection Haags Gemeentemuseum, The Hague: page 8(bottom)
Collection State Museum Kröller-Müller, Otterlo, the Netherlands: pages 2/3, 9(top), 10, 24(top), 26, 36, 40, 46, 49, 50, 56/57, 62, 66/67, 75, 100
Courtesy of Frank Milner: page 16(bottom)
Musée d'Orsay, Paris/photo Réunion des Musées Nationaux: pages 25, 41, 44, 93, 96/97, 101, 102/103

Collection, The Museum of Modern Art, New York: pages 88/89 (acquired through the Lillie P Bliss bequest)
Metropolitan Museum of Art: pages 19 (bequest of Stephen C Clark, 1960, 61.101.17), 94/95 (gift of George N and Helen M Richard, 1964, 64.165.2)
National Gallery of Art, Washington: page 106/107 (Chester Dale collection)
National Gallery, London: pages 54/55, 90/91
Neue Pinakothek, Munich: pages 88/89
Ny Carlsberg Glyptothek, Copenhagen: pages 86/87
Oskar Reinhart Collection 'Am Römerholz', Winterthur: pages 76/77
Roger-Viollet, Paris: page 16(top)
Musée Rodin, Paris/photo Bruno Jarrett © ADAGP, Paris and DACS, London, 1990: pages 45, 52
Scala/Pushkin Museum of Fine Art, Moscow: pages 68/69, 104/105;/**Hermitage Museum, Leningrad:** pages 70/71
Tate Gallery, London: page 72
Courtesy of the Trustees of the Victoria and Albert Museum, London: pages 11(top), 17
Vincent Van Gogh Foundation/National Museum Vincent Van Gogh, Amsterdam: pages 1, 6(all), 9(bottom), 13(bottom), 14(both), 15(top), 19(bottom), 20(bottom), 21, 23, 24(bottom), 28/29, 30/31, 32, 35, 37, 39, 47, 48, 51, 58/59, 63, 64/65, 73, 82, 92, 108/109
Wadsworth Atheneum, Hartford: page 33 (bequest of Anne Parrish Titzell)
Walsall Museum and Art Gallery: page 11(bottom) (Gorman-Ryan Collection)
Collection of Mr and Mrs John Hay Whitney, New York: page 83
Yale University Art Gallery: pages 60/61 (bequest of Stephen Carlton Clark BA.1093)